THE *ART* OF CROCHET BLANKETS

18 PROJECTS INSPIRED BY MODERN MAKERS

Rachele Carmona

Interweave

DEDICATION

To both my husband and my mother,
for wholeheartedly supporting my every whim.

www.fwcommunity.com

 Interweave®
www.interweave.com

22 21 20 19 5 4 3 2

SRN: 17CR03
ISBN-13: 978-1-63250-573-6

Editorial Director: Kerry Bogert
Editors: Maya Elson, Dana Carpenter
Technical Editor & Illustration: Karen Manthey
Art Direction & Cover Design: Ashlee Wadeson
Interior Designer: Julia Boyles
Photographer: George Boe

CONTENTS

INTRODUCTION | 4

1: WEAVING 6
MARYANNE MOODIE
Rolling Plains 8
Rock Ridge 14
Sun and Sky 18

2: DIGITAL ART 24
FRANCISCO VALLE
Graffiti 26
Multifaceted 34
Cozy Corner 40

3: FABRIC DESIGN 46
APRIL RHODES
Boho Desert 48
Abstract Blocks 56
Wanderlust 64

4: PAPER CUTTING 72
MAUD VANTOURS
Color Garden 74
Layered Waves 80
Perfect Scallops 84

5: CEMENT TILE 92
CAITLIN DOWE-SANDES
Stone Path 94
Moroccan Tile 98
The Northerner 104

6: QUILTING 112
TULA PINK
Ombré Stripe 114
City Sunrise 118
Sweet Spring 124

TECHNIQUES | 136
ABBREVIATIONS | 140
GLOSSARY | 141
ACKNOWLEDGMENTS | 142
ABOUT THE AUTHOR | 143
YARN RESOURCES | 143

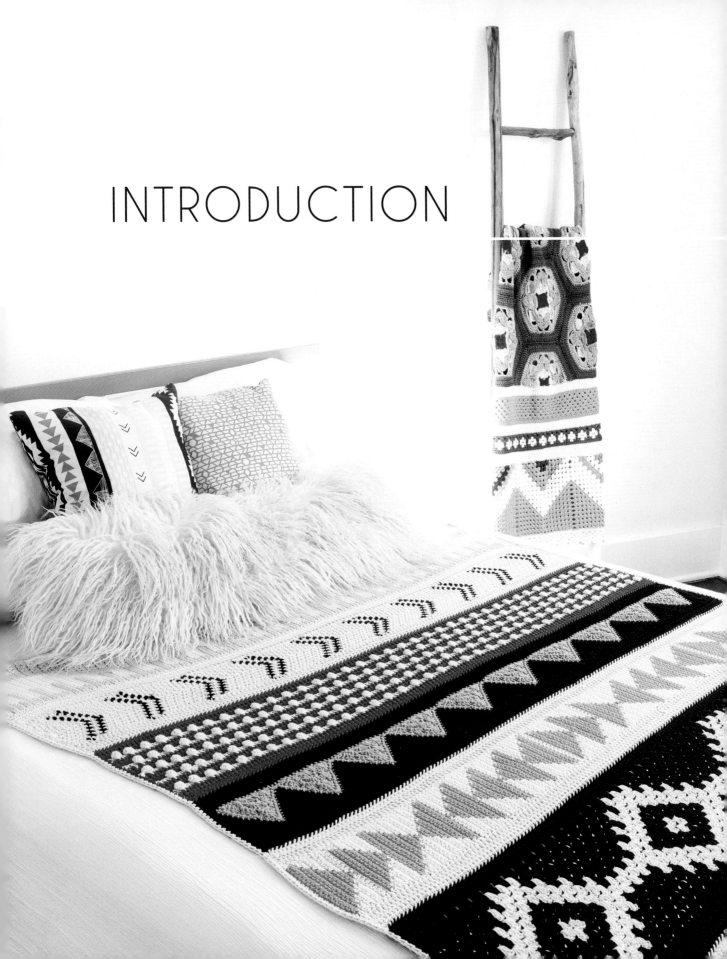

INTRODUCTION

Crochet is my passion and it has been since I first taught myself the craft in 2005. Blogging was an emerging form and YouTube was in its infancy, so I started with books I checked out from the library. I also joined a group of other crocheters and we would meet in a café, where they helped me correct some of the techniques I was doing all wrong, and we had a lot of yarny fun.

Back then, I was already crocheting on a daily basis, trying any pattern I could get my hands on, until I eventually found myself fixated on crochet blankets. Since that time, I have made over 300 blankets, and there is no end in sight. Each and every day, you can find me at my home in Texas, with a hook in my hand, and a cup of coffee by my side.

With a growing number of crochet artists putting patterns and designs out every year, I started to feel a bit like there was nothing new under the sun. After making granny square after granny square, I began to crave inspiration from outside the crochet community.

My journey is not so different from the journey of any artist:

Phase 1: Imitation—Artist creates a direct replica of existing art within her craft, so as to familiarize herself with the process. (All those early blankets crocheted following a pattern designed by someone else.)

Phase 2: Ambition—Artist creates her own pieces, still drawing inspiration from artists within her craft, while seeking out her definitive personal style through color and texture. (My beginning blanket designs were all riffs on traditional crochet shapes.)

Phase 3: Ascension—Artist works on a completely independent plane, and creativity has ascended above the realm of crochet and fused with other art media. (This book and my newer pattern designs are all focused on this idea of ascension.)

Receiving positive comments from artists whose creative interests are rooted outside the crochet community is my personal proof that my craft is evolving through this fusion of art forms. I set out on this journey with the goal of bridging those creative gaps.

This book is more than a straightforward pattern book. In each chapter, we will explore inspiration from other art forms: weaving, digital art, screen-printing, quilting, and even paper crafts. The featured artist for each medium is an influencer in their field. I chose three of their works from which to draw inspiration, and I translated aspects of their work into crochet for an innovative fusion piece.

Through these inspired designs, I hope you'll find new ways to spot shapes, textures, and colors in other beautiful art forms and transform those attributes into your own crochet projects. In addition, within the three uniquely constructed designs in each chapter, I incorporate interesting techniques that you can use in your own future designs.

I hope you will love how these blanket designs make you flex your creative muscles. If you are looking to develop, refresh, or evolve your hooky hobby and learn some new skills along the way, then go ahead, pick a chapter, and dive in.

—Rachele Carmona

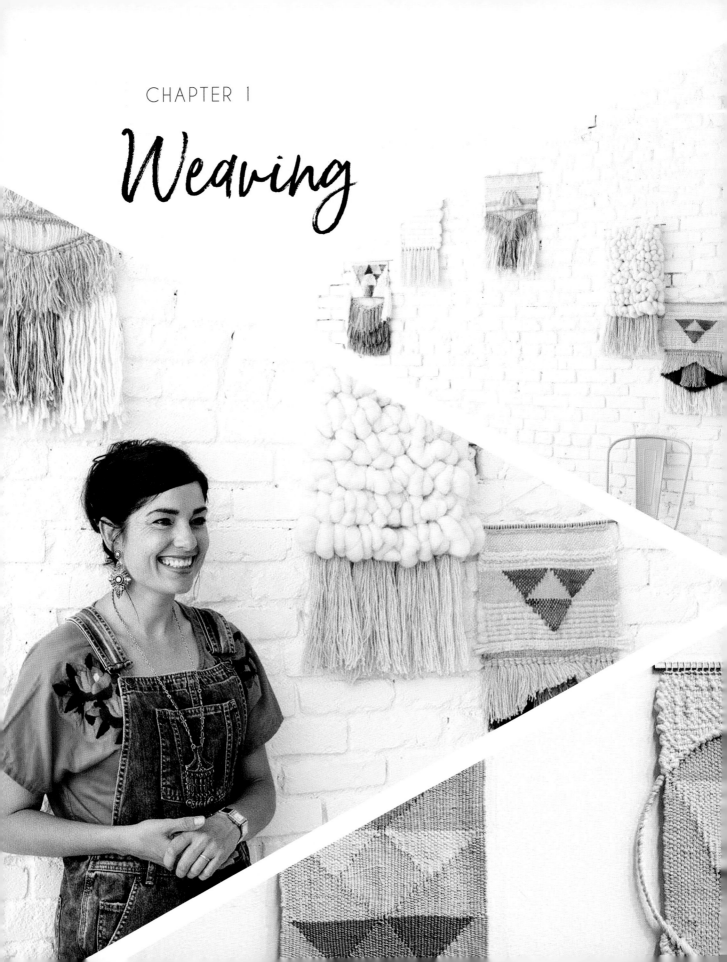

CHAPTER 1

Weaving

MARYANNE MOODIE

The Artist

Maryanne Moodie is an Australian textile artist and educator with a studio based in Brooklyn, New York. As an author and a self-proclaimed "fiber-obsessed" weaver, she explores the tradition of weaving and tapestry while playing with color, form, and texture to bring new life to an ancient art. She is very involved in the textile art community in New York and Australia and spends much of her time teaching the skill to others through workshops worldwide. Maryanne's work has been featured in *New York* magazine; *Anthology*; *O, The Oprah Magazine*; *Grazia*; *Interwoven*; and online on *Design*Sponge* and *The Design Files*.

The Inspiration

Loom weaving is as connected to the earth as petals to a flower, and it draws from the naturally occurring textured surfaces all around us: the dappled pastures of rolling meadows; the geometric striations of rock formations; the lines of a landscape against an orange sunset. The textured planes and contrasting colors in Maryanne's woven art remind me of these nature scenes, and I have designed the blankets for this chapter with them in mind.

To design these blankets, instead of creating an overall pattern as for a typical crocheted piece, I pictured the blanket vertically, with a definite top and bottom, and integrated asymmetric artistic elements that purposefully guide the eye down the piece. This method of designing a blanket from top to bottom is a direct

by-product of examining the weaving process, which also focuses on vertical movement to construct an art piece.

Like a natural loom weaver, I also played with diverse textures to design these blankets. Each project is inspired by one of Maryanne's works and features a different way to crochet a woven stitch. Rolling Plains features springtime colors and gentle texture, including rows of puff stitches, which mimic the thicker fibers that Maryanne incorporates into her pieces. Rock Ridge combines a clay-like landscape with textural stony layers in linen stitch and a unique fringe trim. Sun and Sky is a fun piece that layers puffy white clouds over warm and cool basketweave corner-to-corner patches.

NOTE

Three identical panels are cleverly constructed for this piece, then slip-stitched together for the blanket body. A creative puff-stitch border completes the textured look.

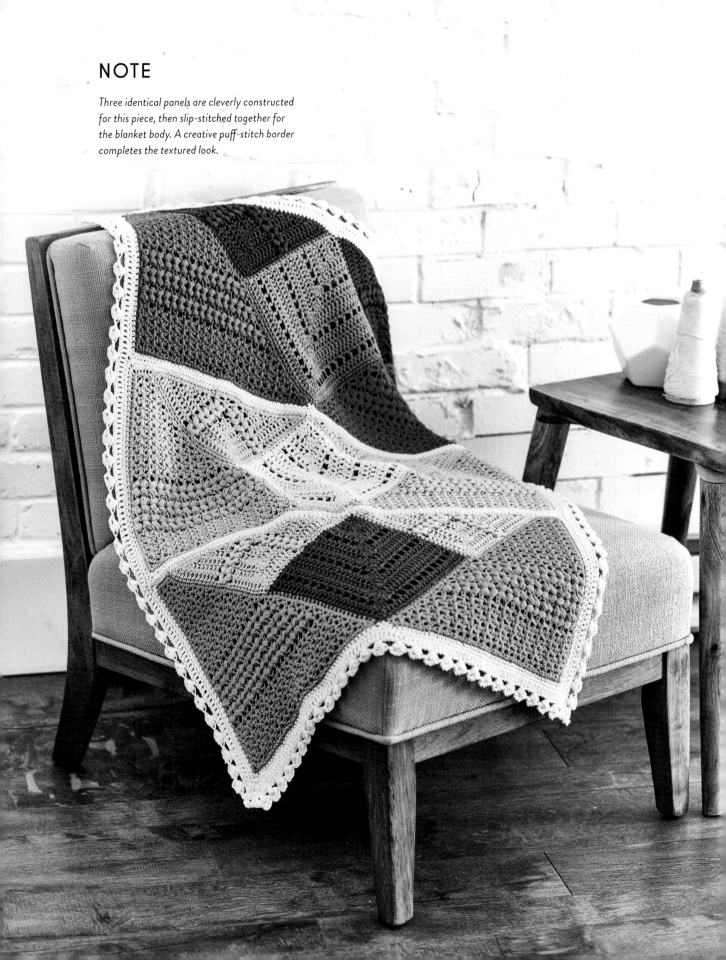

New World by Maryanne Moodie

ROLLING *Plains*

You'll fall in love with texture and color in this unique piece, inspired by Maryanne Moodie's weaving *New World*. With three identical panels constructed in a clever way, this is a fast make that will be perfect for gifting—and even better for keeping!

FINISHED SIZE
26 × 36" (66 × 91.5 cm).

YARN
DK weight (#3 light).

Shown here: Stylecraft Classique Cotton DK (100% cotton; 100 yd [92 m]/1¾ oz [50g]): #3674 Shrimp (A), 2 balls; #3097 Leaf (B), 1 ball; #3656 Toffee (C), 1 ball; #3663 Soft Lime (D), 2 balls; #3665 Ivory (E), 3 balls; #3662 Sunflower (F), 1 ball; #3671 Azure (G), 2 balls; #3566 Teal (H), 1 ball; #3096 Dove (I), 1 ball.

HOOK
US size G-6 (4.25 mm) hook.

Adjust hook size if necessary to achieve gauge.

NOTIONS
Stitch markers; tapestry needle.

GAUGE
6 V-sts and 7 rows = 4" (10 cm), in the V-st pattern of Section 1a.

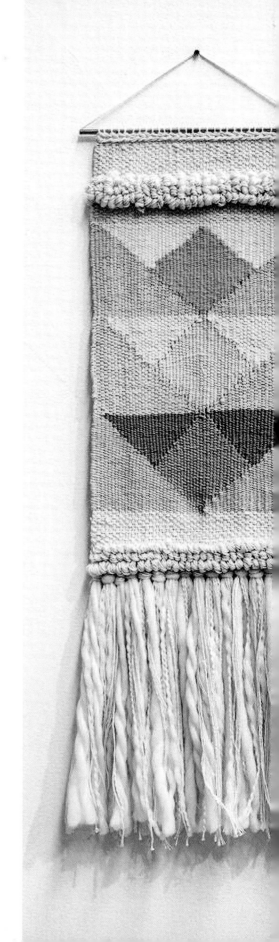

STITCH GUIDE

Puff st
(Yo, insert hook in st/sp indicated, yo, draw up loop) 4 times, yo, draw yarn through all loops on hook. **Note:** *Only ch 1 after the puff st if directed in the pattern.*

Panel 1
Section 1a

Row 1: (WS) With A, ch 43, dc in 5th ch from hook (turning ch counts as a dc, sk 1 ch), (ch 1, dc2tog as follows: yo, insert hook in same ch as prev st, yo, pull up lp, yo, draw yarn through 2 lps on hook, yo, sk next ch, insert hook in next ch, yo, pull up lp, yo, draw yarn through 2 lps on hook, yo, draw yarn through all 3 lps on hook) 9 times, ch 1, dc in same ch as prev st, sk 2 chs, [(puff st [see Stitch Guide], ch 2, puff st) in next ch, sk 2 chs] 3 times, ch 1, dc in next ch, [ch 1, dc2tog as before] 3 times, ch 1, dc in same ch as prev st, sk next st, dc in last ch, turn.

Row 2: Beg dc (see Glossary) in first st, dc in next ch-sp, (ch 1, dc2tog as follows here and throughout the rem of the section: yo, insert hook in same ch-sp as prev st, yo, pull up lp, yo, draw yarn through 2 lps on hook, yo, insert hook in next ch-sp, yo, pull up lp, yo, draw yarn through 2 lps on hook, yo, draw yarn through all 3 lps on hook) 3 times, ch 1, dc in same st as prev st, (puff st, ch 2, puff st) in each of next 3 ch-sps, ch 1, dc in next ch-sp, (ch 1, dc2tog as before) 9 times, ch 1, dc in same ch-sp as prev st, dc in last st, turn.

Row 3: Beg dc in first st, dc in each of next 2 ch-sps, [ch 1, dc2tog as before] 8 times, ch 1, dc in same ch-sp as prev st, (puff st, ch 2, puff st) in each of next 3 ch-sps, ch 1, dc in next ch-sp, [ch 1, dc2tog] 3 times, ch 1, dc in same ch-sp as prev st, dc in last st, turn.

Row 4: Beg dc, dc in first ch-sp, (ch 1, dc2tog) 3 times, ch 1, dc in same ch-sp as prev st, (puff st, ch 2, puff st) in each of next 3 ch-sps, ch 1, dc in next ch-sp, [ch 1, dc2tog] 7 times, ch 1, work ending dec as follows: yo, insert hook in next

ch-sp, yo, pull up lp, yo, draw yarn through 2 lps on hook, yo, sk next dc, insert hook in next dc, yo, pull up lp, yo, draw yarn through 2 lps on hook, yo, draw yarn through all 3 lps on hook, leave Beg dc unworked, turn.

Row 5: Beg dc in ending dec, dc in next 2 ch-sps, [ch 1, dc2tog] 6 times, ch 1, dc in same ch-sp as prev st, (puff st, ch 2, puff st) in each of next 3 ch-sps, ch 1, dc in next ch-sp, [ch 1, dc2tog] 3 times, ch 1, dc in same ch-sp as prev st, dc in last st, turn.

Row 6: Beg dc in first st, dc in first ch-sp, [ch 1, dc2tog] 3 times, ch 1, dc in same ch-sp as prev st, (puff st, ch 2, puff st) in each of next 3 ch-sps, ch 1, dc in next ch-sp, [ch 1, dc2tog] 5 times, ch 1, work ending dec, turn.

Row 7: Beg dc in ending dec, dc in each of next 2 ch-sps, [ch 1, dc2tog] 4 times, ch 1, dc in same ch-sp as prev st, (puff st, ch 2, puff st) in each of next 3 ch-sps, ch 1, dc in next ch-sp, [ch 1, dc2tog] 3 times, ch 1, dc in same ch-sp as prev st, dc in last st, turn.

Row 8: Beg dc in first st, dc in first ch-sp, [ch 1, dc2tog] 3 times, ch 1, dc in same ch-sp as prev st, (puff st, ch 2, puff st) in each of next 3 ch-sps, ch 1, dc in next ch-sp, [ch 1, dc2tog] 3 times, ch 1, work ending dec, turn.

Row 9: Beg dc in ending dec, dc in next 2 ch-sps, [ch 1, dc2tog] twice, ch 1, dc in same ch-sp as prev st, (puff st, ch 2, puff st) in each of next 3 ch-sps, ch 1, dc in next ch-sp, [ch 1, dc2tog] 3 times, ch 1, dc in same ch-sp as prev st, dc in last st, turn.

Row 10: Beg dc in first st, dc in first ch-sp, [ch 1, dc2tog] 3 times, ch 1, dc in same ch-sp as prev st, (puff st, ch 2, puff st) in each of next 3 ch-sps, ch 1, dc in next ch-sp, ch 1, dc2tog, ch 1, work ending dec, turn.

Row 11: Beg dc in ending dec, dc in next 2 ch-sps, ch 1, dc in same ch-sp as prev st, (puff st, ch 2, puff st) in each of next 3 ch-sps, ch 1, dc in next ch-sp, [ch 1, dc2tog] 3 times, ch 1, dc in same ch-sp as prev st, dc in last st, turn.

Row 12: Beg dc in first st, dc in first ch-sp, [ch 1, dc2tog] 3 times, ch 1, dc in same ch-sp as prev st, (puff st, ch 2, puff st) in next 3 ch-sps, ch 1, work ending dec, turn.

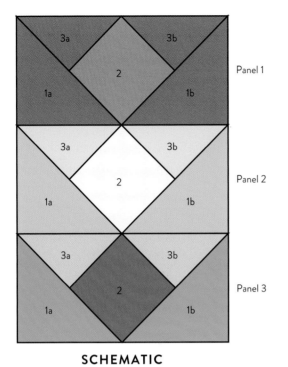

SCHEMATIC

Panel 1: 3a, 3b, 2, 1a, 1b
Panel 2: 3a, 3b, 2, 1a, 1b
Panel 3: 3a, 3b, 2, 1a, 1b

COLOR KEY

= color A = color F
= color B = color G
= color C = color H
= color D = color I
= color E

Row 13: Beg dc in ending dec, (puff st, ch 2, puff st) in next 3 ch-sps, ch 1, dc in next ch-sp, [ch 1, dc2tog] 3 times, ch 1, dc in same ch-sp as prev st, dc in last st, turn.

Row 14: Beg dc, dc in first ch-sp, [ch 1, dc2tog] 3 times, ch 1, dc in same ch-sp as prev st, (puff st, ch 2, puff st) in each of next 2 ch-sps, puff st in next ch-sp, ch 1, dc in Beg dc, turn.

Row 15: Beg dc in first st, dc in next puff st, (puff st, ch 2, puff st) in each of next 2 ch-sps, ch 1, dc in next ch-sp, [ch 1, dc2tog] 3 times, ch 1, dc in same ch-sp as prev st, dc in last st, turn.

Row 16: Beg dc in first st, dc in first ch-sp, [ch 1, dc2tog] 3 times, ch 1, dc in same ch-sp as prev st, (puff st, ch 2, puff st) in next ch-sp, puff st in next ch-sp, ch 1, dc in next dc, turn, leaving Beg dc unworked.

Row 17: Beg dc in first st, dc in next puff st, (puff st, ch 2, puff st) in next ch-sp, ch 1, dc in next ch-sp, [ch 1, dc2tog] 3 times, ch 1, dc in same ch-sp as prev st, dc in last st, turn.

Row 18: Beg dc in first st, dc in first ch-sp, [ch 1, dc2tog] 3 times, ch 1, dc in same ch-sp as prev st, puff st in next ch-sp, ch 1, dc in last st, turn.

Row 19: Beg dc in first st, dc in next puff st, dc in next ch-sp, [ch 1, dc2tog] 3 times, ch 1, dc in same ch-sp as prev st, dc in last st, turn.

Row 20: Beg dc in first st, dc in first ch-sp, [ch 1, dc2tog] twice, ch 1, dc in same ch-sp as prev st, work ending dec, turn.

Row 21: Beg dc in first st, dc in each of next 2 ch-sps, dc2tog, ch 1, dc in same ch-sp as prev st, dc in last st, turn.

Row 22: Beg dc in first st, dc in next ch-sp, ch 1, dc in same ch-sp as prev st, work ending dec, turn.

Row 23: Beg dc in first st, dc in next ch-sp, dc in last st, turn.

Row 24: Beg dc in first st, dc in next dc, ch 1 and pull ch closed to secure last st. Do not fasten off.

Border rnd: (RS) 3 sc in last st, work 53 sc evenly spaced across long diagonal, 2 sc in top side of dc from Row 2, 3 sc in corner, work 39 sc evenly spaced across bottom edge to next corner, 3 sc in next corner, work 47 sc evenly spaced across to beg, sl st in first st. Fasten off.

Section 1b

Rows 1–24: Work as for Section 1a. **Note:** *Row 1 is RS.* Do not fasten off.

Border rnd: (RS) Turn work, 3 sc in last st, work 47 sc evenly spaced across left side to next corner, 3 sc in corner, work 39 sc evenly spaced across bottom edge to next corner, 3 sc in corner, sc in next 3 sts, 2 sc in top side of dc from Row 2, work 53 sc evenly spaced across long diagonal to beg, sl st in first st. Fasten off.

Section 2

Row 1: Lay Section 1a and Section 1b out with RS facing as shown in Schematic, locate the long diagonal of Section 1a, and find the 2 sc at the top. Starting at the beginning of the 53 sc sts, count 28 sts down and mark that st. Do the same for Section 1b. Using B, sl st in the marked st on Section 1b, and remove marker, sc in the same st, and sc in the following 27 sts, starting in the st right before the 53 sc diagonal of Section 1a, sc in the first 28 sts, placing the final sc in the marked st, removing marker, turn.

Row 2: Beg dc in first st, dc in all sts to final 2 sts of Section 1a, dc4tog (see Glossary) over next 4 sts, dc in all sts to end, turn.

Row 3: Beg dc in first st, (ch 1, sk next st, dc in next st) across to 3 sts before center dec, ch 1, sk next st, dc5tog (see Glossary) over next 5 sts, (ch 1, sk next st, dc in next st) across to end, turn.

Rows 4–6: Beg dc, dc in all sts/sps to final dc before center dec, dc5tog over next 5 sts, dc in each st and sp across, turn.

Rows 7–14: Rep Rows 3–6 (twice).

Row 15: Beg dc in first st, dc4tog over next 4 sts. Fasten off.

Border row: With RS facing, locate the sc on Section 1b that is just before the first st of Section 2, Row 1. This is the 27th sc down on the long diagonal. Join B with a sl st in that st, sc in the side of the first sc of Row 1, work 25 sc evenly spaced across Section 2 to the next dc4tog, 3 sc in dc4tog, mark the center sc of this corner, work 26 sc evenly spaced across next side, sl st in the next sc on Section 1a located just after the last st of Section 2, Row 1. Fasten off.

Section 3a

Row 1: With RS facing, join C with a sl st in 2nd sc from marked st at center top of Section 2, sc in same st, work 25 sc evenly spaced across side of Section 2, work 26 sc evenly spaced across side of Section 1a, ending 1 st before the 2 sc increase at the top of the long diagonal, turn.

Row 2: Beg dc3tog (see Glossary) over first 3 sts, dc in each of next 8 sts, sk next 2 sts, (puff st, ch 2, puff st) in next st, ch 1, sk next 2 sts, dc in each of next 8 sts, dc4tog over next 4 sts, dc in each of next 8 sts, sk next 2 sts, (puff st, ch 2, puff st) in next st, ch 1, sk next 2 sts, dc in each of next 8 sts, dc3tog (see Glossary) over last 3 sts, turn.

Row 3: Beg dc3tog over first 3 sts, dc in each dc across to next puff st, (puff st, ch 2, puff st) in next ch-2 sp, ch 1, dc in each dc across to 2 sts before center dec, dc5tog over next 5 sts, dc in each dc across to next puff st, (puff st, ch 2, puff st) in next ch-sp, ch 1, dc in each dc across to last 3 sts, dc3tog over last 3 sts, turn.

Rows 4–6: Rep Row 3.

Row 7: Beg dc in first st, (puff st, ch 2, puff st) in each of next 2 ch-sps, turn.

Row 8: Beg dc in first st, sc in each of next 2 ch-2 sps, dc in last st. Fasten off.

Border row: With RS facing, join C with a sl st in sc on Section 2 that is located just before the first sc of Section 3a, Row 1, work 44 sc evenly spaced across the top edge of Section 3a, sl st in the sc on Section 1a that is located just after the final sc of Section 3a, Row 1. Fasten off.

Section 3b

Row 1: With RS facing, join C with a sl st in 26th sc on left side of Section 1b above junction with Section 2, sc in same st, sc 25 sts across side of Section 1b, sc 26 sts across side of Section 2, turn.

Complete same as Section 3a.

Panel border rnd: With RS facing, join E with a sl st in any corner st, *3 sc in same st, sc evenly across to next corner (working a multiple of 4 sts); rep from * around, join with a sl st in first sc. Fasten off.

Panel 2

Work as for Panel 1, working Sections 1a and 1b with D; Section 2 with E; Sections 3a and 3b with F; and Panel border with E.

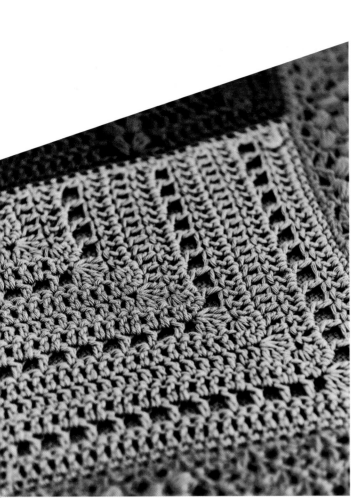

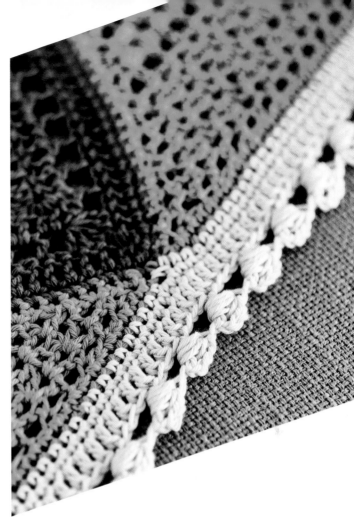

Panel 3

Work as for Panel 1, working Sections 1a and 1b with G; Section 2 with H; Sections 3a and 3b with I; and Panel border with E.

Join Panels

Lay panels out as shown in Schematic. Hold the first two panels with WS together, and with E, sl st through back loops of both panels to join them, sl st in back loops only across. Fasten off. Rep for next joining edge.

Work the Border

Rnd 1: With RS facing, join E with a sl st in any corner st, *3 sc in same st, sc evenly across to next corner (working a multiple of 4 sts); rep from * around, join with a sl st in first sc. Fasten off.

Note: Be sure opposing sides have equal number of sts.

Rnd 2: Sl st in corner sc, (Beg dc, ch 2, 2 dc) in corner st, *dc in each st across to next corner**, (2 dc, ch 2, 2 dc) in next corner st; rep from * around, ending last rep at **, dc in first corner to complete it, join with a sl st in top of Beg dc.

Rnd 3: Sl st in next corner ch-sp, (Beg dc, ch 3, sc in prev dc for picot, 2 dc) in corner st, *sk next st, (dc, ch 3, puff st around previous dc, sk 3 sts) across to last 2 sts before corner**, (2 dc, ch 3, sl st in last dc for picot, 2 dc) in corner st; rep from * around, ending last rep at **, dc in first corner to complete it, join with a sl st in Beg dc. Fasten off.

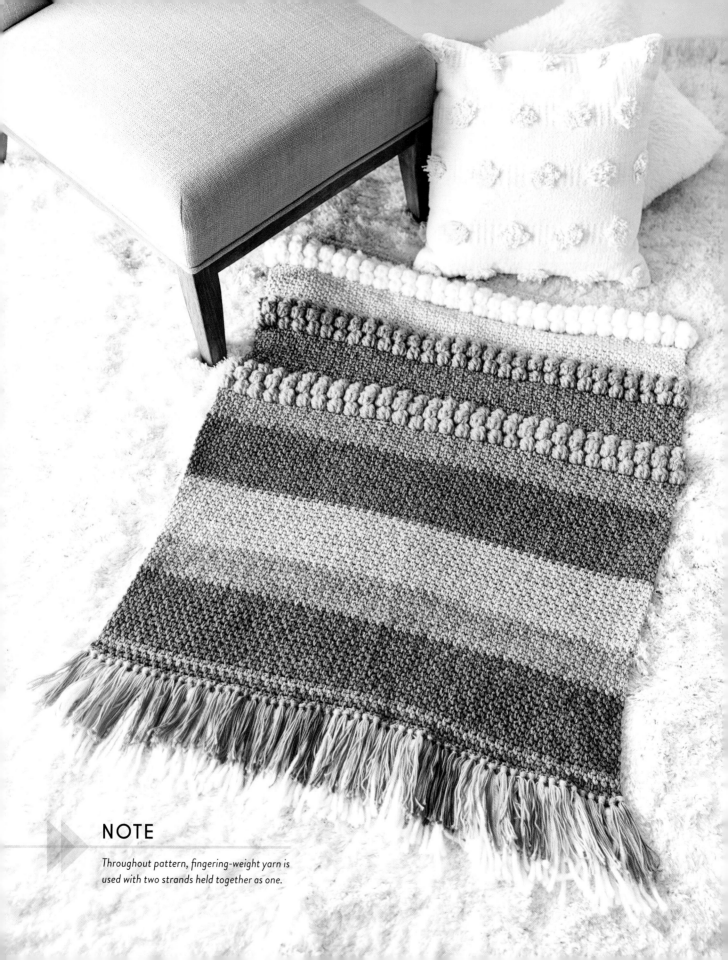

NOTE

Throughout pattern, fingering-weight yarn is used with two strands held together as one.

ROCK *Ridge*

A combination of a simple woven stitch with the varying textures of bobbles and fringe makes this the perfect "tummy time" blanket. Picking up on the colors, fringe, and textures of *Blush Gold* by Maryanne Moodie, this cuddly blanket echos Moodie's distinctive weaving style.

FINISHED SIZE
32 × 36" (81 × 91.5 cm)—excluding 6" (15 cm) fringe along bottom edge.

YARN
Fingering weight (#2 fine).

Shown here: Scheepjes Catona Denim (100% cotton; 136 yd [125 m]/1¾ oz [50 g]): #130 (A), 4 balls; #131 (B), 4 balls; #124 (C), 2 balls; #192 (D), 2 balls; #102 (E), 2 balls.

Bulky Weight #5

Shown here: Scheepjes Roma Big (100% acrylic; 144 yd [132 m]/7¾ oz [220 g]): #56 (F), 1 ball; #2 (G), 1 ball; #1 (H), 2 balls.

HOOKS
US size H-8 (5 mm) hook.

US size I-9 (5.5 mm) hook.

US size M-13 (9 mm) hook.

Adjust hook size if necessary to achieve gauge.

NOTIONS
Tapestry needle.

GAUGE
15 sts and 14 rows = 4" (10 cm) in linen stitch using size H-8 (5 mm) hook, with 2 strands of fingering-weight yarn held double.

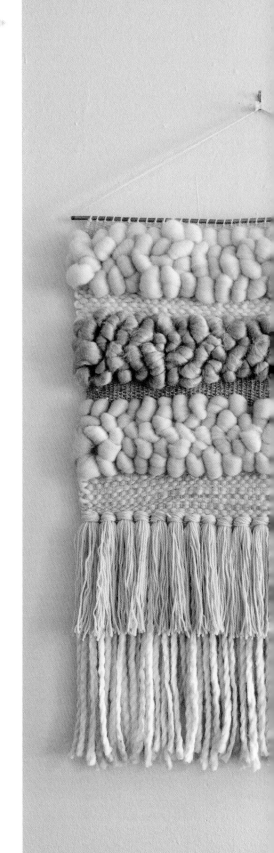

STITCH GUIDE

Slip-stitch join
With right sides together (on wrong side of piece), join blocks together with sl st through back loops only.

Bobble
(Yo, insert hook in indicated sp, yo, pull up loop, yo, draw yarn through 2 loops on hook) 4 times, yo, draw yarn through all 5 loops on hook.

Row 1: (RS) With 2 strands of A held together as one and size H-8 (5 mm) hook, ch 119, sc in 3rd ch from hook (this turning ch counts as 1 sc), sc in each ch across, turn—118 sc.

Row 2: *Ch 1, sk next sc, sc in next sc; rep from * across, turn.

Row 3: *Ch 1, sc in next ch-sp; rep from * across, turn.

Rep Row 3 for **Linen Stitch Pattern.**

Row 4: Work in Linen Stitch Pattern to final st, change to B by pulling B through during final yo of sc st, turn. Drop A to WS to be picked up later. Do not carry yarn under work.

Switch to size I-9 (5.5 mm) hook for the remainder of the fingering-weight yarn portions of the pattern.

Rows 5 and 6: Work in Linen Stitch Pattern. Drop B, pick up A.

Rows 7 and 8: With A, work in Linen Stitch Pattern. Fasten off A, pick up B.

Work in Linen Stitch Pattern for 17 rows with B; 11 rows with A; 17 rows with C; 17 rows with B; and 10 rows with A.

Row 81: With RS facing, using size M-13 (9 mm) hook, join F with a sl st in first ch-sp of last row, sc in same ch-sp, *bobble (see Stitch Guide) in next ch-sp, sc in next ch-sp; rep from across, turn—29 bobbles.

Row 82: Sc in first 2 sts, *bobble in next st, sc in next st; rep from * across to last st, sc in last st, turn.

Row 83: Sc in first st, ch 1, *bobble in next st, sc in next st; rep from * across to last 2 sts, bobble in next st, dc in last st, turn. Fasten off.

Row 84: With RS facing, using size I-9 (5.5 mm) hook, join D with a sl st in first st of row, *ch 1, sc in next ch-sp; rep from * across, turn.

Rows 85–98: With D, work in Linen Stitch Pattern for 14 rows. Fasten off.

Rows 99–101: With G and size M-13 (9 mm) hook, rep Rows 81–83.

Rows 102–117: With E and size I-9 (5.5 mm) hook, rep Rows 84–98.

Rows 118–120: With H and size M-13 (9 mm) hook, rep Rows 81–83.

Rows 121 and 122: With E and size I-9 (5.5 mm) hook, rep Rows 84 and 85.

Row 123: Change to size H-8 (5 mm) hook, sc in each st and sp across, turn.

Row 124: Working from left to right, reverse sc (see Glossary) in each st across. Fasten off.

Attach Fringe on Bottom Edge
Bulky-Weight Yarn Fringe—Added to Row 2

Cut 80 pieces of H, each measuring 12" (30.5 cm). Take 2 cut pieces and fold them in half. With RS facing, insert size M-13 (9 mm) hook **back to front** in first ch-sp of Row 2 and pull center of folded fringe through to form a loop at back of work. Being sure to keep the ends of the fringe even, use your fingers to pull the loop toward you and use the large hook or your fingers to pull the fringe ends down through the loop. Gently tighten the knot to finish attaching the fringe. Working with 2 pieces of yarn for each fringe, attach fringe in the next space of Row 2. *Sk 1 ch-sp, attach fringe in each of next 2 ch-sps; rep from * across to, until all 80 yarn pieces are used for 40 ch-sps.

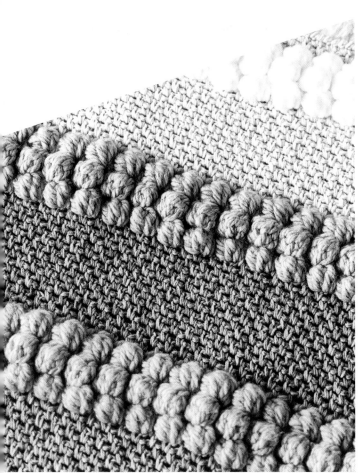
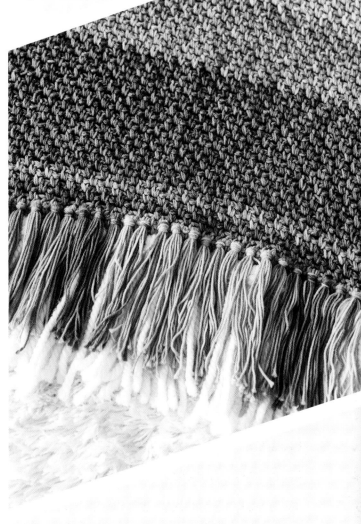

Fingering-Weight Yarn Fringe—Added to Row 4

Using the leftover yarn from A, B, and C, cut 236 pieces of yarn, each measuring 12" (30.5 cm). Take 4 cut pieces of each color and fold them in half. With RS facing, insert size I-9 (5.5 mm) hook **front to back** through first ch-sp of Row 3 and **back to front** in first sc of Row 4. Hook is now through the piece, going in on Row 3 and coming out of Row 4. Use hook to draw loop of fringe through path of hook so that the loop ends up on the RS of the piece. Use hook to pull fringe ends down through loop and gently tighten to attach fringe, being sure to keep fringe ends even. Repeat this process in all sc sts of Row 4 so that 59 "fringes" are attached across the row. Trim any necessary pieces of fringe across both layers to finish off piece.

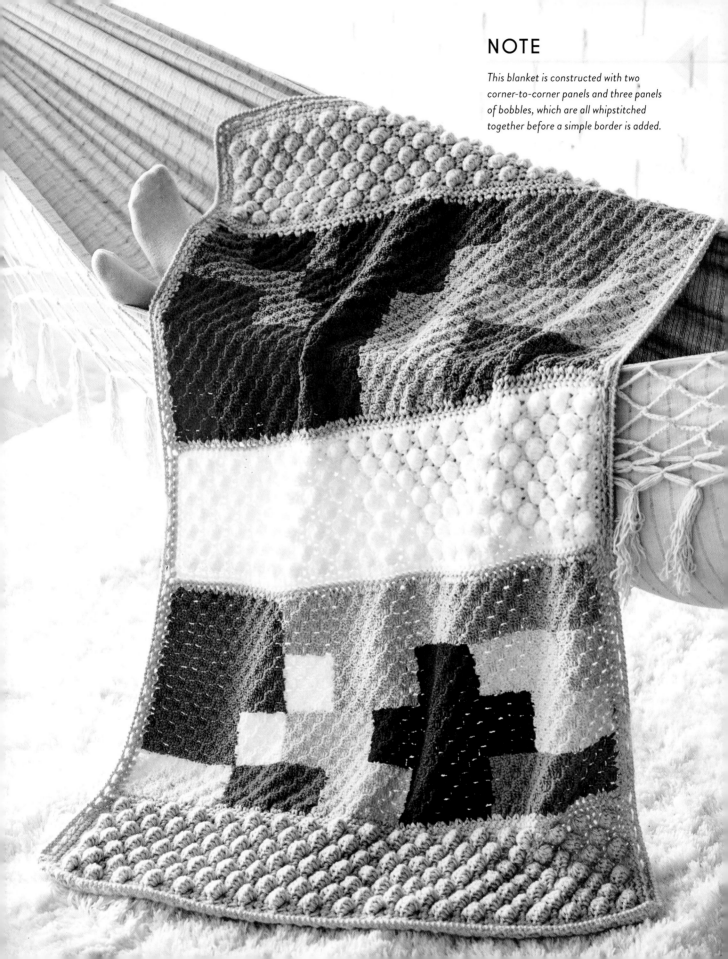

Texture by Maryanne Moodie

SUN
and Sky

I drew inspiration from Maryanne Moodie's wall hanging *Texture* to create this whimsical blanket. The blocks of color are reminiscent of the harmony of the golden-red colors of the sunset playing on the cool blues of the daytime sky. This blanket features a corner-to-corner style on the panels and puffy accent bobbles—there will never be a dull stitching moment!

FINISHED SIZE
33 × 52" (84 × 132 cm).

YARN
DK weight (#3 light).

Shown here: Scheepjes Merino Soft (50% superwash merino wool, 25% microfiber, 25% acrylic; 115 yd [105 m]/1¾ oz [50 g]): One ball each of the following colors, unless specified: #645 Van Eyck (A); #608 Dali (B), 2 balls; #634 Copley (C); #606 Da Vinci (D); #639 Monet (E); #632 Degas (F); #641 Van Gogh (G); #644 Dürer (H); #642 Caravaggio (I); #600 Malevich (J); #612 Vermeer (K); #617 Cézanne (L); #628 Botticelli (M); #610 Turner (N); #636 Carney (O); #638 Hockney (P); #625 Kandinsky (Q).

Scheepjes Colour Crafter (100% premium acrylic; 328 yd [300m]/3½ oz [100 g]): #2010 Hasselt (R), 2 balls; #1026 Lelystad (S), 2 balls; #1001 Weert (T), 2 balls.

HOOKS
US size G-6 (4.25 mm) hook.

US size N (10 mm) hook.

Adjust hook size if necessary to achieve gauge.

NOTIONS
Tapestry needle.

GAUGE
6 blocks = 4" (10 cm), working in C2C Panel pattern with smaller hook.

STITCH GUIDE

Bobble

(Yo, insert hook in st indicated, yo, pull up loop, yo, draw yarn through 2 loops on hook) 4 times, yo, draw yarn through all 5 loops on hook.

Corner-to-Corner (C2C) Panel 1

Row 1: (WS) Starting in the bottom left corner on the chart, using A and smaller hook, ch 6, dc in 4th ch from hook, dc in each of next 2 ch, turn—1 block.

*Note: This begins the **corner-to-corner (c2c) method** of creating a blanket. Reference diagram for clarification. The 3-dc "block" here is represented by the small grid square at the bottom left corner of the chart. On Row 2, we will begin moving in diagonal rows to make the panel, changing color when indicated on the chart.*

Row 2: Ch 6, dc in 4th ch from hook and in next 2 ch, sl st in bet turning ch and first dc on Row 1, ch 3, 3 dc over turning ch of Row 1, turn—2 blocks.

Row 3: Ch 6, dc in 4th ch from hook and in each of next 2 ch, sl st in bet next turning ch and first dc on Row 2 (refer to chart for placement), ch 3, 3 dc over next turning ch of Row 2, sl st as before, ch 3, 3 dc over turning ch, turn—3 blocks.

Rows 4 and 5: Continue in this manner, following the diagram and color chart—5 blocks at end of Row 5.

Row 6: Note: *The first square on the chart is in a new color.* Drop A, always making sure to keep dropped yarns on the WS of the blanket—do not cut the yarn. Join B with sl st in final dc of Row 5, ch 6, dc in 4th ch from hook and in each of next 2 ch, sl st as before but catch A in the sl st since it will be used next, drop B, pick up A and ch 3, 3 dc over turning ch, and continue the row, keeping in pattern—5 blocks with A; 1 block with B.

Row 7: Work in pattern for 5 blocks, until a color change is needed. Drop A, pick up B, and work the final 2 blocks, turn—5 blocks with A; 2 blocks with B.

Rows 8–19: Continue in this manner, changing colors as needed, and keeping the small yarn floats at the back of the work. You will also need to join C starting in Row 16—19 blocks in 3 colors at end of Row 19.

Row 20: Work in pattern. Carefully work from both ends of the ball for C to maintain the color pattern on the chart—20 blocks.

Rows 21–25: Work in pattern, changing colors where indicated—25 blocks at end of Row 25.

Row 26: Work in pattern across to last ch-3 sp, sl st bet the dc and turning ch as normal, do not work a block on top of last block in Row 25, turn, sl st in next 3 dc, sl st under next ch-3 sp to begin next row.

Rows 27–54: Work in pattern, working 3 sl sts in the 3 dc at the top side of the panel and working ch 6 at the bottom of the blanket as shown in the diagram.

Rows 55–79: Work in pattern, working 3 sl sts in 3 dc on both sides of the row as shown in the diagram, until the corner is decreased completely.

C2C Panel 2

Rows 1–19: Work as for Corner-to-Corner Panel 1, following Corner-to-Corner Panel 2 Chart.

Row 20: Work as Row 26 of Panel 1.

Rows 21–55: Work same as Rows 27–55 of Panel 1, decreasing on top edge only.

Rows 56–74: Work same as Rows 56–79 of Panel 1, decreasing on both edges. Fasten off.

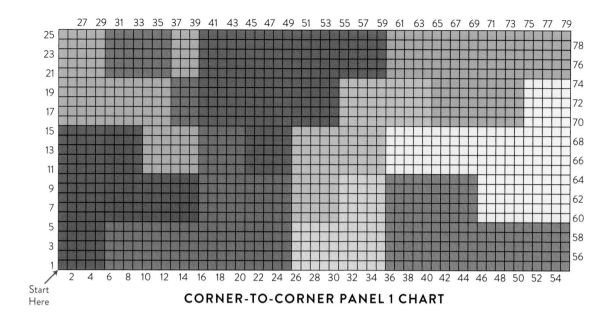

CORNER-TO-CORNER PANEL 1 CHART

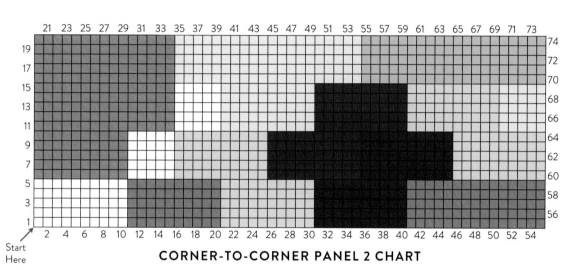

CORNER-TO-CORNER PANEL 2 CHART

COLOR KEY

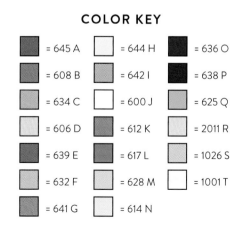

= 645 A = 644 H = 636 O

= 608 B = 642 I = 638 P

= 634 C = 600 J = 625 Q

= 606 D = 612 K = 2011 R

= 639 E = 617 L = 1026 S

= 632 F = 628 M = 1001 T

= 641 G = 614 N

Bobble Panels

Note: Make 1 Each in Colors R, S, and T.

Row 1: (RS) Using the yarn held double and larger hook, ch 16, sc in 2nd ch from hook (turning ch does not count as a st), sc in each ch across, turn—15 sc.

Row 2: Sc in first st, [bobble (see Stitch Guide) in next st, sc in each of next 3 sts] 3 times, bobble in next st, sc in last st, turn—4 bobbles.

Note: Bobbles are worked on WS, but will be pushed through to the RS.

Row 3: Sc in each st across, turn.

Row 4: Sc in first 3 sts, (bobble in next st, sc in next 3 sts) across, turn—3 bobbles.

Row 5: Sc in each st across, turn.

Rows 6–75: Rep Rows 2–4, ending with Row 3 of pattern.

Panel Borders

C2C Panel 1: Using 2 strands of R held together as one and larger hook, sl st in the corner before one long side, *3 sc in corner, work 73 sc evenly spaced across long side of panel, working about 3 sc per four 3-dc blocks, 3 sc in corner, work 18 sc evenly spaced across short side; rep from * once, sl st in first sc. Fasten off.

C2C Panel 2: Using 2 strands of R held together as one and larger hook, sl st in the corner before a long side, *3 sc in corner, work 73 sc evenly spaced across long side of panel, working about 3 sc per four 3-dc blocks, 3 sc in corner, work 14 sc evenly spaced across short side; rep from * once, sl st in first sc. Fasten off.

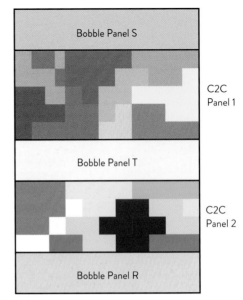

SCHEMATIC

STITCH KEY

⬭ = chain (ch)

• = slip stitch (sl st)

╈ = double crochet (dc)

╈╈╈ = 3-dc group/one square on chart

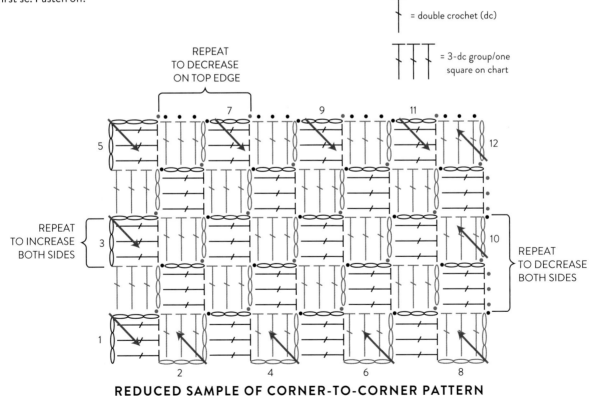

REDUCED SAMPLE OF CORNER-TO-CORNER PATTERN

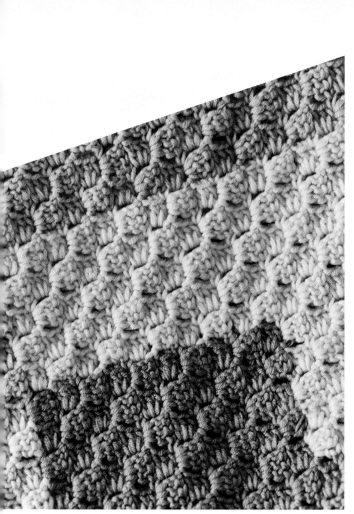

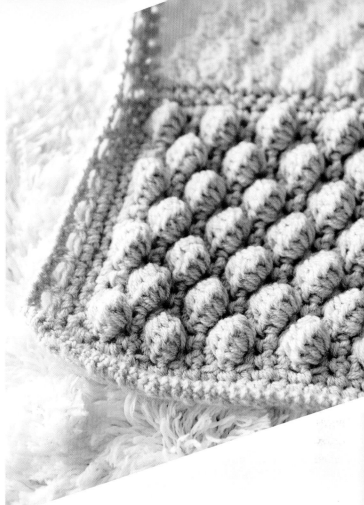

Join Panels

Lay panels out as shown in Schematic. Cut a length of R (held double) that is a little more than twice the length of the panels. Holding top 2 panels with WS together, and matching up sts along the way, sl st through center sc of right-hand side corner on both panels, going through both loops of sts. Whipstitch the panels together using tapestry needle (see Techniques). When the end of the panel is reached. Fasten off.

Repeat 3 more times until all 5 panels are joined.

Border

Rnd 1: With 2 strands of R held together as one and larger hook, sl st in any corner, *3 sc in corner st, sc in each st across to next corner (working an odd number of sts); rep from * around, sl st in first sc. Fasten off.

Note: Be sure to verify opposing sides of piece have the same number of sc.

Rnd 2: With RS facing, and smaller hook, join 1 strand of R with a sl st in any corner st, *(sc, ch 3, sc) in corner st, (ch 2, sk next st, sc in next st) across to last 2 sts before corner st, ch 3; rep from * around, join with a sl st in first sc.

Rnd 3: Sl st in corner ch-sp, *3 sc in corner ch-sp, (sc in next sc, 2 sc in next ch-sp) across to next corner, sc in last sc before corner st; rep from * around, join with a sl st in first sc.

Rnd 4: Working from left to right, reverse sc (see Glossary) in each st around, join with a sl st in first reverse sc.

Note: Do not work any extra sts in the corners to leave a neat, rounded corner.

Fasten off.

Digital Art

FRANCISCO VALLE

THE ARTIST

Francisco Valle is a Brazilian digital artist based in Belo Horizonte. He is a graduate scholar of both fine arts and advertising communications, which lend to his works having a broad stylistic range from highly detailed acrylic paintings to minimalist graphic illustrations. His unique creating process as a digital painter includes developing textures with acrylic paints on paper and photographing the surface to layer in his digital works. Francisco's work can be found in *Latin American Illustration, Luerzer's Magazine Archive 200 Best Digital Artists*, and in interior design, art, and decor stores worldwide, as well as through the finest online shops.

THE INSPIRATION

The idea of pulling inspiration from a digital print to create a piece of fiber art that you can hold in your hands and even wrap around yourself is a liberating aesthetic experience. Francisco Valle produces digital artwork with styles that range from complex to clean and repetitive, which is the perfect inspiration for fiber art. When I browse his body of work, I am constantly inspired by the many geometric pieces he has created with simple lines and triangles. His use of bright jewel tones in fresh arrangements and photographed paint-on-paper textures breathes new life into that little three-sided shape that we take for granted. In this way, Valle's work does something we, too, can do with crochet—create small textured motifs that are then joined together in a geometric art piece.

The blankets in this chapter are one short step away from the baseline of the ever-prevalent square motif. For these designs, I endeavored to keep one foot firmly planted in the tradition of repeating symmetric shapes, but also make a move in the modern direction of triangle motif designs. I designed the Graffiti blanket as homage to the brightly colored and radiant street art of the same name, inspired by Valle's *Geometric Sun*. For the more subdued jewel-tone piece, Multifaceted, I took inspiration from *Triangles Rusty* and put together lacy triangle motifs and surrounded them with a fun puff-stitch border. Finally, Cozy Corner, inspired by the piece *Geometric Triangles Perspective*, combines the traditional granny stitch with an updated way to use triangles in a design.

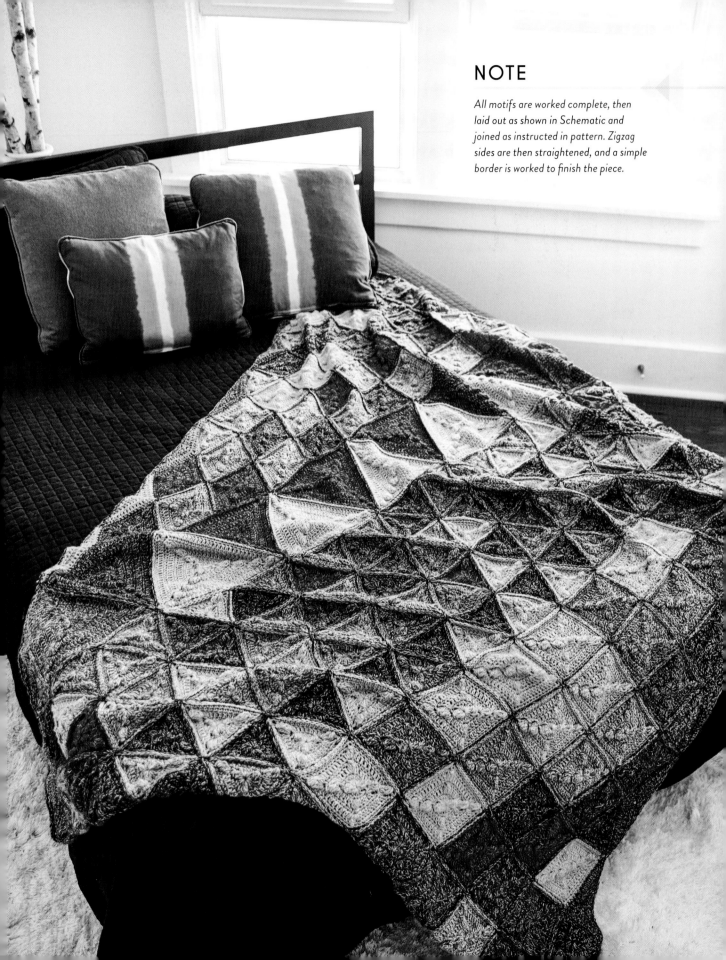

NOTE

All motifs are worked complete, then laid out as shown in Schematic and joined as instructed in pattern. Zigzag sides are then straightened, and a simple border is worked to finish the piece.

Geometric Sun by Francisco Valle

Graffiti

Francisco Valle's *Geometric Sun* is the inspiration for this bright and textured piece. The moment I saw the colors of Francisco's digital artwork, I had to incorporate the palette into a unique and modern blanket design. Graffiti is bold and buzzing with energy like the colorful living art of its namesake, a powerful revelation of the artist's passionate heart.

FINISHED SIZE

58 × 85" (147.5 × 216 cm).

YARN

DK weight (#3 light).

Shown here: Scheepjes Colour Crafter Velvet (100% acrylic; 328 yd [300 m]/3½ oz [100 g]): #844 Hepburn (A), 3 balls; #846 Monroe (B), 2 balls; #852 Garland (C), 2 balls; #847 Bogart (D), 2 balls; #841 Kelly (E), 3 balls; #860 Fonda (F), 1 ball; #853 Leigh (G), 1 ball; #855 Chaplin (H), 1 ball; #854 Turner (I), 1 ball; #858 Martin (J), 1 ball; #850 Crawford (K), 3 balls; #845 Astaire (L), 1 ball; #842 Taylor (M), 1 ball.

HOOKS

US size G-6 (4.25 mm) hook.

US size I-9 (5.5 mm) hook.

US size J-10 (6 mm) hook for joining motifs.

Adjust hook size if necessary to achieve gauge.

NOTIONS

Tapestry needle.

GAUGE

1 Small Triangle measures 4½" (11.5 cm) across 1 side, as worked in pattern, using size I-9 (5.5 mm) hook, unblocked.

STITCH GUIDE

Beg dc shell
(Beg dc, 3 dc) all in same st or sp (counts as dc shell).

Beg tr
Sc, ch 2.

Beg tr shell
(Beg tr, 3 tr) all in same st or sp (counts as tr shell).

Dc bobble
Insert hook from front to back through first st of dc shell, and from back to front through 4th st of dc shell, working through both sts, (sc, ch 1, sc) to close dc shell, creating dc bobble.

Dc bobble 1
Insert hook from front to back through first st of dc shell, and from back to front through 4th st of dc shell, working through both sts, work 1 sc to close dc shell, creating dc bobble.

Dc shell
4 dc in same st/sp.

Tr bobble 1
Insert hook from front to back through first st of tr shell, and from back to front through 4th st of tr shell, working through both sts, (sc, ch 1, sc) to close tr shell, creating tr bobble.

Tr bobble 3
Insert hook from front to back through first st of tr shell, and from back to front through 4th st of tr shell, working through both sts, (sc, ch 3, sc) to close tr shell, creating tr bobble.

Tr shell
4 tr in same st/sp.

Small Triangle

Note: Make 140 total, in the following colors: A = 13, B = 10, C = 6, D = 4, E = 17, F = 4, G = 17, H = 7, I = 16, J = 12, K = 22, L = 9, M = 3.

Rnd 1: With size I-9 (5.5 mm) hook, ch 4, join with a sl st in 4th ch from hook to form a ring. Beg dc shell (see Stitch Guide) in ring, *ch 1, 3 dc in ring, ch 1**, dc shell (see Stitch Guide) in ring; rep from * once, rep from * to ** once, do not join rnd, and instead go straight into Rnd 2—3 dc shells; 6 ch-sps, 9 dc.

Rnd 2: *Dc bobble (see Stitch Guide), sc in next ch-sp, sc in each of next 3 sts, sc in next ch-sp; rep from * around, join with a sl st in first sc—21 sc; 3 ch-sps.

Rnd 3: Sl st in first ch-sp, Beg tr shell (see Stitch Guide) in first ch-sp, *ch 1, 2 dc in next sc, dc in each of next 5 sts, 2 dc in next st, ch 1**, tr shell (see Stitch Guide) in ch-sp; rep from * around, ending last rep at **, do not join rnd, and instead go straight into Rnd 4—3 tr shells; 6 ch-sps; 27 dc.

Rnd 4: *Tr bobble 1 (see Stitch Guide), sc in next ch-sp, sc in each of next 9 sts, sc in next ch-sp; rep from * around, join with a sl st to first sc—39 sc, 3 ch-sps.

Rnd 5: Sl st in next ch-sp, *3 sc in ch-sp, sc in each of next 13 sts; rep from * around, join with a sl st in first sc—48 sc. Fasten off.

Large Triangle

Note: Make 17 total in the following colors: A = 5, B = 3, C = 2, D = 4, J = 1, M = 2.

Rnds 1–4: With size G-6 (4.25 mm) hook, work same as Small Triangle through Rnd 4.

Rnd 5: Change to size I-9 (5.5 mm) hook. Sl st in first ch-sp, Beg tr shell in first ch-sp, *ch 1, 2 dc in next sc, dc in each of next 11 sts, 2 dc in next st, ch 1**, tr shell (see Stitch Guide) in next ch-sp; rep from * once; rep from * to ** once, do not join—3 tr shells; 6 ch-sps, 45 dc.

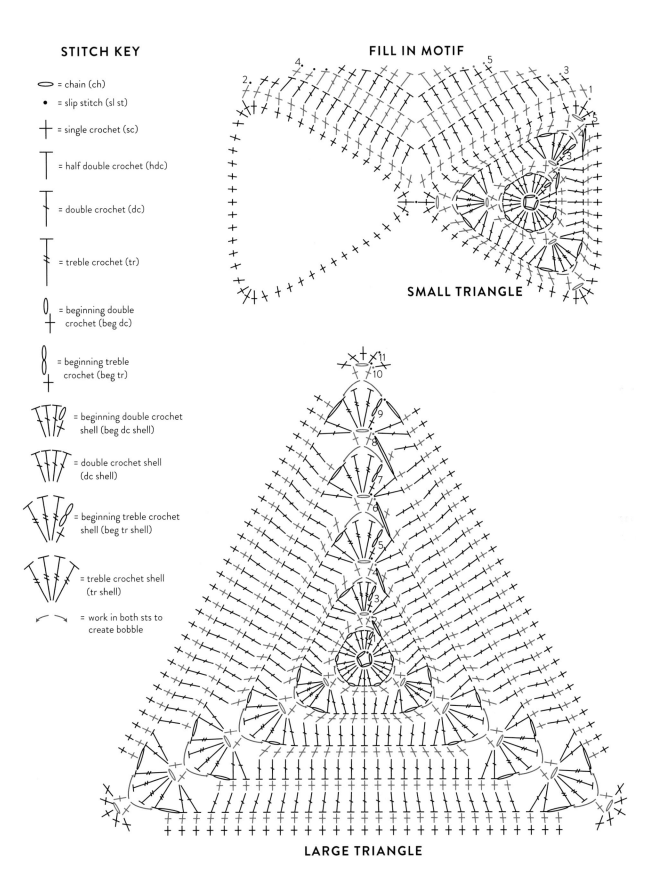

STITCH KEY

= chain (ch)

• = slip stitch (sl st)

+ = single crochet (sc)

= half double crochet (hdc)

= double crochet (dc)

= treble crochet (tr)

= beginning double crochet (beg dc)

= beginning treble crochet (beg tr)

= beginning double crochet shell (beg dc shell)

= double crochet shell (dc shell)

= beginning treble crochet shell (beg tr shell)

= treble crochet shell (tr shell)

= work in both sts to create bobble

FILL IN MOTIF

SMALL TRIANGLE

LARGE TRIANGLE

Rnd 6: *Tr bobble 1, sc in next ch-sp, sc in each of next 15 sts, sc in next ch-sp; rep from * around, join with a sl st in first sc—57 sc; 3 ch-sps.

Rnd 7: Sl st in first ch-sp, Beg tr shell in first ch-sp, *ch 1, 2 dc in next sc, dc in each of next 17 sts, 2 dc in next st, ch 1**, tr shell in ch-sp; rep from * once; rep from * to ** once, do not join—3 tr shells; 6 ch-sps; 63 dc.

Rnd 8: *Tr bobble 1, sc in next ch-sp, sc in each of next 21 sts, sc in next ch-sp; rep from * around, join with a sl st in first sc—75 sc; 3 ch-sps.

Rnd 9: Sl st in first ch-sp, Beg tr shell in first ch-sp, *ch 1, 2 dc in next sc, dc in each of next 23 sts, 2 dc in next st, ch 1**, tr shell in ch-sp; rep from * once; rep from * to ** once, do not join—3 tr shells; 6 ch-sps; 81 dc.

Rnd 10: *Tr bobble 1, sc in next ch-sp, sc in next 27 sts, sc in next ch-sp; rep from * around, join with sl st to first sc—93 sc; 3 ch-sps.

Rnd 11: Sl st in first ch-sp, 3 sc in ch-sp, sc in each of next 31 sts; rep from * around, join with a sl st in first sc—102 sc. Fasten off.

Diamond

Note: Make 84 total, in the following colors: A = 7, B = 10, C = 7, D = 10, E = 7, F = 11, G = 1, H = 6, I = 2, K = 13, L = 6, M = 4.

Rnd 1: Using size I-9 (5.5 mm) hook, ch 4, join with a sl st in 4th chain from hook to form a ring. Beg tr shell in ring, *ch 1, (dc, hdc, sc, hdc, dc) in ring, ch 1**, tr shell in ring; rep from * to ** once, do not join—2 tr shells; 4 ch-sps; 4 dc; 4 hdc, 2 sc.

Rnd 2: *Tr bobble 3 (see Stitch Guide), sc in next ch-sp, sc in each of next 5 sts, sc in next ch-sp; rep from * once, join with a sl st in first sc—18 sc; 2 ch-sps.

Rnd 3: Sl st in first ch-sp, make Beg tr shell in first ch-sp, *ch 1, 2 dc in next sc, dc in each of next 3 sts, ch 1, dc shell in next st, ch 1, dc in each of next 3 sts, 2 dc in next st, ch 1**, tr shell in ch-sp; rep from * to ** once, do not join rnd—2 tr shells; 2 dc shells; 8 ch-sps; 20 dc.

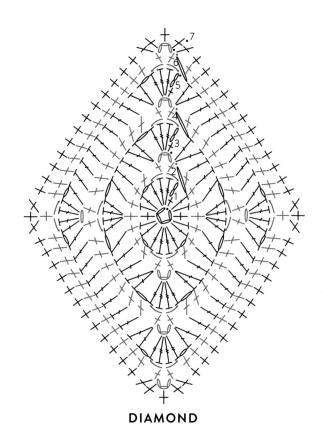

DIAMOND

STITCH KEY

= chain (ch)

• = slip stitch (sl st)

╬ = single crochet (sc)

┬ = half double crochet (hdc)

╪ = double crochet (dc)

╪ = treble crochet (tr)

= beginning double crochet (beg dc)

= beginning treble crochet (beg tr)

= beginning double crochet shell (beg dc shell)

= double crochet shell (dc shell)

= beginning treble crochet shell (beg tr shell)

= treble crochet shell (tr shell)

= work in both sts to create bobble

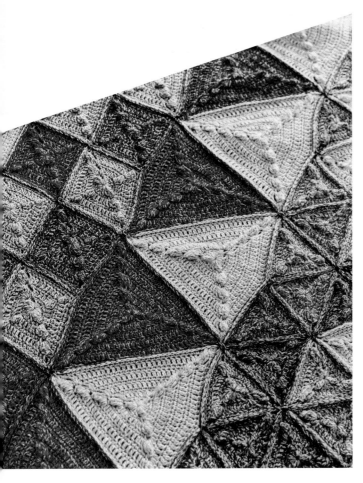

Rnd 7: Sl st in first ch-sp, 3 sc in first ch-sp, *sc in each of next 13 sts, 3 sc in next st, sc in each of next 13 sts**, 3 sc in next ch-sp; rep from * to ** once, join with a sl st in first sc—64 sc. Fasten off.

Join the Blocks

Lay out blocks as shown in Schematic.

Work the joins using size J-10 (6 mm) hook and A. Working in diagonal and horizontal rows, join blocks by working slip st on the back side through back loops only as follows:

Pick up two adjacent motifs and, holding right sides together, sl st through both loops of both motifs across. Without breaking yarn, pick up next pair of motifs and continue in this manner down the piece until the end of the final motif is reached. Fasten off and weave in ends. Join each subsequent row of squares, until all diagonal and horizontal columns are joined.

> **TIP**
> *When working join and crossing over a completed join, work one chain to "cross over" the completed join. If this chain is omitted, the blanket may pull or pucker at the corners where motifs meet.*

Fill the Zigzag Sides

Work 18 total in random colors or follow the colors on the Schematic.

Row 1: With size I-9 (5.5 mm) hook, join A with a sl st in a corner just before a zigzag side. Work sc in each of next 17 sts across first motif, sc in each of next 17 sts across 2nd motif, turn.

Row 2: Sl st in first st, sc in each of next 2 sts, hdc in next st, dc in each of next 12 sts, sk next 2 sts, dc in each of next 12 sts, hdc in next st, sc in each of next 2 sts, turn.

Row 3: Sl st in each of first 3 sts, sc in each of next 2 sts, hdc in next st, dc in each of next 8 sts, sk next 2 sts, dc in each of next 8 sts, hdc in next st, sc in each of next 2 sts, turn.

Rnd 4: *Tr bobble 3, sc in next ch-sp, sc in each of next 5 sts, sc in next ch-sp, dc bobble, sc in next ch-sp, sc in each of next 5 sts, sc in next ch-sp; rep from * once, join with a sl st in first sc—36 sc; 4 ch-sps.

Rnd 5: Sl st in first ch-sp, Beg tr shell in first ch-sp, *ch 1, 2 dc in next sc, dc in each of next 8 sts, ch 1, dc shell in next ch-sp, ch 1, dc in each of next 8 sts, 2 dc in next st, ch 1**, tr shell in next ch-sp; rep from * to ** once, do not join—2 tr shells; 2 dc shells; 8 ch-sps; 40 dc.

Rnd 6: *Tr bobble 3, sc in next ch-sp, sc in each of next 10 sts, sc in next ch-sp, dc bobble 1 (see Stitch Guide), sc in next ch-sp, sc in each of next 10 sts, sc in next ch-sp; rep from * once, join with a sl st in first sc—54 sc; 2 ch-sps.

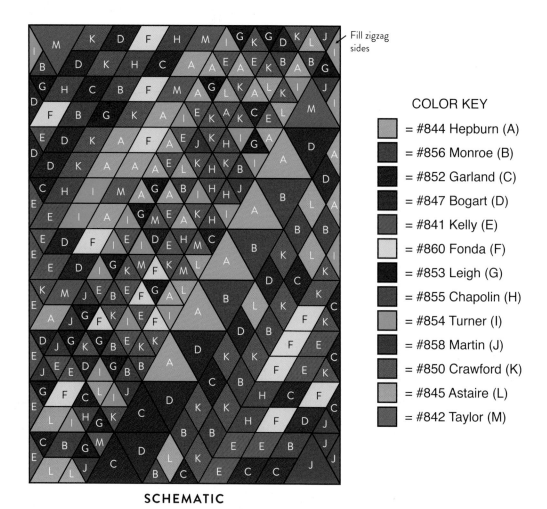

Fill zigzag sides

SCHEMATIC

COLOR KEY

- = #844 Hepburn (A)
- = #856 Monroe (B)
- = #852 Garland (C)
- = #847 Bogart (D)
- = #841 Kelly (E)
- = #860 Fonda (F)
- = #853 Leigh (G)
- = #855 Chapolin (H)
- = #854 Turner (I)
- = #858 Martin (J)
- = #850 Crawford (K)
- = #845 Astaire (L)
- = #842 Taylor (M)

Row 4: Sl st in each of first 3 sts, sc in each of next 2 sts, hdc in next st, dc in each of next 4 sts, sk next 2 sts, dc in each of next 4 sts, hdc in next st, sc in each of next 2 sts, turn.

Row 5: Sl st in each of first 3 sts, sc in each of next 2 sts, hdc in next st, sk next 2 sts, hdc in next st, sc in each of next 2 sts. Fasten off.

Repeat for 8 more triangle gaps on this side of the piece and then repeat for the other side until blanket is completely squared off.

Note: *I worked many of the triangle gap fillers in random left-over yarn from colors B–M to ensure I had enough yarn for the border.*

Border

Using size I-9 (5.5 mm) hook, join A with a sl st in any corner, *3 sc in corner st, sc evenly across to next corner; rep from * around, join with a sl st in first sc. Fasten off. Weave in ends.

> **TIP**
> *Place 2 sc on the side of each dc, and 3 sc on the side of each tr. Be sure to verify opposing sides of piece have the same number of sc.*

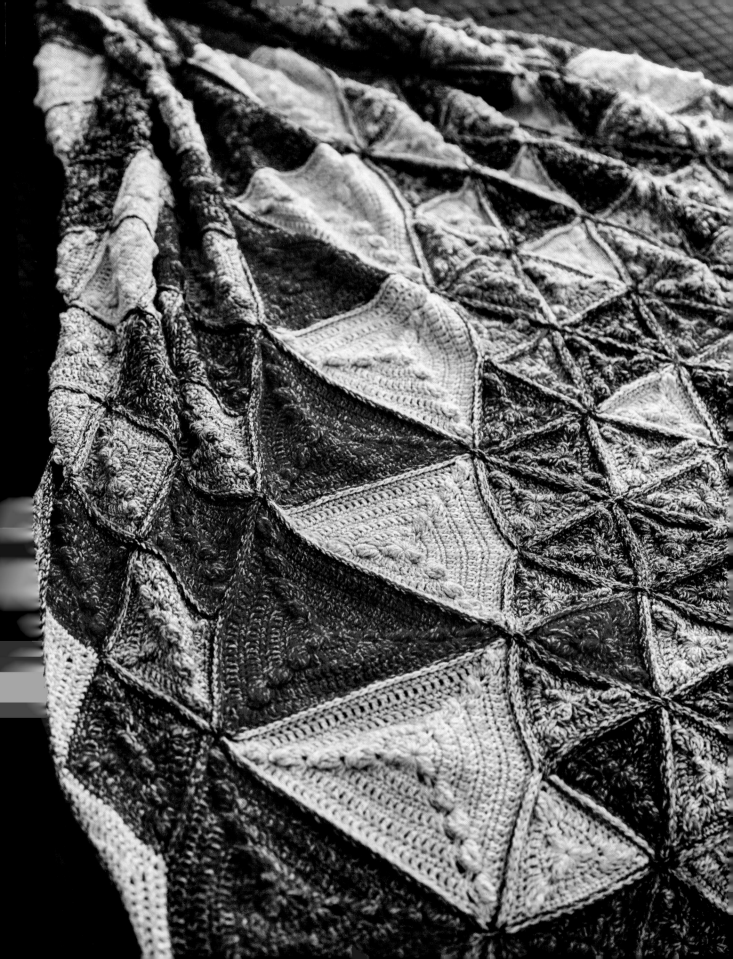

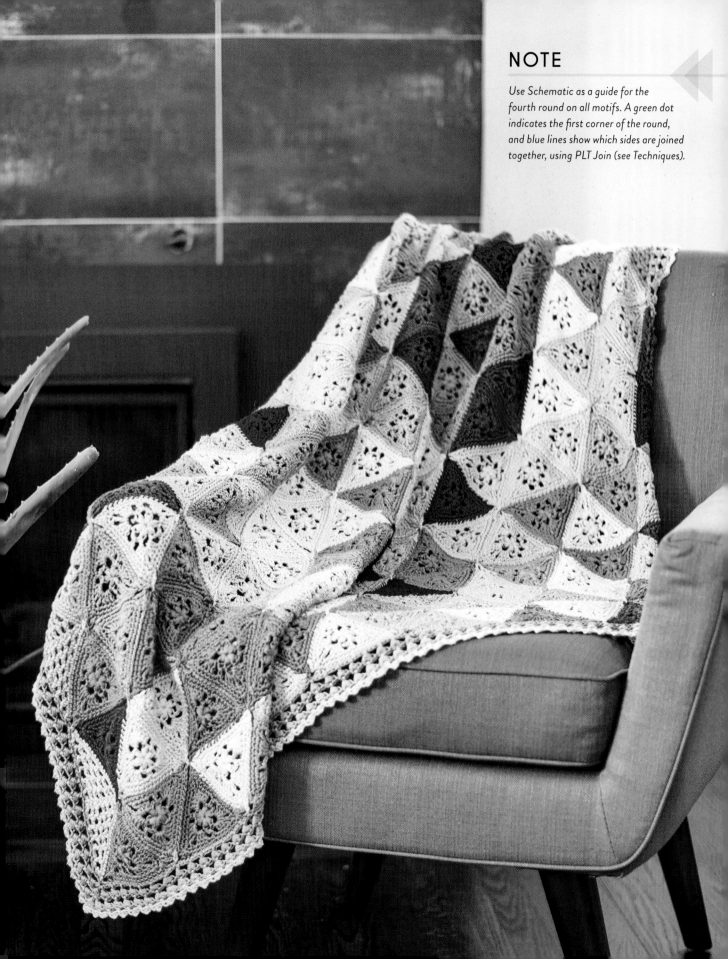

NOTE

Use Schematic as a guide for the fourth round on all motifs. A green dot indicates the first corner of the round, and blue lines show which sides are joined together, using PLT Join (see Techniques).

Multifaceted

Inspired by the mesmerizing piece *Triangles Rusty* by digital artist Francisco Valle, Multifaceted is a tribute to the rustic, traditional, and comforting lacy crochet motif. Joining these triangles as you go is so addictive and watching the corners come together perfectly is very satisfying. Pair the puff stitches of the motif centers with a clever puff-stitch border, and you have a delicate and feminine piece that, when made with the 100% pima cotton shown, gives such lush drape and warmth. A perfect blanket for cool spring evenings on the patio swing.

FINISHED SIZE
48 × 48" (122 × 122 cm).

YARN
DK weight (#3 light).

Shown here: Cascade Yarns Ultra Pima (100% pima cotton; 220 yd [200 m]/3½ oz [100 g]): one hank each unless specified: #3731 Alaska Sky (A), 2 hanks; #3720 Sage (B); #3707 Purple Ice (C), 2 hanks; #3798 Suede (D), 2 hanks; #3713 Wine (E); #3716 Chocolate (F); #3806 Grape Juice (G); #3729 Grey (H); #3757 Zen Green (I); #3759 Taupe (J); #3711 China Pink (K); #3712 Primrose (L); #3797 Dark Sea Foam (M); #3801 Silver (N).

HOOK
US size F-5 (3.75 mm) hook.

Adjust hook size if necessary to achieve gauge.

NOTIONS
Tapestry needle.

GAUGE
1 triangle motif measures 4" (10 cm), from top point straight down to base, blocked.

STITCH GUIDE

Beg puff st

Pull loop up to height of puff st, (yo, insert hook in magic ring, yo, pull up a loop to height of work) twice, yo, draw yarn through 5 loops on hook.

Picot

Ch 3, sc in 3rd ch from hook.

Puff st

(Yo, insert hook in magic ring or sp indicated, yo, pull up a loop to height of work) 3 times, yo, draw yarn through 7 loops on hook.

Motif

Rnd 1: (RS) With correct motif color according to Schematic, make a Magic Ring, Beg puff st (see Stitch Guide) in ring, [ch 3, puff st (see Stitch Guide), ch 5, puff st] twice in ring, ch 3, puff st in ring, pull yarn tail to close Magic Ring tight, ch 2, dc in top of Beg puff st so that next rnd will begin in the center of this "mock ch-5 sp."—6 puff sts; 3 ch-3 sps; 3 ch-5 sps.

Rnd 2: Beg tr (see Stitch Guide) around mock ch-5 sp, ch 1, 3 dc in same ch-sp, *ch 2, sc in next ch-sp, ch 2, (3 dc, ch 1, tr, ch 1, 3 dc) in next ch-5 sp; rep from * once, ch 2, sc in next ch-sp, ch 2, 3 dc in first ch-sp, ch 1, do not join—3 tr; 18 dc; 3 sc; 6 ch-2 sps; 6 ch-1 sps.

Rnd 3: *(Sc, ch 1, sc) in tr of Rnd 2, sc in next ch-sp, sc in each of next 3 sts, 2 sc in each of next 2 ch-sps, sc in each of next 3 sts, sc in next ch-sp; rep from * twice, join with a sl st in first sc, do not fasten off—42 sc; 3 ch-1 sps.

Move on to Joining Rnd.

Joining

Motif 1

Rnd 4: Sl st in next ch-sp, *(hdc, dc, ch 3, dc, hdc) in ch-sp (**Plain Corner** made), sc in each of next 14 sts (**Plain Side** made); rep from * twice, join with a sl st in first hdc. Fasten off. (0 sides joined; 0 corners joined)

Motifs 2–10

Rnd 4: Sl st in next ch-sp, *make Plain Corner in ch-sp, work Plain Side; rep from * once, (hdc, dc, ch 1, holding previous motif with one corner pointing down, in top right corner ch-sp PLT (see Techniques), ch 1 encasing the ch-sp, ch 1, dc, hdc) in corner ch-sp, work Plain Side, join with a sl st in first hdc. Fasten off. Motifs 1–10 will be connected in a line and form the top edge of the blanket—0 sides joined; 1 corner joined between each motif.

Motifs 11–19

Rnd 4: Following Schematic for color choice and motif placement, sl st in next ch-sp, make Plain Corner in ch-sp, *sc in first st, PLT in corresponding st on Motif 2, (sc, PLT) in each of next 12 sts, joining this side to the side of Motif 2, sc in next st (**Joined Side** made)**, (hdc, dc, ch 1, PLT around join between Motifs 1 and 2, and ch 1 to encase the join, ch 1, dc, hdc) in corner ch-sp on current motif; rep from * to ** once, joining to the side of Motif 1, make Plain Corner in next ch-sp, work Plain Side, join with a sl st in first hdc. Fasten off—2 sides joined; 1 corner joined.

Motif 20

Rnd 4: Sl st in next ch-sp, make Plain Corner in ch-sp, make Plain Side, (hdc, dc, ch 1, PLT in Plain Corner ch loop located diagonally (in this case, it is the Plain Corner of Motif 12), ch 1, encasing the Plain Corner, ch 1, dc, hdc) all in ch-sp (**Joined Corner** made), make Joined Side to adjacent side of Motif 11, make Joined Corner to Motif 1, make Plain Side, join with a sl st in first hdc. Fasten off—1 side joined; 2 corners joined.

BORDER

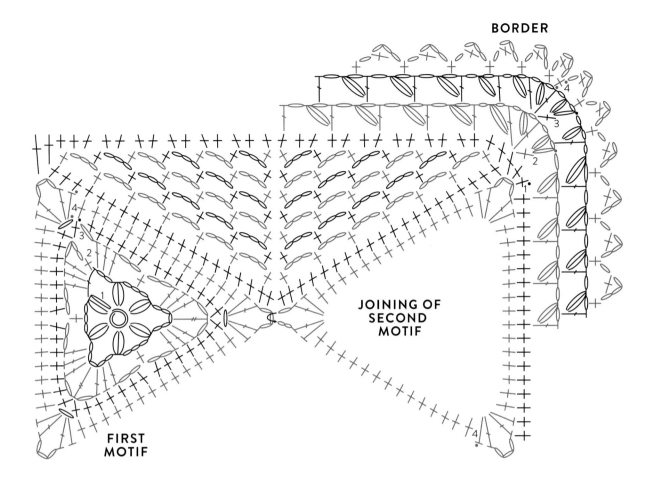

JOINING OF
SECOND
MOTIF

FIRST
MOTIF

STITCH KEY

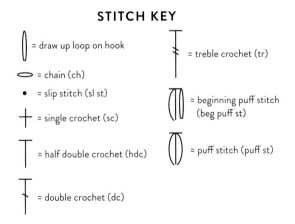

| = draw up loop on hook

◯ = chain (ch)

• = slip stitch (sl st)

+ = single crochet (sc)

⊤ = half double crochet (hdc)

┼ = double crochet (dc)

‡ = treble crochet (tr)

= beginning puff stitch
(beg puff st)

= puff stitch (puff st)

Motifs 21–28

Rnd 4: Work as for Motif 20, but be sure to make Joined Corner on 2nd and 3rd corners, using PLT Join in Plain Corners of diagonally located motifs. For example, on Motif 21, the 2nd Corner will be PLT Joined with the Plain Corner of Motif 13, and the 3rd Corner will be PLT Joined with the Plain Corner of Motif 11—1 side joined; 2 corners joined on each motif.

Motif 29

Rnd 4: Sl st in next ch-sp, make Plain Corner, make Joined Side to Motif 20, make Joined Corner to Motif 11, make Plain Side, make Plain Corner, make Plain Side, join with a sl st in first hdc. Fasten off—1 side joined; 1 corner joined.

Motifs 30–38

Rnd 4: Work as for Motifs 11–19, but make 2nd Corner PLT Join with diagonal motif. For example, on Motif 30, the 2nd Corner will PLT Join with Motif 2—2 sides joined; 1 corner joined on each motif.

Motif 39

Rnd 4: Sl st in next ch-sp, make Plain Corner, make Plain Side, make Joined Corner to Motif 30, make Joined Side, make Joined Corner to Motif 29, make Plain Side, join with a sl st in first hdc—1 side joined; 2 corners joined. Fasten off.

Motifs 40–48

Rnd 4: Work as for Motifs 20–28.

Rem Motifs

Rnd 4: Work as for previous motifs, paying attention to the placement of motifs so that correct sides and corners are joined up. On final 9 motifs, join 3rd corner to adjacent Plain Corner, working through the Plain Corner of the motif in between them. This will mirror the same neatly finished effect as the top row of triangles.

Fill Zigzag Sides
First Triangle Gap

Row 1: Using color as indicated on Schematic, join with a sl st in first corner loop on Motif 38, sc in same loop, sc in each of next 18 sts, sc in each of next 2 corner ch-sps, sc in each of next 18 sts, sc in last corner ch-sp on Motif 10, turn—40 sc.

Row 2: *[Sc in sc, ch 3, sk next 2 sts] 6 times, sc in next st,** sk next 2 sts; rep from * to ** once, turn.

Row 3: Sl st in next ch-sp, sc in same ch-sp, [ch 3, sc in next ch-sp] 5 times, [sc in next ch-sp, ch 3] 5 times, sc in next ch-sp, turn.

Row 4: Sl st in next ch-sp, sc in same ch-sp, [ch 3, sc in next ch-sp] 4 times, [sc in next ch-sp, ch 3] 4 times, sc in next ch-sp, turn.

Row 5: Sl st in next ch-sp, sc in same ch-sp, [ch 3, sc in next ch-sp] 3 times, [sc in next ch-sp, ch 3] 3 times, sc in next ch-sp, turn.

Row 6: Sl st in next ch-sp, sc in same ch-sp, [ch 3, sc in next ch-sp] twice, [sc in next ch-sp, ch 3] twice, sc in next ch-sp, turn.

Row 7: Sl st in next ch-sp, sc in same ch-sp, ch 3, sc in each of next 2 ch-sps, ch 3, sc in next ch-sp, turn.

Row 8: Sl st in next ch-sp, sc in same ch-sp, sc in next ch-sp. Fasten off.

Rep for rem 11 triangle gaps, following Schematic for colors.

Border

Rnd 1: With RS facing, join D with a sl st in either corner ch-sp just before a zigzag side, 3 sc in same corner, *sc in side of first 2 sts of triangle gap, 2 sc in each of next 6 ch-sps, sc in each of next 2 sc, 2 sc in each of next 6 ch-sps, sc in last 2 sts of triangle gap, sc in next 2 corner ch-sps; rep from * 5 times, omitting last 2 sts on last rep, 3 sc in next corner ch-sps, **sc in each of next 18 sts across first motif, sc in next 2 corner ch-sps; rep from ** 9 times, omitting last 2 sts on last rep, 3 sc in next corner ch-sp, work in this manner across rem 2 sides, joining with a sl st in first sc at beg of rnd.

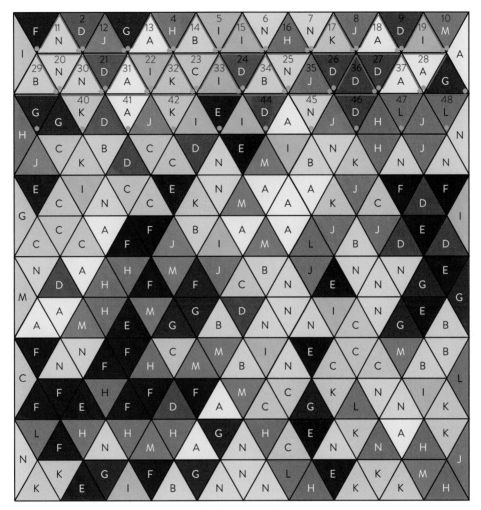

SCHEMATIC

Rnd 2: Sl st in next sc, (Beg dc [see Glossary], ch 1, puff st around Beg dc, ch 1, [dc, ch 1, puff st around last dc, ch 1] twice) in corner sc (**beg Corner** made), *(sk next 2 sts, dc in next st, ch 1, puff st around last dc, ch 1) across side, to next corner st**, [dc in corner st, ch 1, puff st around last dc, ch 1] 3 times (**Corner** made); rep from * around, ending last rep at **, join with sl st in top of Beg dc. Fasten off.

Row 3: With RS facing, join C with a sl st in ch just before corner puff st of Row 2, Beg Corner in same ch-sp, (dc in top ch just before next puff st, ch 1, puff st around last dc, ch 1) across row to next corner puff st, make Corner in top ch-sp just before puff st, work in this manner around blanket, joining with a sl st in top of Beg dc. Fasten off.

Row 4: With RS facing, join A with a sl st in ch just before corner puff st of Row 3, (sc, Picot [see Stitch Guide], ch 1, sc) in same ch-sp (**Picot Corner** made), (Picot, ch 1, sc) in next ch-sp located just before next puff st) across side to corner puff st, make Picot Corner in ch-sp just before corner puff st. Work around the blanket in this manner, joining with a sl st in first sc when first corner is reached. Fasten off. Weave in ends.

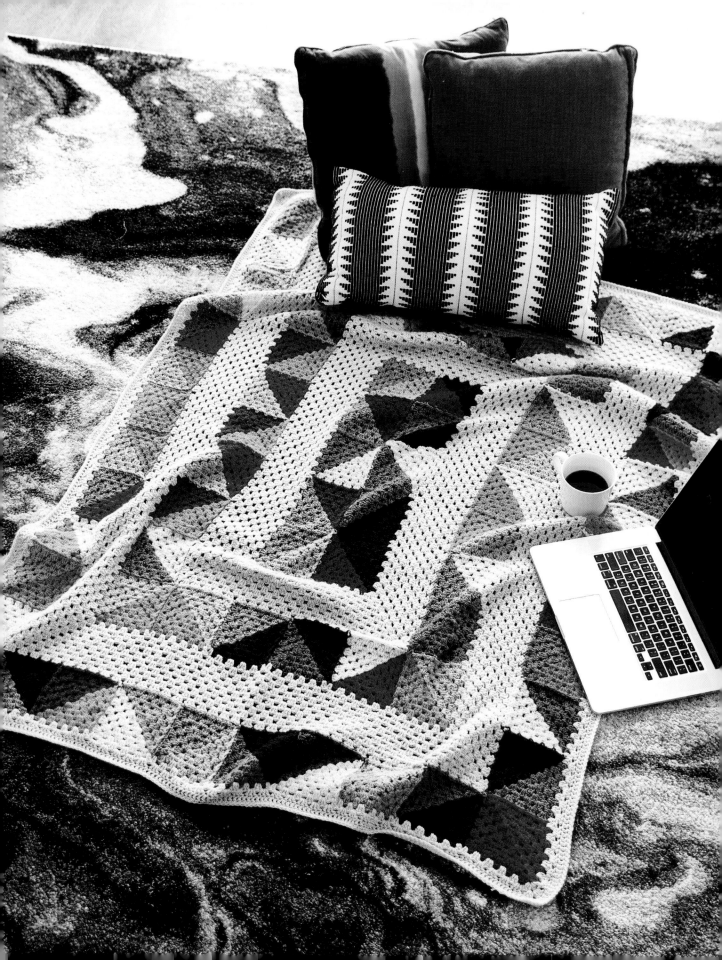

COZY *Corner*

Inspired by Francisco Valle's *Geometric Triangles Perspective*, Cozy Corner is a picture-perfect, timeless addition to any room decor. The clever mix of fun granny squares and plain granny-stitch rounds will definitely keep your interest but is simple enough that it can be worked in a fireside easy chair with feet up during family movie night for extra coziness.

FINISHED SIZE
48 × 62" (122 × 157.5 cm).

YARN
DK weight (#3 light).

Shown here: Scheepjes Colour Crafter (100% acrylic; 328 yd [300 m]/3½ oz [100 g]): #1218 Zandvoort (A), 5 balls; #1099 Wolvega (B), 1 ball; #2018 Pollare (C), 1 ball; #1188 Rhenen (D), 1 ball; #1277 Amstelveen (E), 1 ball; #2007 Spa (F), 1 ball; #1435 Apeldoorn (G), 1 ball; #1246 Maastricht (H), 1 ball; #1712 Nijmegen (I), 1 ball; #1316 Almelo (J), 1 ball; #1034 Urk (K), 1 ball; #2012 Knokke (L), 1 ball; #1062 Dordrecht (M), 1 ball; #1114 Eindhoven (N), 1 ball; #2008 Leuven (O), 1 ball; #2002 Gent (P), 1 ball; #1132 Leek (Q), 1 ball; #1723 Vlissingen (R), 1 ball.

HOOKS
US size H-8 (5 mm) hook for blanket.

US size G-6 (4 mm) hook for last 2 rnds of border.

Adjust hook size if necessary to achieve gauge.

NOTIONS
Tapestry needle.

GAUGE
First 3 rnds of Square 1 as instructed in pattern = 4 × 4" (10 × 10 cm), using size H-8 (5 mm) hook, blocked.

Starting in the center of the blanket with Section 1, Diagonal Granny Squares are each worked up to the final rnd and then joined as-you-go to the piece on the final rnd. Use Chart as a general pattern guide and written instruction for information on creating color diagonal. Each square is numbered in order of joining and then squares are joined moving clockwise around the blanket. Other squares are also outlined for clarification in the pattern. Each square is made of two colors, as shown in the Cozy Corner Schematic. First color on each square is shaded gray, and Color 2 is on the opposite diagonal of the square.

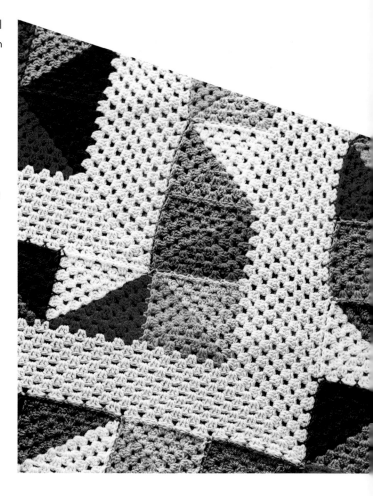

Diagonal Granny Square (DGS) Section 1

Square 1

Rnd 1: (RS) With size H-8 (5 mm) hook and Color 1 designated by shaded triangle in Block #1, ch 3, join with a sl st in 3rd ch from hook to form a ring, with Color 1, Beg dc (see Glossary) in ring, 2 dc in ring, ch 1, 3 dc in ring, completing yo of last dc with Color 2 (**Color Change** made), with Color 2, [ch 1, 3 dc] twice in ring, join with sc in top of Beg dc, turn—12 dc; 4 ch-sps.

Note: Do not work over yarn when not in use. Instead, as emphasized, simply drop yarn to be picked up later.

Rnd 2: (WS) With Color 2, (Beg dc, 2 dc) in first sp, (3 dc, ch 1, 3 dc) in next ch-sp (**Corner** made), 3 dc in next ch-sp making Color Change to Color 1 when completing last yo of 3rd dc, with Color 1, ch 1, 3 dc in same ch-sp (**Color Change Corner** made), make Corner in next ch-sp, 3 dc in first corner sp, join with sc in top of Beg dc, turn—24 dc; 4 ch-sps.

Rnd 3: With Color 1, (Beg dc, 2 dc) in first sp, 3 dc between 3 dc groups, make Corner in next ch-sp, 3 dc between 3-dc groups, make Color Change Corner in next ch-sp, continuing with Color 2, 3 dc between 3-dc groups, make Corner in next ch-sp, 3 dc between 3-dc groups, 3 dc in first corner sp, join with sc in top of Beg dc, turn—36 dc; 4 ch-sps.

Rnd 4: With Color 2, (Beg dc, 2 dc) in first sp, [3 dc between 3-dc groups] twice, make Corner in next ch-sp, [3 dc between 3-dc groups] twice, make Color Change Corner in next ch-sp, continuing with Color 1, [3 dc between 3-dc groups] twice, make Corner in next ch-sp, [3 dc between 3-dc groups] twice, 3 dc in first corner sp, join with sc in top of Beg dc, turn—48 dc; 4 ch-sps.

Rnd 5: With Color 1, (Beg dc, 2 dc) in first sp, [3 dc between 3-dc groups] 3 times, make Corner in next ch-sp, [3 dc between 3-dc groups] 3 times, make Color Change Corner in next ch-sp, continuing with Color 2, [3 dc between 3-dc groups] 3 times, make Corner in next ch-sp, [3 dc between 3-dc groups] 3 times, 3 dc in first corner sp, ch 1, join with a sl st in top of Beg dc. Fasten off—60 dc; 4 ch-sps.

Square 2

Rnds 1–4: Rep Rnds 1–4 of Square 1.

Rnd 5: With Color 1, (Beg dc, 2 dc) in first sp, [3 dc between 3-dc groups] 3 times, 3 dc in next ch-sp, sl st in Color 2

GRANNY-STITCH RNDS

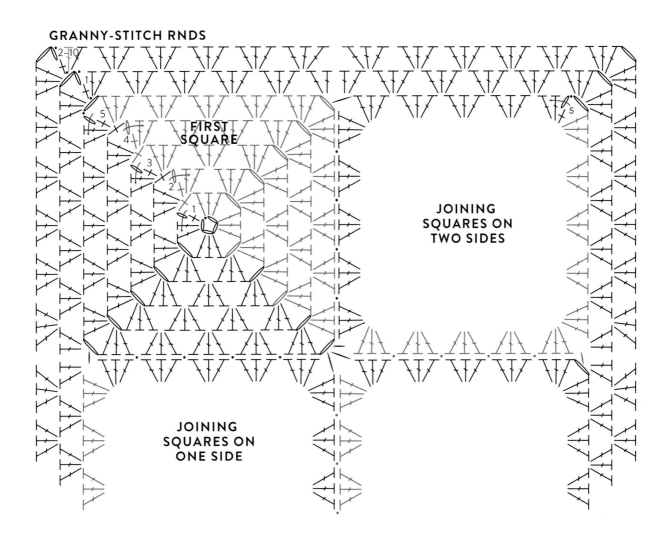

Corner of Square 1 (see Schematic for placement), 3 dc in same corner ch-sp on current square, [sl st between corresponding 3-dc groups on previous square, 3 dc between 3-dc groups on current square] 3 times, sl st between corresponding 3-dc groups on previous square, 3 dc in next corner ch-sp, sl st in corresponding corner ch-sp on previous square, change to Color 2, with Color 2, 3 dc in same corner ch-sp, [3 dc between 3-dc groups] 3 times, make Corner in next ch-sp, [3 dc between 3-dc groups] 3 times, 3 dc in first corner sp, ch 1, join with a sl st in top of Beg dc—1 side joined. Fasten off.

Square 3
Rnds 1–4: Rep Rnds 1–4 of Square 1.

STITCH KEY

⬯ = chain (ch)

• = slip stitch (sl st)

+ = single crochet (sc)

┬ = double crochet (dc)

𝄐 = Beginning double
 crochet (Beg dc)

Rnd 5: With Color 1, (Beg dc, 2 dc) in first sp, [3 dc between 3-dc groups] 3 times, make Corner in next ch-sp, [3 dc between 3-dc groups] 3 times, make Color Change Corner in next ch-sp, continuing with Color 2, [3 dc between 3-dc groups] 3 times, 3 dc in next corner ch-sp, sl st in corresponding Color 2 corner of Square 2 (see Schematic for placement), 3 dc in same corner ch-sp on current square, [sl st between corresponding 3-dc groups on previous square, 3 dc between 3-dc groups on current square] 3 times, sl st between corresponding 3-dc groups on previous square, 3 dc in next corner ch-sp, ch 1, join with a sl st in top of Beg dc—1 side joined. Fasten off.

Square 4

Work same as Square 2, joining to bottom of Square 3.

Square 5

Work same as Square 3, joining to bottom of Square 4.

Square 6

Work same as Square 3, joining to right side of Square 5.

Square 7

Rnds 1–4: Rep Rnds 1–4 of Square 1.

Rnd 5: With Color 1, (Beg dc, 2 dc) in first sp, [3 dc between 3-dc groups] 3 times, make Corner in next ch-sp, [3 dc between 3-dc groups] 3 times, 3 dc in next corner ch-sp, sl st in corresponding top right-hand corner of Square 6 (see Schematic for placement), change to Color 2, continuing with Color 2, [sl st between corresponding 3-dc groups on previous square, 3 dc between 3-dc groups on current square] 3 times, sl st between corresponding 3-dc groups on previous square, 3 dc in next corner ch-sp, sl st in corresponding corner sp on Square 5, 3 dc in same corner ch-sp on current square, [sl st between corresponding 3-dc groups on previous square, 3 dc between 3-dc groups on current square] 3 times, sl st between corresponding 3-dc groups on previous square, 3 dc in next corner ch-sp, ch 1, join with a sl st in top of Beg dc—2 sides joined. Fasten off.

Square 8

Rnds 1–4: Rep Rnds 1–4 of Square 1.

Rnd 5: With Color 1, (Beg dc, 2 dc) in first sp, [3 dc between 3-dc groups] 3 times, 3 dc in next ch-sp, sl st in Color 1 Corner of Square 7 (see Schematic for placement), 3 dc in same corner ch-sp on current square, [sl st between corresponding 3-dc groups on previous square, 3 dc between 3-dc groups on current square] 3 times, sl st between corresponding 3-dc groups on previous square, 3 dc in next corner ch-sp, sl st in corresponding corner ch-sp on previous square, change to Color 2, with Color 2, [sl st between corresponding 3-dc groups on previous square, 3 dc between 3-dc groups on current square] 3 times, sl st between corresponding 3-dc groups on previous square, 3 dc in next corner ch-sp, ch 1, join with a sl st in top of Beg dc—2 sides joined. Fasten off.

Square 9

Work same as Square 7, joining to top of Square 8 and right side of Square 2.

Square 10

Work same as Square 8, joining to top of Square 9 and right side of Square 1.

First Granny-Stitch Rounds

Rnd 1: With size H-8 (5 mm) hook, join A (main background color) with a sl st in any corner ch-sp, (Beg dc, ch 1, 3 dc) in same sp, *3 dc between 3-dc groups across until spot where two DGS corners meet. Work over this spot as follows: 2 dc in first corner, 2 dc in 2nd corner (counts as 3 dc group on next rnd), 3 dc across to corner ch-sp**, (3 dc, ch 1, 3 dc) in corner ch-sp; rep from * around, ending last rep at **, being sure to treat all spots where 2 DGS meet as explained previously, 2 dc in the corner to complete it, join with a sl st in top of Beg dc.

Rnds 2–10: Sl st in first ch-sp, (Beg dc, ch 1, 3 dc) in first ch-sp, *3 dc between 3-dc groups across to next corner**, (3 dc, ch 1, 3 dc) in corner ch-sp; rep from * around, ending last rep at **, 2 dc in first corner to complete it, join with a sl st in top of Beg dc.

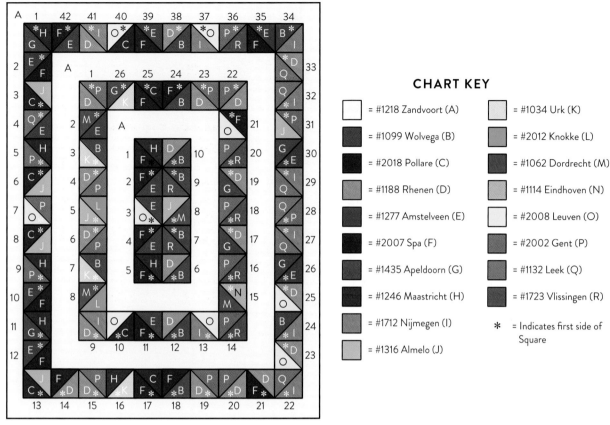

SCHEMATIC

CHART KEY

= #1218 Zandvoort (A)		= #1034 Urk (K)	
= #1099 Wolvega (B)		= #2012 Knokke (L)	
= #2018 Pollare (C)		= #1062 Dordrecht (M)	
= #1188 Rhenen (D)		= #1114 Eindhoven (N)	
= #1277 Amstelveen (E)		= #2008 Leuven (O)	
= #2007 Spa (F)		= #2002 Gent (P)	
= #1435 Apeldoorn (G)		= #1132 Leek (Q)	
= #1246 Maastricht (H)		= #1723 Vlissingen (R)	
= #1712 Nijmegen (I)		* = Indicates first side of Square	
= #1316 Almelo (J)			

DGS Section 2

Square 1

Rnds 1–5: Work same as Square 1 of Section 1, but sl st to join at corner that touches corner of Granny-Stitch Rounds (use Schematic as a visual guide).

Squares 2–26

Rnds 1–5: Work in the same manner as squares in Section 1, joining to previous square and corresponding section of Rnd of Granny-Square Rounds, following instructions for Squares 7 or 8 (joined on 2 sides) as appropriate.

Second Granny-Stitch Rounds

Rnds 1–10: With size H-8 (5 mm) hook and A, work as for First Granny-Stitch Rounds.

DGS Section 3

Squares 1–42

Work as for DGS Section 2, joining to Second Granny-Stitch Rounds.

Border

Rnds 1 and 2: With size H-8 (5 mm) hook and A, work as for First Granny-Stitch Rounds through Rnd 2.

Rnd 3: With size G-6 (4 mm) hook, sl st in first ch-sp, (Beg dc, ch 1, 2 dc) in first ch-sp, *dc in each st across to next corner**, (2 dc, ch 1, 2 dc) in corner ch-sp; rep from * around, ending last rep at **, dc in first corner to complete it, join with a sl st in top of Beg dc.

Rnd 4: Sl st in first ch-sp, 3 sc in first ch-sp, sc in each st around**, 3 sc corner ch-sp; rep from * around, ending last rep at **, join with a sl st in first sc. Fasten off. Weave in ends.

CHAPTER 3

Fabric Design

APRIL RHODES

THE ARTIST

April Rhodes is a fabric designer and dabbler in all things crafty who lives in her hometown of Columbus, Ohio. She is famous for her modern fabric designs, which she describes as "free-spirited, earthy, and bold." She works closely with Art Gallery Fabrics to create inspired fabric collections, which often incorporate geometric shapes and neutral colors to create unique patterns. When April is not trying her hand at a new craft—most recently, knitting!—she is taking a stand for what she believes in, staying active in benefits and fund drives for environmental and human-rights causes.

THE INSPIRATION

Fabric design in and of itself is a process that combines elements of the art forms in the previous two chapters: digital design and textile art. In the case of April Rhodes, she begins by creating her modern and free-spirited designs on a computer, and they are then printed as fabric collections in conjunction with Art Gallery Fabrics. April's finished product is distinctive fabric that, through organic geometric designs, evokes a primal yearning to connect with one's roots and be touched by nature. It is in this earthly connection that I glean textile inspiration from April's work and incorporate it into my own art to produce blanket patterns that are simultaneously organic in design and visually modern.

With the three projects in this chapter, we will discover innovative ways to fill the design space of a rectangle blanket, just as fabric designs seek to creatively fill a rectangle of fabric. To this end, these patterns borrow elements from freeform crochet design, making them fun and engaging. Desert Boho, a refreshingly contemporary pattern inspired by April's "Arid Horizon" fabric, is constructed in panels, each with its own colors and unique textures. Abstract Blocks is a complex-looking motif, which is repeated in clever ways, drawing from her "Painted Morale" fabric design. Finally, Wanderlust, a blanket based on the fabric "Sylph's Freedom Flower," pushes the boundaries of design, combining vastly different patterns together to create a visually striking art piece.

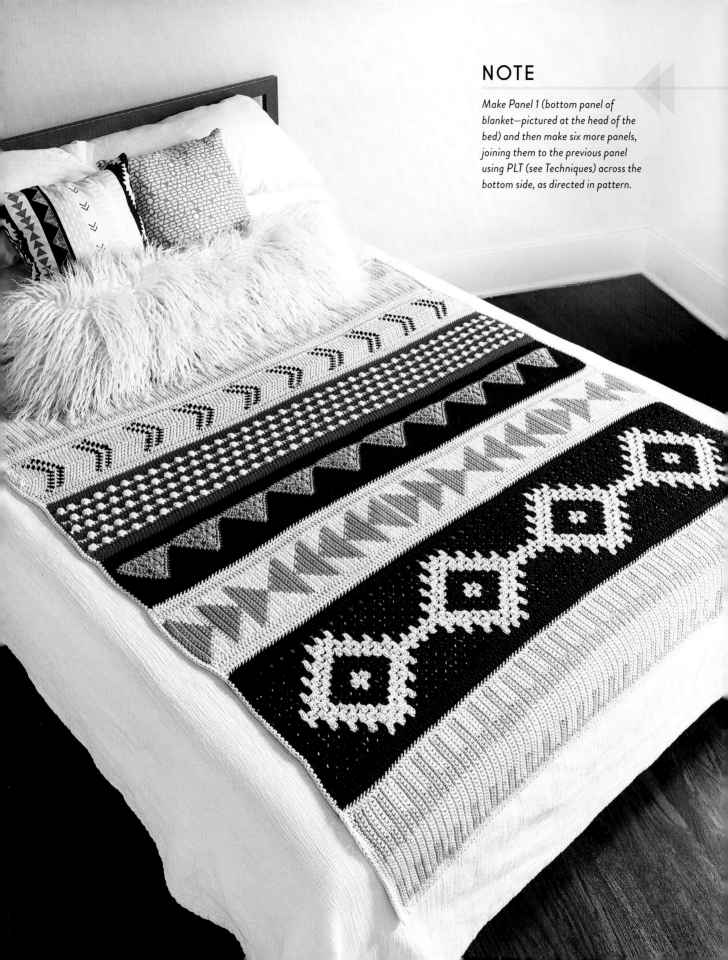

NOTE

Make Panel 1 (bottom panel of blanket—pictured at the head of the bed) and then make six more panels, joining them to the previous panel using PLT (see Techniques) across the bottom side, as directed in pattern.

BOHO *Desert*

Arid Horizon by April Rhodes

Imagine wrapping this blanket around your shoulders on a cool morning, knowing that you created such a free-spirited and thoughtful piece. Every fabric that April Rhodes designs gives off a peaceful feeling that always sends me into creative mode. *Arid Horizon* drew me in instantly, and the result is a sort of stitch-sampler blanket that lets you enjoy the process just as much as the finished piece.

FINISHED SIZE
50 × 60" (127 × 152 cm).

YARN
Aran/Worsted weight (#4 medium).

Shown here: Wool and the Gang Shiny Happy Cotton (100% pima cotton; 155 yd [142 m]/3½ oz [100 g]): #02 Ivory White (A), 12 balls; #18 Magic Mint (B), 3 balls; #05 Midnight Blue (C), 5 balls; #17 Coral Crush (D), 3 balls; #09 Timberwolf (E), 1 ball; #15 Mellow Yellow (F), 2 balls.

HOOKS
US size I-9 (5.5 mm) for all Panels and Panel Borders.

US size H-8 (5 mm) for Blanket Border.

Adjust hook size if necessary to achieve gauge.

NOTIONS
Tapestry needle.

GAUGE
14 sts and 14 rows = 4" (10 cm) in sc, blocked.

STITCH GUIDE

Bobble
[Yo, insert hook in next st, yo, draw yarn through st, yo, draw yarn through 2 loops on hook] 5 times, yo, draw yarn through all 6 loops on hook.

Inc
(Sc, ch 1, sc) in same st or sp indicated.

Panel 1

Note: Entire panel is worked in sc, worked back and forth in rows, changing colors by drawing new color through 2 loops on hook during final yo of last sc in current color. Work over yarn when not in use.

Row 1: With A and size I-9 (5.5 mm) hook, ch 29, sc in 2nd ch from hook (turning ch does not count as st), sc in each ch across, changing to B in last sc, turn. (28 sc) Row 1 of Panel 1 Color Chart complete.

Row 2: Following Panel 1 Color Chart, with B, carrying A under sts, sc in each of first 9 sts, changing to A on last sc, with A, carrying B, sc in each of next 8 sts, changing to B on last st, with B, carrying A, sc in each of next 10 sts changing to A on last st, with A, carrying B, sc in last st, turn.

Rows 3–7: Following Panel 1 Color Chart for color changes, work in sc rows.

Rows 8–169: Rep Rows 2–7 (27 times).

Rows 170–172: Rep Rows 2–4.

Row 173: With A only, sc in each st across. Fasten off.

Panel Border

Rnd 1: With RS facing, join A with a sl st in top right-hand corner before one long side, *3 sc in corner st, work 148 sc evenly spaced across long side, 3 sc in next corner, work 25 sc evenly spaced across short side; rep from * around, join with a sl st in first sc.

Rnd 2: Sl st in next sc, *3 sc in center st of corner, sc in each st across to next corner; rep from * around, join with a sl st in first sc. Fasten off.

Panel 2

Row 1: With A, ch 3 and join with a sl st in 3rd ch to form ring, Beg dc (see Glossary) in ring, 8 dc in ring, turn.

Row 2: Inc (see Stitch Guide) in first st, *ch 1, sk next st, sc next st, ch 1, sk next st, inc in next st; rep from * once, turn.

Row 3: Inc in first ch-sp, (ch 1, sc in next ch-sp) across to center ch-sp, ch 1, inc in center ch-sp, (ch 1, sc in next ch-sp) across to last ch-sp, ch 1, inc in last ch-sp, turn.

Row 4: Rep Row 3.

Row 5: (Pattern Row) Sc in first ch-sp, (ch 1, sc in next ch-sp) across to center ch-sp, ch 1, inc in center ch-sp, (ch 1, sc in next ch-sp) across to last ch-sp, ch 1, sc in last ch-sp, turn.

Rows 6–8: Rep Row 5.

Row 9: Drop A to be picked up later, join C, with C, rep Row 5, do not turn. Drop C to be picked up later.

Rows 10 and 11: Pick up A, rep Row 5, do not turn after row 11. Drop A, pick up C from 2 rows below.

Row 12: With C, rep Row 5. Fasten off C. Pick up A.

Rows 13–23: With A, rep Row 5.

Rows 24–138: Rep Rows 9–23 (8 times) maintaining color change.

Rows 139–142: With A, rep Row 5. Fasten off.

Fill Corners to Square Off End

Right-Hand Side
Row 1: With RS facing, join A with a sl st in first ch-sp, sc in same ch-sp, (ch 1, sc in next ch-sp) across, putting last sc in center ch-sp, turn.

Rows 2–5: Sc in first ch-sp, (ch 1, sc in next ch-sp) across, turn.

PANEL 1 COLOR CHART

PANEL 1 KEY

☐ = #02 Ivory White (A)

▦ = #18 Magic Mint (B)

Row 6: Sc in ch-sp. Fasten off.

Left-Hand Side
Rows 1–6: With WS facing, rejoin A in first ch-sp, and rep Rows 1–6 as for right-hand side. Fasten off.

Panel Border

Long Side 1
Row 1: With RS facing, join A in top right-hand corner before one long side, being sure to orient C "arrows" in the correct direction as seen in photo of finished piece, Beg dc in first st, work 151 dc evenly spaced across long side, turn.

Row 2: Sc in each st across. Fasten off.

Long Side 2
Repeat Rows 1 and 2 on Long Side 1 on bottom long side of panel. Do not fasten off. Turn work to RS.

Joining Rnd

Note: *Read through completely before beginning.*

Prepare panels for joining: Lay Panel 2 above Panel 1, lining up bottom edge of Panel 2 with top edge of Panel 1.

Continuing with A, work 2 sc in first st, remove loop from hook, insert hook in center st of corner on Panel 1, catch loop, PLT (see Techniques) to front of work, sc in same st to complete corner, PLT in corresponding st on Panel 1, (sc in next st on current panel, PLT to previous panel), ending with 2nd sc of next 3 sc corner, work sc in same corner to complete it, work 17 sc evenly spaced across short side of panel, 3 sc in 3rd corner, sc in each st across top edge to next corner, 3 sc in corner dc, 17 sc evenly spaced across short side of panel, join with a sl st in first sc. Fasten off.

Panel 3

Row 1: (WS) With D, ch 155, dc in 4th ch from hook (turning ch counts as 1 dc), dc in each ch across, turn—153 dc.

Row 2: Sc in each st across, changing to A in last st, turn—153 sc.

Row 3: With A, sc in each of first 2 sts, bobble (see Stitch Guide) in next st, *sc in each of next 3 sts, bobble in next st; rep from * across to last 2 sts, sc in last 2 sts, do not turn. Fasten off A—38 bobbles, 115 sc.

Row 4: With WS still facing, join D in first st, Beg dc in first st, dc in each st across, turn—153 dc.

Row 5: Sc in each st across, changing to A in last st, turn.

Row 6: With A, sc in each of first 4 sts, bobble in next st, *sc in each of next 3 sts, bobble in next st; rep from * across to last 4 sts, sc in each of last 4 sts, do not turn. Fasten off A—37 bobbles.

Row 7: Rep Row 4.

Rows 8–12: Rep Rows 2–6.

Rows 13–17: Rep Rows 7–11. Fasten off.

Panel Border

Joining Rnd
Prepare panels for joining as before, lining up bottom of Panel 3 with top edge of Panel 2. With RS facing, join D in bottom left corner of Panel 3. Work Border same as Border for Panel 2, but work 22 sc evenly spaced across short sides of panel, join with a sl st in first sc. Fasten off.

Panel 4

Base Triangle (Make 10)

Row 1: (RS) With E, ch 3, join with a sl st in 3rd ch from hook to form a ring, Beg dc in ring, [ch 1, 3 dc] twice in ring, ch 1, dc in ring, turn—8 dc; 3 ch-sps.

Row 2: Beg dc in first st, ch 1, 3 dc in next ch-sp, (3 dc, ch 1, 3 dc) in next ch-sp, 3 dc in next ch-sp, ch 1, dc in last st, turn—14 dc; 3 ch-sps.

Row 3: Beg dc in first st, ch 1, 3 dc in ch-sp, 3 dc between 3-dc groups, (3 dc, ch 1, 3 dc) in next ch-sp, 3 dc between 3-dc groups, 3 dc in next ch-sp, ch 1, dc in last st—20 dc; 3 ch-sps. Fasten off.

Connect Base Triangles

Note: Base Triangles will be joined end-to-end to form a strip.

Joining rnd: Holding first Base Triangle with RS facing, join E in Beg dc of Row 3, sc in same st, *sc in next ch-sp, sc in each st across to next ch-sp, 3 sc in next ch-sp, sc across to next ch-sp, sc in next ch-sp**, leave final st of Base Triangle unworked, do not fasten off, pick up next Base Triangle, skip first Beg dc; rep from * across next 8 Base Triangles, ending last rep at ** forming a strip, sc in last st, rotate piece to work across bottom edge of strip, work 152 sc evenly spaced across bottom edge of Base Triangle Strip. Fasten off.

Note: Work 15 sc across bottom of each Base Triangle, plus one extra sc at beginning and end of row of bottom edge.

Fill Triangle Gaps

Note: This step will square off beginning and end of Base Triangle Strip, starting with right-hand side of strip. Then center triangle gaps are filled in to make long rectangle panel.

Right-Hand Side

Row 1: (RS) Holding first Base Triangle with RS facing, join C with a sl st in first sc, sc in same st, sc in each st across, placing final sc in center "peak" sc of first triangle, turn—13 sts.

Row 2: Beg dc3tog in first 3 sts, dc in each of next 7 sts, dc3tog (see Glossary) over last 3 sts, turn.

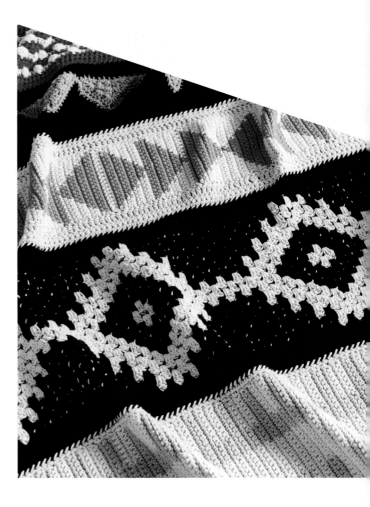

Row 3: Beg dc3tog in first 3 sts, dc in each of next 3 sts, dc3tog over last 3 sts, turn.

Row 4: Beg dc3tog in first 3 sts, dc2tog (see Glossary) over last 2 sts, turn.

Row 5: Sc2tog (see Glossary) over 2 sts. Fasten off.

Left-Hand Side

Rows 1–5: Holding last Base Triangle with WS facing, work same as for Right-Hand Side.

Center Triangle Gaps

Row 1: With RS facing, join C in top "peak" sc above first Base Triangle, sc in same st, sc in each of next 10 sts, sc2tog over next 2 sts, sc in each of next 11 sts, with last sc being worked in next "peak" sc, turn.

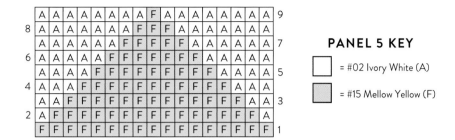

PANEL 5 KEY

☐ = #02 Ivory White (A)

▨ = #15 Mellow Yellow (F)

PANEL 5 COLOR CHART

Row 2: Beg dc3tog (see Glossary) over first 3 sts, dc in each of next 6 sts, dc5tog (see Glossary) over next 5 sts, dc in each of next 6 sts, dc3tog over last 3 sts, turn.

Row 3: Beg dc3tog over first 3 sts, dc in each of next 2 sts, dc5tog over next 5 sts, dc in each of next 2 sts, dc3tog over last 3 sts, turn.

Row 4: Beg dc in first st, dc6tog over next 6 sts. Fasten off.

Fill rem 8 center triangle gaps in this manner.

Panel Border

Long Side 1
Row 1: With RS facing, join A in top right corner just before long side, being sure to orient the Panel with Base Triangles on the bottom, as seen in photos of finished piece, Beg dc in first st, work 151 dc evenly spaced across long side, turn.

Row 2: Sc in each st across. Fasten off.

Long Side 2
Repeat Rows 1 and 2 on bottom long side of panel, but do not fasten off. Turn work to RS.

Joining Rnd

Prepare panels for joining as before, lining up bottom of Panel 4 with top edge of Panel 3. With RS facing, with A, work Border same as Border for Panel 2, but work 13 sc evenly spaced across short sides of panel, join with sl st in first sc. Fasten off.

Panel 5

Note: This panel is worked in plain sc back and forth, making color changes for pattern and working over the yarn when not in use, just like for Panel 1. Use Panel 5 Color Chart for reference.

Row 1: With F, ch 18, sc in 2nd ch from hook, sc in each ch across, changing to A on last st, turn. Row 1 of Panel 5 Color Chart complete.

Rows 2–9: Work following Panel 5 Color Chart, turn.

Rows 10–27: Rep Rows 1–9 twice.

Rows 28–36: Reverse chart, working 9-row triangle in opposite direction starting with Row 9 of chart, working back to Row 1.

Rows 37–72: Rep Rows 28–36 (4 times).

Row 73: With A, sc in each st across, turn.

Rows 74–100: Rep Rows 1–9 of chart (3 times).

Rows 101–136: Rep Rows 28–36 (4 times).

Row 137: Rep Row 73.

Rows 138–155: Rep Rows 1–9 of chart (twice).

Rows 156–173: Rep Rows 28–36 (twice). Fasten off.

Panel Border

Long Side 1
Row 1: With RS facing, join A in top right-hand corner before top long side, Beg dc in first st, work 151 dc evenly spaced across long side, turn.

Row 2: Sc in each st across. Fasten off.

Long Side 2

Rep Rows 1 and 2 on bottom long side of panel, do not fasten off, turn work to RS facing.

Joining Rnd

Prepare panels for joining as before, lining up bottom of Panel 5 with top edge of Panel 4. With RS facing, with A, work Border same as Border for Panel 2, but work 21 sc evenly spaced across short sides of panel, join with sl st in first sc. Fasten off.

Panel 6

Note: Follow chart for Panel 6. From one red line to the other is one center repeat. Work three center repeats for a total of four diamond shapes as shown in photo of finished piece.

Row 1: With C, ch 151, 2 dc in 4th ch from hook to make first 3-dc group on Row 1 of Panel 6 Chart, *sk next 2 ch, 3 dc in next ch; rep from * across, turn—fifty 3-dc groups. Row 1 of Panel 6 Chart complete.

> **TIP**
>
> *Work over yarn when not in use. These "caught floats" peek through for a cozy tweed effect. Be sure not to pull floats too tight or the Panel will pucker and alter gauge.*

Row 2: Ch 2 (counts as dc), 3 dc between first two 3-dc groups of row below, **[3 dc between next 3-dc groups] 4 times, changing to A in last yo of last st, with A, [3 dc between next 3-dc groups] 3 times, changing to C in last yo of last st***, with C, [3 dc between next 3-dc groups] 9 times; rep from * across, ending last rep at ***, with C, [3 dc between next 3-dc groups] 5 times, dc in last dc, turn—forty-eight 3-dc groups; 1 dc on each end.

Row 3: With C, ch 2, 2 dc in same st, 3 dc between next two 3-dc groups, work as established following Panel 6 Chart.

Rows 4–21: Work as established following Chart. Fasten off.

Panel Border

Long Side 1

Row 1: With RS facing, join C in top right-hand corner before long side, Beg dc in first st, work 151 dc evenly spaced across long side, turn.

Row 2: Sc in each st across. Fasten off.

PANEL 6 KEY

■ = 3 dc in color C

▨ = 3 dc in color A

□ = space between two 3-dc groups

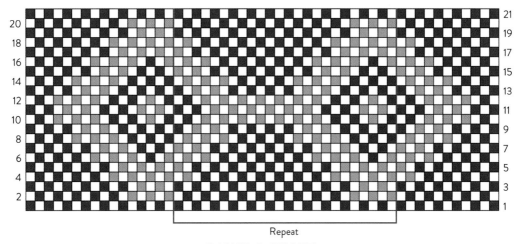

Repeat

PANEL 6 CHART

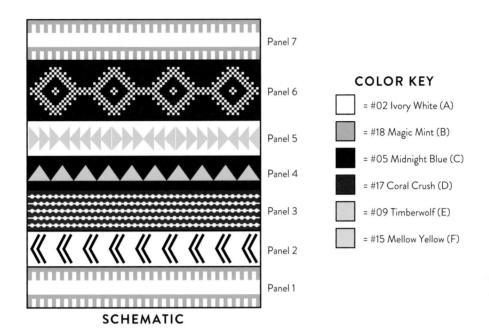

SCHEMATIC

Panel 7
Panel 6
Panel 5
Panel 4
Panel 3
Panel 2
Panel 1

COLOR KEY

☐ = #02 Ivory White (A)

▨ = #18 Magic Mint (B)

■ = #05 Midnight Blue (C)

■ = #17 Coral Crush (D)

☐ = #09 Timberwolf (E)

☐ = #15 Mellow Yellow (F)

Long Side 2

Rep Rows 1 and 2 on bottom long side of panel, do not fasten off, turn work to RS facing.

Joining Rnd

Prepare panels for joining as before, lining up bottom of Panel 6 with top edge of Panel 5. With RS facing, with C, work Border same as Border for Panel 2, but work 24 sc evenly spaced across short sides of panel, join with sl st in first sc. Fasten off.

Panel 7

Work same as Panel 1.

Joining Rnd

Prepare panels for joining as before, lining up bottom of Panel 7 with top edge of Panel 6, with A, work Border same as Border for Panel 2, join with sl st in first sc. Fasten off.

Blanket Border

Rnd 1: With size H-8 (5 mm) hook, join A in any corner, *3 sc in corner st, sc evenly across to next corner; rep from * around, join with a sl st in first sc.

Note: Be sure to work the same number of sc on opposing sides of the piece.

Rnd 2: Sl st in next sc, *3 sc in corner st, sc in each st across to next corner; rep from * around, join with a sl st in first sc. Fasten off. Weave in ends.

NOTE

To make Full Block, Schematic shows
which sections to work in numbered
order, and which color to use, as well
as the direction of the work, which
is marked with arrows. Refer to
Schematic throughout instructions.

ABSTRACT *Blocks*

Bordering on "freeform" crochet, this project will get you very familiar with how each section of color interacts with the colors around it on a piece. I imagine April Rhodes digitally painting abstract art to create her *Painting Morale* fabric and playing with how the shapes will fit together on the fabric canvas. By drawing on her beautiful work, we can create a truly unique crochet art piece that also happens to double as a blanket. Perfection.

FINISHED SIZE
43 × 43" (109 × 109 cm).

YARN
Fingering weight (#2 fine).

Shown here: Scheepjes Sunkissed (100% cotton; 186 yd [170 m]/1¾ oz [50 g]): #11 Peach Ice (A), 1 ball; #16 Soft Cloud (B), 2 balls; #07 Pistachio Ice (G), 1 ball; #03 Breeze (I), 1 ball.

Scheepjes Catona (100% cotton; 138 yd [125 m]/1¾ oz [50 g]): #257 Antique Mauve (C), #105 Bridal White (D), 5 balls; #179 Topaz (E), 1 ball; #383 Ginger Gold (F), 1 ball; #242 Metal Grey (H), 2 balls; #247 Bluebird (J), 2 balls; #264 Light Coral (K), 1 ball.

HOOKS
US size F-5 (3.75 mm) hook for squares.

US size E-4 (3.5 mm) hook for last rnd of border.

Adjust hook size if necessary to achieve gauge.

NOTIONS
Tapestry needle.

GAUGE
18 sts and 10 rows = 4" (10 cm) in dc, with size F-5 (3.75 mm) hook, blocked.

Full Square (Make 8)

Sections 1–3

Row 1: (RS) With size F-5 (3.75 mm) hook and A, ch 20, dc in 3rd ch from hook (turning ch counts as 1 dc), dc in each ch across, turn—19 dc.

Row 2: Sc in each st across, turn—19 sc.

Rows 3–5: Beg dc (see Glossary) in first st, dc in each st across, turn. Fasten off—19 dc.

Row 6: With RS facing, join B with a sl st in first st, rep Row 3.

Rows 7–10: Rep Rows 2–5. Fasten off.

Rows 11–15: With RS facing, join C with sl st in first st, rep Rows 6–10. Fasten off.

Turn piece RS facing with the "top edge" at the left-hand side, so that left to right, the colors are C, B, A. Now you are ready to work Sections 4–9.

Section 4

Row 1: With RS facing and size F-5 (3.75 mm) hook, join D with a sl st in the side of the first st near the bottom of Row 1 on Section 1, Beg dc in same st, dc in the side of the same st near the top, work 12 dc evenly spaced across side of next 7 rows, dc in side of next st near the bottom, dc3tog (see Glossary), ending at top left corner of Section 2, turn—15 dc; dc3tog.

Row 2: Beg dc3tog (see Glossary) over first 3 sts, dc in each st across, turn—13 dc; 1 dc3tog.

Row 3: Beg dc in first st, dc in each st across to last 3 sts, dc3tog over last 3 sts, turn—11 dc; 1 dc3tog.

Rows 4–8: Rep Rows 2 and 3, ending on a Row 2—1 dc; 1 dc3tog after Row 8.

Row 9: Sc2tog (see Glossary) over first 2 sts. Fasten off.

Section 5

Row 1: With RS facing and size F-5 (3.75 mm) hook, rejoin D in side of the first st near the bottom of Row 11 on Section 3, Beg dc3tog over side of this row and Row 12 of Section 3, work 6 dc evenly spaced across remaining rows of Section 3, turn—6 dc; 1 dc3tog.

Row 2: Beg dc in first st, dc in each of next 3 sts, dc3tog over next 3 sts, turn—4 dc; 1 dc3tog.

Row 3: Beg dc3tog over first 3 sts, dc in last 2 sts, turn—2 dc; 1 dc3tog.

Row 4: Sc3tog (see Glossary) over first 3 sts, turn. Do not fasten off.

Make Border Across Top Edge of Sections 5 and 4

Border: Make 10 sc evenly spaced downslope of Section 5, sc2tog over last st of Section 5 and first st of Section 4, work 22 sc evenly spaced upslope of Section 4. Fasten off.

Sections 6 and 7

Row 1: With RS facing and size F-5 (3.75 mm) hook, join E with a sl st in last sc of the Section 5 "border" (far right sc), Beg dc3tog over first 3 sts, dc in each of next 17 sts, dc5tog (see Glossary) over next 5 sts, dc in each of next 7 sts, (2 dc, tr) in last st, turn—26 dc; 1 tr; 1 dc3tog; 1 dc5tog.

Row 2: (Beg tr [see Glossary], 2 dc) in first st, dc in each of next 7 sts, dc5tog over next 5 sts, dc in each of next 13 sts, dc3tog over last 3 sts, turn—22 dc; 1 tr; 1 dc3tog; 1 dc5tog. Fasten off.

Row 3: With RS facing, join F with a sl st in first st, Beg dc3tog over first 3 sts, dc in each of next 9 sts, dc5tog over next 5 sts, dc in each of next 7 sts, (2 dc, tr) in last st, turn—18 dc; 1 tr; 1 dc3tog; 1 dc5tog.

Row 4: Beg dc3tog over first 3 sts, dc in each of next 5 sts, dc5tog over next 5 sts, dc in each of next 5 sts, dc3tog over last 3 sts, turn—10 dc; 2 dc3tog; 1 dc5tog.

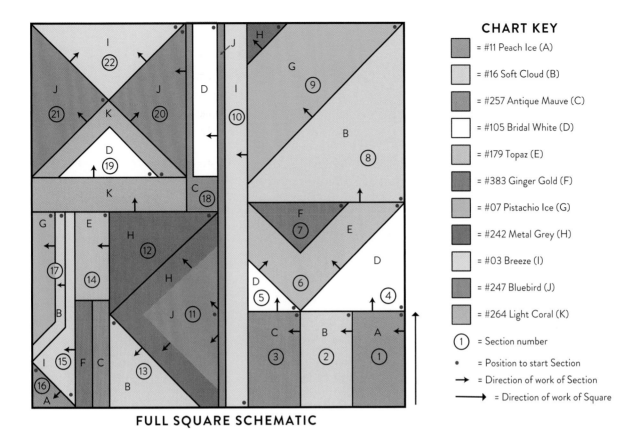

FULL SQUARE SCHEMATIC

CHART KEY

= #11 Peach Ice (A)

= #16 Soft Cloud (B)

= #257 Antique Mauve (C)

= #105 Bridal White (D)

= #179 Topaz (E)

= #383 Ginger Gold (F)

= #07 Pistachio Ice (G)

= #242 Metal Grey (H)

= #03 Breeze (I)

= #247 Bluebird (J)

= #264 Light Coral (K)

① = Section number

• = Position to start Section

→ = Direction of work of Section

⟶ = Direction of work of Square

Row 5: Beg dc3tog over first 3 sts, dc in next st, dc5tog over next 5 sts, dc in next st, dc3tog over last 3 sts, turn—2 dc; 2 dc3tog; 1 dc5tog.

Row 6: Beg dc5tog (see Glossary) over first 5 sts. Fasten off.

Section 8

Row 1: With RS facing and size F-5 (3.75 mm) hook, join B with a sl st in the last sc of the Section 4 "border," Beg dc in same st, work 26 dc evenly spaced across top edge of Sections 6 and 7, turn—27 dc.

Row 2: Beg dc3tog over first 3 sts, dc in each st across, turn—24 dc; 1 dc3tog.

Row 3: Beg dc in first st, dc in each st across to last 3 sts, dc3tog over last 3 sts, turn—22 dc; 1 dc3tog.

Rows 4–13: Rep Rows 2 and 3, ending with Row 3, turn—2 dc; 1 dc3tog after Row 13.

Row 14: Beg dc3tog over first 3 sts, turn. Do not fasten off.

Make Border Downslope of Section 8

Border: Work 36 sc evenly spaced downslope of Section 8. Fasten off.

Section 9

Row 1: With RS facing and size F-5 (3.75 mm) hook, join G with a sl st in top corner sc of Section 8 "border," Beg dc3tog over first 3 sts, dc in each st across to last 3 sts, dc3tog over last 3 sts, turn—30 dc; 2 dc3tog.

Rows 2–7: Rep Row 1—6 dc; 2 dc3tog after Row 7. Fasten off.

Row 8: With WS facing, join H with a sl st in first st; rep Row 1—2 dc; 2 dc3tog.

Row 9: Beg dc3tog over first 3 sts, dc in last st, turn.

Row 10: Sc2tog over first 2 sts. Fasten off.

Rotate so that Sections 1–3 are on the left-hand side. Section 10 is worked across the top edge.

Section 10

Row 1: With WS facing and size F-5 (3.75 mm) hook, join I in first st (this will be the first st of Row 15 on Sections 1–3), work 67 sc evenly spaced across, ending on the other side at the final row of Section 9, turn.

Row 2: Beg dc in first st, dc in each st across, do not turn—67 dc. Fasten off.

Row 3: With RS facing and size F-5 (3.75 mm) hook, join J with a sl st in first st, sc in each st across. Fasten off, leaving a 12" (30.5 cm) sewing length.

Set aside. Sections 11–16 will be made and then sewn onto this piece using the sewing length.

Section 11

Row 1: With size F-5 (3.75 mm) hook and J, ch 3, sl st in 3rd ch from hook to form a ring, (Beg tr, 7 dc, tr) in ring, turn.

Row 2: (Beg tr, 2 dc) in first st, dc in each of next 3 sts, 5 dc in center st, dc in each st across to last st, (2 dc, tr) in last st, turn—15 dc; 2 tr.

Row 3: (Beg tr, 2 dc) in first st, dc in each of next 7 sts, 5 dc in center st, dc in each st across to last st, (2 dc, tr) in last st, turn—23 dc; 2 tr.

Row 4: (Beg tr, 2 dc) in first st, dc in each of next 11 sts, 5 dc in center st, dc in each st across to last st, (2 dc, tr) in last st, turn—31 dc; 2 tr. Fasten off.

Row 5: With RS facing and size F-5 (3.75 mm) hook, join H with a sl st in first st, (Beg tr, 2 dc) in first st, dc in each of next 15 sts, 5 dc in center st, dc in each st across to last st, (2 dc, tr) in last st, turn—39 dc; 2 tr.

Row 6: With RS facing, join H in first st, (Beg tr, 2 dc) in first st, dc in each of next 19 sts, 5 dc in center st, dc in each st across to last st, (2 dc, tr) in last st, turn—47 dc; 2 tr. Do not fasten off.

Section 12

Row 7: With size F-5 (3.75 mm) hook and H, Beg dc3tog over first 3 sts, dc in each of next 19 sts, dc3tog over next 3 sts, turn—19 dc; 2 dc3tog.

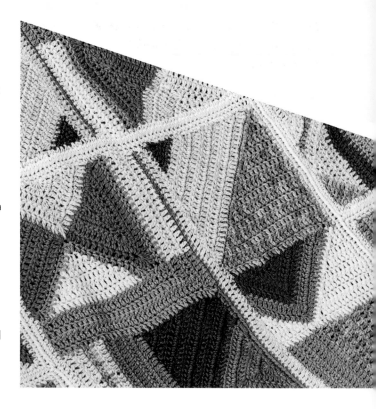

Rows 8–11: Beg dc3tog over first 3 sts, dc in each st across to last 3 sts, dc3tog over last 3 sts, turn—3 dc; 2 dc3tog after Row 11.

Row 12: Beg dc3tog over first 3 sts, dc2tog (see Glossary) over last 2 sts, turn.

Row 13: Sc2tog over first 2 sts. Fasten off.

Section 13

Rows 1–7: Fill other side of triangle as follows: With RS facing and size F-5 (3.75 mm) hook, join B with a sl st in center st of Row 6 of Section 11, rep Rows 7–13 of Section 12.

Section 14

Row 1: With RS facing and size F-5 (3.75 mm) hook, join E with a sl st in last row of Section 12, Beg dc in same st, work 15 dc evenly spaced across sides of Row 12 across to bottom of Row 8 of Section 12, dc in next st, change to C by pulling new yarn through final 2 loops of last dc, drop E to be picked up later, do not work over it, with C, work 20 dc evenly spaced down to last row of Section 13, turn—37 dc.

Row 2: With C, Beg dc in first st, dc in each of next 19 sts, change back to E on last dc, fasten off C, with E, dc in each st across, turn.

Row 3: With E, Beg dc in first st, and dc in each of next 16 sts, change F on last dc, drop E, with F, dc in each st across, turn.

Row 4: With F, Beg dc in first st, dc in each of next 19 sts, pick up E on last dc, fasten off F, with E, dc in each st across. Fasten off.

Section 15

Row 1: With WS facing and size F-5 (3.75 mm) hook, join I with a sl st in first st of Row 4 of Section 14, Beg dc3tog over first 3 sts, dc in each of next 12 sts, dc3tog over next 3 sts, turn.

Rows 2 and 3: Beg dc3tog over first 3 sts, dc in each st across to last 3 sts, dc3tog over last 3 sts, turn—4 dc; 2 dc3tog after Row 3.

Row 4: Beg dc3tog over first 3 sts, dc3tog over last 3 sts, turn—2 dc3tog.

Row 5: Sc2tog over first 2 sts, turn. Do not fasten off.

Make Border Downslope of Section 15 and Across Section 14

Border: With WS facing and size F-5 (3.75 mm) hook, Beg dc3tog over first 3 sts, work 8 dc evenly spaced downslope of Section 15, dc3tog at "elbow" where top of Section 14 begins, dc in each of last 18 sts. Fasten off.

Section 16

Work across left slope of Section 15 to form fill-in triangle.

Row 1: With RS facing and size F-5 (3.75 mm) hook, join A with a sl st in last st of Row 5 of Section 15, Beg dc3tog over first 2 row-end sts, work 6 dc evenly spaced across to last row-end st, dc3tog over last row-end st, turn—6 dc; 2 dc3tog.

Row 2: Beg dc3tog over first 3 sts, dc in each of next 2 sts, dc3tog over last 3 sts, turn—2 dc; 2 dc3tog.

Row 3: Beg dc4tog (see Glossary) over first 4 sts. Fasten off.

Section 17

Row 1: With RS facing and size F-5 (3.75 mm) hook, join B with a sl st in last st of Section 15 "border," Beg dc in same st, dc in each of next 16 sts, dc3tog over next 3 sts, dc in each of next 5 sts, dc3tog over last 3 sts, turn—22 dc; 2 dc3tog. Fasten off.

Row 2: With WS facing and size F-5 (3.75 mm) hook, join G with a sl st in first st, Beg dc3tog over first 3 sts, dc in each of next 2 sts, dc3tog over next 3 sts, dc in each st across, turn—18 dc; 2 dc3tog.

Row 3: Beg dc in first st, dc in each of next 14 sts, dc5tog over next 5 sts. Fasten off.

Join 2 Pieces

Rotate piece so that Section 11 is on the right-hand side. Use Full Block Schematic as a placement guide. Line up bottom corner of Section 11 with bottom corner of Section 10 where the long tail is. Holding with wrong sides together, whip-stitch pieces using tapestry needle and sewing length from Section 10. Use 39 sc from Section 10. Make sure that the top corner of Section 12 just about lines up with top corner of Section 7 as seen in Schematic. 28 sc will remain unsewn on Section 10. Sections 17–21 will fill the upper left area of the Full Block.

Section 18

Row 1: With RS facing and size F-5 (3.75 mm) hook, join D with a sl st in first st of Row 3 on Section 10, Beg dc in same st, dc in each of next 19 sts, changing to C in last dc, drop D to WS to be picked up later, do not work over it, with C, dc in each of next 6 sts, dc5tog placing first 2 legs of dec on Section 10, center leg in corner, and last 2 legs on Section 12, dc in each of next 6 sts, changing to K in last dc, drop C to be picked up later, with K, work 26 dc evenly spaced across, making sure last dc is in top left corner of Section 17, turn—58 dc; 1 dc5tog.

Row 2: With K, Beg dc in first st, dc in each of next 25 sts, changing to C in last dc, with C, dc in each of next 4 sts, dc5tog over next 5 sts, dc in each of next 4 sts, changing to D in last st, with D, dc in each st across, turn—54 dc; 1 dc5tog.

Row 3: With D, Beg dc in first st, dc in each of next 19 sts, changing to C in last dc, with C, dc in each of next 2 sts, dc5tog over next 5 sts, dc in each of next 2 sts, changing to K in last dc, with K, dc in each st across—50 dc; 1 dc5tog. Fasten off D.

Row 4: With K, Beg dc in first st, dc in each of next 25 sts, changing to C in last dc, with C, dc5tog over next 5 sts, changing to C, with C, dc in each st across. Fasten off C. Do not fasten off K. K will be used later on—46 dc; 1 dc5tog.

Section 19

Row 1: With WS facing and size F-5 (3.75 mm) hook, join D in 4th st from the right on Section 18 (on the K section), Beg dc3tog over this and next 2 sts, dc in each of next 15 sts, dc3tog over last 3 sts, turn.

Rows 2–4: Beg dc3tog over first 3 sts, dc in each st across to last 3 sts, dc3tog over last 3 sts, turn—3 dc; 2 dc3tog after Row 4.

Row 5: Beg dc5tog over first 5 sts. Fasten off.

Make Border Over Section 19

Border: Pick up K at end of Section 18, and with RS facing, Beg dc5tog, placing last 2 legs of decrease on side of Row 1 on Section 18, work 10 dc evenly spaced across slope of Section 18, 5 dc at "peak" of Section 18, work 10 dc evenly spaced downslope of Section 18, dc5tog, placing last 3 legs in last 3 unworked sts—25 dc; 2 dc5tog. Fasten off.

Section 20

Row 1: With RS facing and size F-5 (3.75 mm) hook, join J with a sl st in last dc of Section 18, Beg dc3tog over first 3 sts, dc in each of next 13 sts, dc8tog (see Glossary), placing first 4 legs in Section 18, 1 leg in corner, and last 3 legs in Section 19 border, dc in each of next 12 sts, turn—25 dc; 1 dc3tog; 1 dc8tog.

Row 2: Beg dc in first st, dc in each of next 8 sts, dc8tog over next 8 sts, dc in each of next 7 sts, dc3tog over next 3 sts, turn—16 dc; 1 dc3tog; 1 dc8tog.

Row 3: Sc in each of first 6 sts, sc5tog (see Glossary) over next 5 sts, sc in each of last 7 sts, turn—13 sc; 1 sc5tog.

Row 4: Sc in each of first 5 sts, sc5tog over next 5 sts, sc in each of last 4 sts, turn—9 sc; 1 sc5tog.

Row 5: Sc6tog (see Glossary) over first 3 sts and last 3 sts of last row, skipping over center 4 sts. Fasten off.

Section 21

Row 1: With RS facing and size F-5 (3.75 mm) hook, join J in center dc of Section 19 border. Beg dc in first st, dc in each st across to last 3 sts, dc3tog over last 3 sts, turn—11 dc; 1 dc3tog.

Row 2: Beg dc3tog over first 3 sts, dc in each st across, turn—9 dc; 1 dc3tog.

Rows 3–6: Rep Rows 1 and 2 (twice), turn—1 dc; 1 dc3tog after Row 6.

Row 7: Sc2tog over first 2 sts, turn. Do not fasten off.

Make Border Across Sections 21 and 20

With WS facing and size F-5 (3.75 mm) hook, work 16 sc evenly spaced across slope of Section 21, sc in center dc of Section 18 border, work 16 sc evenly spaced across slope of Section 20—33 sc. Fasten off.

Section 22

Row 1: With RS facing and size F-5 (3.75 mm) hook, join I with a sl st in last sc of Section 20 border, Beg dc3tog over first 3 sts, dc in each of next 11 sts, dc5tog over next 5 sts, dc in each of next 11 sts, dc3tog over last 3 sts, turn—22 dc; 2 dc3tog; 1 dc5tog.

Row 2: Beg dc3tog over first 3 sts, dc in next 7 sts, dc5tog over next 5 sts, dc in next 7 sts, dc3tog over last 3 sts, turn—14 dc; 2 dc3tog; 1 dc5tog.

Row 3: Beg dc3tog over first 3 sts, dc in each of next 3 sts, dc5tog over next 5 sts, dc in next 3 sts, dc3tog over last 3 sts, turn—6 dc; 2 dc3tog; 1 dc5tog.

Row 4: Beg dc9tog (see Glossary) over first 9 sts. Fasten off.

Full Square Border

Rnd 1: With RS facing and size F-5 (3.75 mm) hook, join D with a sl st in any corner of Full Square, *3 sc in corner st, work 63 sc evenly spaced across to next corner; rep from * around, join with a sl st in first sc.

Rnd 2: Sl st in next corner sc, *3 sc in corner st, sc in each st across to next corner; rep from * around, join with a sl st in first sc. Fasten off.

Half Square A

Using size F-5 (3.75 mm) hook and all necessary colors, work Sections 1–7, make Section 10, but work only 39 dc evenly spaced across side of Sections 1–7. Fasten off, leaving a 12" (30.5 cm) sewing length. Work Sections 11–17 and whipstitch pieces together as for Full Block.

Half Square A Border

Rnd 1: With RS facing, join D with a sl st in corner just before a short side, *3 sc in corner st, work 35 sc evenly spaced across short side, 3 sc in corner, work 63 sc evenly spaced across long side; rep from * once, join with a sl st in first sc.

Rnd 2: Sl st in next corner sc, *3 sc in corner st, sc in each st across to next corner; rep from * around, join with a sl st in first sc. Fasten off.

Half Square B

With B and size F-5 (3.75 mm) hook, ch 28, dc in 3rd ch from hook, dc in each ch across. Work Rows 2–14 and Border row of Section 8. Work Section 9. Work Section 10, but work only 28 dc instead of the original 67. Fasten off, leaving a 12" (30.5 cm) sewing length. Join K in final st of Section 10, ch 35, cut yarn and pull through on 35th ch, closing the last ch to secure it. With RS facing and D, work Section 18, making K section over the ch length. Work Sections 19–22. Using sewing length, whipstitch 2 pieces together. Weave in ends.

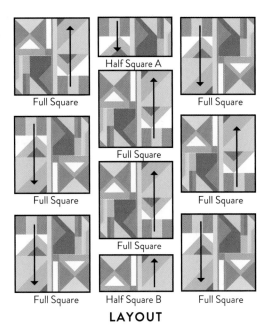

Full Square · Half Square A · Full Square

Full Square · · Full Square

Full Square · · Full Square

Full Square · · Full Square

Full Square · Half Square B · Full Square

LAYOUT

Half Square B Border

Rnd 1: With RS facing, join D with a sl st in corner just before a short side, *3 sc in corner st, work 23 sc evenly spaced across short side, 3 sc in corner st, work 63 sc evenly spaced across long side; rep from * once, join with a sl st in first sc.

Rnd 2: Sl st in next sc, *3 sc in corner st, sc in each st across to next corner; rep from * once, join with a sl st in first sc. Fasten off.

Sew Squares Together

Lay out pieces according to Layout chart, paying attention to square orientation. Whipstitch squares together, using D and tapestry needle.

Blanket Border

Rnd 1: With RS facing and size F-5 (3.75 mm) hook, join D with a sl st in any corner st, *3 sc in corner st, sc in each st across to next corner; rep from * once, join with a sl st in first sc.

Rnd 2: Change to smaller hook, reverse sc (see Glossary) in each st around, join with a sl st in first reverse sc. ***Note:*** *Do not work any extra sts in the corners to leave a neat, rounded corner.* Fasten off. Weave in ends.

NOTE

Panel 1 is made of motifs that are joined together. Then stitches are crocheted across the bottom edge of Panel 1 to work Panel 2. Panel 3 is worked separately and sewn to the bottom edge of Panel 2. A pretty lace border is then added to complete the piece.

Sylph's Freedom Flower by April Rhodes

Wanderlust

If you've ever wanted to create a work of crochet art with a process as pleasing as the outcome, then Wanderlust is the perfect project. Inspired by the *Sylph's Freedom Flower* fabric by April Rhodes, this piece is just complex enough to keep your interest by branching out with unique stitches, but simple enough to make you feel cozy and right at home. Enjoy this blanket nestled in bed with a cup of coffee while browsing your favorite getaway destinations.

FINISHED SIZE
44 × 49" (112 × 124.5 cm).

YARN
Sportweight (#3 light).

Shown here: Cascade Yarns 220 Superwash Sport (100% superwash merino wool; 136 yd [125 m]/1¾ oz [50 g]): #809 Really Red (A), 1 hank; #820 Lemon (B), 1 hank; #894 Strawberry Cream (C), 2 hanks; #877 Golden (D), 2 hanks; #1946 Silver Grey (E), 3 hanks; #818 Mocha (F), 3 hanks; #871 White (G), 6 hanks; #1910 Summer Sky Heather (H), 1 hank; #900 Charcoal (I), 3 hanks; #1940 Peach (J), 2 hanks.

HOOK
US size G-6 (4 mm) hook.

Adjust hook size if necessary to achieve gauge.

NOTIONS
Tapestry needle.

GAUGE
Rnds 1 and 2 = 2½" (6.5 cm) in diameter, blocked.

STITCH GUIDE

Beg Cluster over first 3 sts

Beg dc in first st, yo, insert hook in same st, yo, pull up loop, yo, draw yarn through 2 loops on hook, yo, insert hook in next st, yo, pull up loop, yo, draw yarn through 2 loops on hook, [yo, insert hook in next st, yo, pull up loop, yo, draw yarn through 2 loops on hook] twice, yo, draw yarn through all 5 loops on hook.

Cluster over 3 sts

[Yo, insert hook in first st, yo, pull up loop, yo, draw yarn through 2 loops on hook] twice, yo, insert hook in next st, yo, pull up loop, yo, draw yarn through 2 loops on hook, [yo, insert hook in next st, yo, pull up loop, yo, draw yarn through 2 loops on hook] twice, yo, draw yarn through all 6 loops on hook.

Large Cluster over # of sts indicated

[Yo twice, insert hook in next st/ch, yo, pull up loop, (yo, draw yarn through 2 loops on hook) twice] # times indicated, yo, draw yarn through all (# + 1) loops on hook.

Panel 1

Full Hexagon 1 (Make 8)

Rnd 1: With A, ch 3, sl st in 3rd ch from hook to form a ring, work 12 sc in ring, join with a sl st in first sc—12 sc.

Rnd 2: Beg Cluster over first 3 sts, *ch 6, Cluster over next 3 sts (see Stitch Guide); rep from * twice, ch 6, join with a sl st in top of Beg dc (see Glossary)—4 Clusters; 4 ch-sps. Fasten off.

Rnd 3: Join B with a sl st on far left side of any ch-sp, Beg dc in same sp, *ch 2, 8 dc in next ch-sp; rep from * twice, ch 2, 7 dc in first ch-sp, join with a sl st in top of Beg dc—32 dc; 4 ch-sps.

Rnd 4: (Beg dc, 4 dc) in first ch-sp, *ch 4, make Large Cluster over next 8 sts, ch 4**, 5 dc in next ch-sp; rep from * around, ending last rep at **, join with a sl st in top of Beg dc—4 Large Clusters; 8 ch-sps; 20 dc. Fasten off.

Rnd 5: With RS facing, join C with a sl st in top of any Large Cluster, (Beg tr [see Glossary], ch 1, 3 tr) in same st, *ch 2, 2 dc in back loop only of next dc, dc in back loop only of each of next 3 sts, 2 dc in back loop only of next st, ch 2**, (3 tr, ch 1, 3 tr) in top of next Large Cluster (corner made); rep from * around, ending last rep at **, 2 tr in first corner to complete it, join with a sl st in top of Beg tr—24 tr; 28 dc; 8 ch-2 sps; 4 ch-1 sps.

Rnd 6: *Ch 1, sk next ch-1 sp, sc in each of next 3 sts, ch 6, Large Cluster over next 7 sts, ch 6, sc in next 3 sts; rep from * around, join with a sl st in first ch of rnd—4 Large Clusters; 24 sc; 8 ch-6 sps; 4 ch-1 sps. Fasten off.

Rnd 7: With RS facing, join D with a sl st in center of first partial tr of any Large Cluster from Rnd 4, working around st and treating it as a ch-sp, and also working around ch-4 sp from Rnd 4, (Beg tr, 2 tr) around same 2 ch-sp, *ch 1, (3 tr, dc, hdc, sc) in final partial tr of same Large Cluster from Rnd 4, sl st in front loop only of each of next 5 dc sts from Rnd 5, (sc, hdc, dc, 3 tr) all around first partial tr of next Large Cluster from Rnd 4 and also around ch-4 sp from Rnd 4; rep from * around, omitting last 3 tr on last rep, join with a sl st in top of Beg tr—24 tr; 8 dc; 8 hdc; 8 sc; 20 sl sts; 4 ch-sps.

Rnd 8: Sc in first st, *ch 4, Large Cluster over next 5 sts and sps, working through both layers (sc sts from Rnd 6 and tr sts from Rnd 7), ch 4, sc in next tr, ch 6, sc in top of next Large Cluster in Rnd 6, ch 6, sk next 3 sts**, sc in next st; rep from * around, ending last rep at **, join with a sl st in first sc—12 sc; 4 Large Clusters; 8 ch-6 sps; 8 ch-4 sps. Fasten off.

Rnd 9: With RS facing, join E with a sl st in top of any Large Cluster in Rnd 8, *sc in Large Cluster, ch 2, (2 tr, 6 dc) in next ch-sp, working around both ch-6 sps in Rnd 8 and Rnd 6 here and throughout, dc in top of next Large Cluster in Rnd 6, (6 dc, 2 tr) in next set of ch-sps, ch 2; rep from * around, join with a sl st in first sc—16 tr; 52 dc; 4 sc; 8 ch-sps.

Rnd 10: *Sc in sc, 3 sc in next ch-sp, sc in each of next 17 sts, 3 sc in next ch-sp; rep from * around, join with a sl st in first sc—96 sc. Fasten off.

Rnd 11: With RS facing, join F with a sl st in first sc, (Beg dc, ch 1, dc) in first st, *dc in each of next 15 sts**, (dc, ch 1, dc) in next st; rep from * around, ending last rep at **, join with a sl st in top of Beg dc—102 dc; 6 ch-sps.

Rnd 12: Beg dc in first st, *dc each st across to next ch-sp**, (dc, ch 1, dc) in next ch-sp; rep from * around, ending last rep at **, join with a sl st in top of Beg dc—114 dc; 6 ch-sps. Fasten off.

Rnd 13: With RS facing, join G with a sl st in any ch-sp, *3 sc in ch-sp, sc in each st across to next ch-sp; rep from * around, join with a sl st in first sc. Fasten off.

Full Hexagon 2 (Make 4)

Rnds 1–13: Work same as Full Hexagon 1, using H instead of B for Rnds 3 and 4.

Half Hexagon (Make 6)

Row 1: (RS) With A, ch 3, sl st in 3rd ch from hook to form a ring, work 8 sc in ring, turn.

Row 2: Beg dc in first st, ch 3, Cluster over next 3 sts, ch 6, Cluster over next 3 sts, ch 3, dc in last st, do not turn—2 dc; 2 Clusters; 3 ch-sps. Fasten off.

Row 3: With WS still facing, join B with a sl st in first st, Beg dc in same st, 3 dc in next ch-sp, ch 2, 8 dc in next ch-sp, ch 2, 3 dc in last ch-sp, dc in last st, turn—16 dc; 2 ch-sps.

Row 4: Beg tr in first st, Large Cluster over next 3 sts, ch 4, 5 dc in next ch-sp, ch 4, Large Cluster over next 8 sts, ch 4, 5 dc in next ch-sp, ch 4, Large Cluster over next 4 sts, turn—3 Large Clusters; 4 ch-sps; 10 dc. Fasten off.

Rnd 5: With WS facing, join C with a sl st in top of first Large Cluster, (Beg tr, ch 1, 3 tr) in same st, *ch 2, 2 dc in front loop only of next dc, dc in front loop only of each of next 3 sts, 2 dc in front loop only of next st, ch 2**, (3 tr, ch 1, 3 tr) in top of next Large Cluster; rep from * to ** once, (3 tr, ch 1, tr) in last st, turn—14 tr; 14 dc; 4 ch-2 sps; 3 ch-1 sps.

Row 6: Sc in first st, *ch 1, sk next ch-1 sp, sc in each of next 3 sts, ch 6, Large Cluster over next 7 sts, ch 6, sc in each of next 3 sts; rep from * once, ch 1, sc in last st, do not turn—2 Large Clusters; 14 sc; 4 ch-6 sps; 3 ch-1 sps. Fasten off.

Row 7: With RS still facing, join D with a sl st in first st of Row 4, Beg tr in same st, *ch 1, (3 tr, dc, hdc, sc) in center of final partial tr of Large Cluster from Row 4, working around st and treating it as a ch-sp, and also working around ch-4 sp from Rnd 4, sl st in front loop only of each of next 5 dc sts in Rnd 5, (sc, hdc, dc, 3 tr) around first partial tr of next Large Cluster from Rnd 4 and also ch-4 sp in Row 4; rep from * once, ch 1, tr in last st, turn—14 tr; 3 dc; 8 hdc; 8 sc; 20 sl sts; 4 ch-sps.

Row 8: Beg tr through both layers of last sc in Row 6 and last st in Row 7, Large Cluster over next 3 sts/sp, working through both layers as for Full Hexagon here and throughout, *ch 4, sc in next tr, ch 6, sc in top of next Large Cluster in Rnd 6, ch 6, sc in next tr, ch 4**, Large Cluster over next 5 sts/sp; rep from * to ** once, Large Cluster over next 3 sts/sp, tr in last st, turn—2 tr; 6 sc; 3 Large Clusters; 4 ch-6 sps; 4 ch-4 sps. Fasten off.

Row 9: With RS facing, join E with a sl st in first st, *sc in top of Large Cluster, ch 2, (2 tr, 6 dc) in next ch-sp, working around both ch-6 sps from Row 6 and Row 8 here and throughout, dc in top of Large Cluster from Row 6, (6 dc, 2 tr) in next ch-sp, ch 2; rep from * once, sc in last st, turn—8 tr; 26 dc; 3 sc; 4 ch-sps.

Row 10: *Sc in sc, 3 sc in next ch-sp, sc in each of next 17 sts, 3 sc in next ch-sp; rep from * once, sc in last st, do not turn—49 sc. Fasten off.

Row 11: With WS facing, join F with a sl st in first sc, (Beg dc, ch 1, dc) in first st, *dc in each of next 15 sts, (dc, ch 1, dc) in next st; rep from * across, turn—53 dc; 4 ch-sps.

Row 12: (Beg dc, ch 1, dc) in first st, *dc in each st across to next ch-sp, (dc, ch 1, dc) in next ch-sp; rep from * across, do not turn—59 dc; 4 ch-sps. Fasten off.

Row 13: With RS facing, join G with a sl st in first st, sc in first st, sc in next ch-sp, *sc in each st across to next ch-sp, 3 sc in next ch-sp; rep from * once, sc in each st across to next ch-sp, sc in next ch-sp, sc in last st. Fasten off.

Join Hexagons

Lay out all Full and Half Hexagons as directed in Schematic. Using G and tapestry needle, whipstitch all motifs together, holding WS of pieces together and whipstitching through top 2 loops of both layers.

> **TIP**
>
> *To reduce the amount of ends to weave in, join Half and Full Hexagons in columns first and then make a zigzag of whipstitches down the columns.*

Fill In Side Gaps

Row 1: (RS) With RS facing, join I with a sl st in either corner just before one short side, sc in first 2 sts, hdc in each of next 2 sts, dc in each of next 17 sts, placing last dc in 3rd sc of corner on first motif, dc in each of next 17 sts, placing last dc in first sc of corner on next motif, hdc in each of next 2 sts, sc in each of next 2 sts, turn—34 dc; 4 hdc; 4 sc.

Row 2: Sl st in each of first 4 sts, sc in each of next 2 sts, hdc in each of next 2 sts, dc in each of next 12 sts, sk next 2 sts, dc in each of next 12 sts, hdc in each of next 2 sts, sc in each of next 2 sts, turn—24 dc; 4 hdc; 4 sc.

Row 3: Sl st in each of first 4 sts, sc in each of next 2 sts, hdc in each of next 2 sts, dc in each of next 7 sts, sk next 2 sts, dc in each of next 7 sts, hdc in each of next 2 sts, sc in each of next 2 sts, turn—14 dc; 4 hdc; 4 sc.

Row 4: Sl st in each of first 4 sts, sc in each of next 2 sts, hdc in each of next 2 sts, dc in each of next 2 sts, sk next 2 sts, dc in each of next 2 sts, hdc in each of next 2 sts, sc in each of next 2 sts, turn—4 dc; 4 hdc; 4 sc.

Row 5: Sl st in each of first 4 sts, sc in next st, sk next 2 sts, sc in next st. Fasten off.

Rep in rem 5 side gaps.

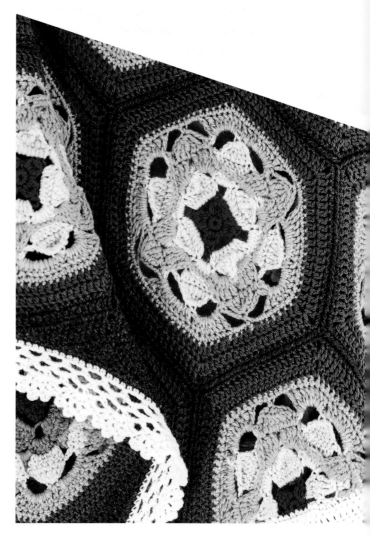

Panel 2

Row 1: With RS facing, join G in first st of one long side of Panel 1, work 175 sc evenly spaced across, turn.

Row 2: Sc in each st across, turn.

Row 3: Beg dc in first st, dc in each st across, turn—175 dc.

Rows 4 and 5: Rep Row 2. Fasten off.

Row 6: With RS facing, join D with a sl st in first st, sc in each st across, turn.

Row 7: Rep Row 2.

Row 8: (Beg dc, dc) in first st, (sk next 2 sts, 3 dc in next st) across to last 3 sts, sk next 2 sts, 2 dc in last st, turn—fifty-seven 3-dc groups; two 2-dc groups.

Row 9: Beg dc in first st, 3 dc between next st and 3-dc group, (3 dc between 3-dc groups) across row to last 2 sts, dc in last st, turn—fifty-eight 3-dc groups; 2 dc.

Row 10: Beg dc in first st, dc between first dc and next 3-dc group, (3 dc between 3-dc groups) across row to last 4 sts, dc in sp before last st, dc in last st, turn—fifty-seven 3-dc groups; two 2-dc groups.

Rows 11–14: Rep Rows 9 and 10 (twice).

Rows 15 and 16: Rep Row 2. Fasten off.

Row 17: (RS) Sc in each st across, turn.

Rows 18–21: Rep Rows 2–5.

Row 22: With RS facing, join F with a sl st in first st, rep Row 2.

Row 23: Rep Row 8.

Row 24: Note: *This is a color-change row.* Beg dc in first st, sk next st, with F, 3 dc between next 2 sts, changing to G in last dc by pulling G through final 2 loops of st, *with G, working over F, work 3 dc between 3-dc groups, changing back to F in last yo of last st, with F, working over G, work 3 dc between 3-dc groups**, changing back to G in last yo of last st; rep from * across, ending last rep at **, dc in last st, turn.

Row 25: With G, rep Row 8.

Row 26: Rep Row 24. Fasten off G.

Row 27: With F, rep Row 8.

Row 28: Rep Row 2. Fasten off.

Row 29: (RS) Sc in each st across, turn.

Rows 30–33: Rep Rows 2–5.

Panel 3

Note: Panel 3 is worked separately and then sewn to Panel 2 using whipstitch.

Triangle 1

Row 1: (RS) With G, ch 3, sl st in 3rd ch from hook to form a ring, (Beg dc, ch 1, 3 dc, ch 3, 3 dc, ch 1, dc) in ring, turn—8 dc; 3 ch-sps.

Row 2: (Beg dc, ch 1, 3 dc) in first ch-sp, (3 dc, ch 3, 3 dc) in center ch-sp (corner made), (3 dc, ch 1, dc) in last ch-sp, turn. Fasten off.

Rows 3 and 4: Within RS facing, join D with a sl st in first ch-sp, (Beg dc, ch 1, 3 dc) in same sp, 3 dc between 3-dc groups across to corner ch-sp, (3 dc, ch 3, 3 dc) in next ch-sp, 3 dc between 3-dc groups across to last ch-sp, (3 dc, ch 1, dc) in last ch-sp, turn. Fasten off.

Rows 5 and 6: With I, rep Rows 3 and 4.

Rows 7 and 8: With G, rep Rows 3 and 4. Fasten off.

Triangle 2

Rows 1–4: With H, rep Rows 1–4 of Triangle 1.

Rows 5 and 6: With A, rep Row 3 of Triangle 1.

Rows 7 and 8: With J, rep Row 3 of Triangle 1.

Triangle 3

Rows 1–8: Work same as Triangle 1, using I, J, D, G, respectively.

Triangle 4

Rows 1–8: Work same as Triangle 1, using H, G, D, G, respectively.

Triangle 5

Rows 1–8: Work same as Triangle 1, using A, D, I, H, respectively.

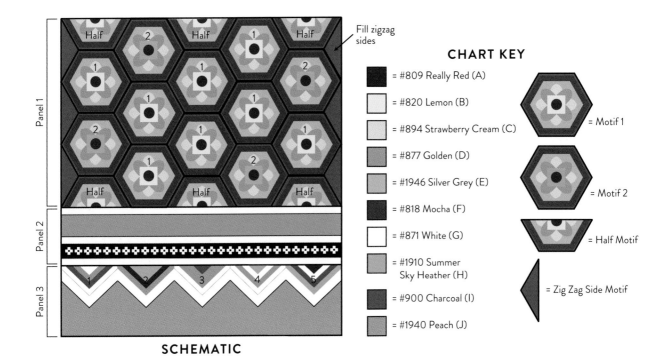

Fill zigzag sides

CHART KEY

■ = #809 Really Red (A)

□ = #820 Lemon (B)

□ = #894 Strawberry Cream (C)

■ = #877 Golden (D)

■ = #1946 Silver Grey (E)

■ = #818 Mocha (F)

□ = #871 White (G)

■ = #1910 Summer Sky Heather (H)

■ = #900 Charcoal (I)

■ = #1940 Peach (J)

= Motif 1

= Motif 2

= Half Motif

= Zig Zag Side Motif

SCHEMATIC

Chevron

Note: On Row 1, Triangles will be joined together in a line, then all subsequent rows will continue in a chevron pattern.

Row 1: (RS) With RS of Triangle 1 facing, join G with a sl st in first st at end of last row, Beg dc in first st, sk first ch-sp, sk next 3 dc, *3 dc between 3-dc groups across to next ch-sp, (3 dc, ch 3, 3 dc) in next ch-sp, 3 dc between 3-dc groups across to last 5 sts/sps**, pick up next Triangle, sk first 5 sts/sps; rep from * across remaining 4 triangles, ending last rep at **, (3 dc, ch 1, dc) in last ch-sp, turn. Triangles are now joined in a line.

Row 2: (Pattern Row) Beg dc in first ch-sp, ch 1, *3 dc between 3-dc groups across to next ch-sp, (3 dc, ch 3, 3 dc) in next ch-sp, 3 dc between 3-dc groups (6 times)**, sk next two 3-dc groups; rep from * across, ending last rep at **, ch 1, dc last ch-sp, turn.

Rows 3–6: Rep Row 2. Fasten off.

Row 7: With RS facing, join J with a sl st in first ch-sp, work same as Row 3.

Rows 8–10: Work same as Row 3, do not fasten off.

Fill Triangles to Square Off Chevron

First Triangle Gap Filler

Row 1: (RS) Beg dc in first ch-sp, ch 1, 3 dc between 3-dc groups across to next ch-sp, ch 1, dc in ch-sp, turn, leaving rem sts unworked.

Rows 2–6: Beg dc in first ch-sp, ch 1, 3 dc between 3-dc groups across to next ch-sp, ch 1, dc in last ch-sp, turn.

Row 7: Beg dc in first ch-sp, dc in last ch-sp. Fasten off.

Next Triangle Gap Filler

Row 1: (RS) With RS facing, join J with a sl st in corner ch-sp of same Triangle, Beg dc in first ch-sp, ch 1, 3 dc between 3-dc groups (6 times), sk next 6 sts, 3 dc between 3-dc groups across to next ch-sp, ch 1, dc in next ch-sp, turn, leaving rem sts unworked.

Rows 2–7: Beg dc in first ch-sp, ch 1, 3 dc between 3-dc groups (6 times), sk next 6 sts, 3 dc between 3-dc groups across to next ch-sp, ch 1, dc in next ch-sp, turn.

Row 8: Beg dc in first ch-sp, dc in last ch-sp. Fasten off.

Rep this Triangle Gap Filler in rem 3 triangle gaps.

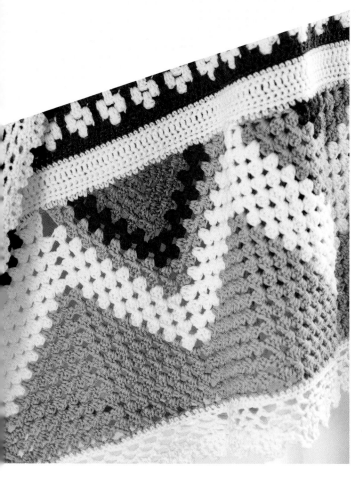

First Triangle Gap Filler

Row 1: (RS) With RS facing, join J with a sl st in Corner ch-sp of last Triangle, Beg dc in first ch-sp, ch 1, 3 dc between 3-dc groups across to next ch-sp, ch 1, dc in ch-sp, turn, leaving rem sts unworked.

Rep Rows 2–7 of First Triangle Gap to square off final corner.

Join Panel 3 to Panel 2

Hold Panel 3 with Triangles pointing downward and work a row of sc across top of Panel as follows: Join G with a sl st in upper right corner, work 175 sc evenly spaced across top edge of panel. Fasten off, leaving a sewing length about twice the width of the panel. Using sewing length, hold panels with wrong sides facing. With tapestry needle, whipstitch panels together.

Border

Rnd 1: With RS of blanket facing and Panel 1 on the top, locate the upper left corner of Panel 2, join G with a sl st in first st of Panel 2, with G, work 76 sc evenly spaced down left-hand side of Panels 2 and 3, 3 sc in corner, work 171 sc evenly spaced across bottom edge of Panel 3, 3 sc in corner, work 76 sc evenly spaced up right-hand side of Panels 2 and 3, changing to F in last sc. *Note: Be sure your last sc in G is at the end of Panel 2, complete last yo of last sc with F.* Fasten off G. With F, work 106 sc evenly spaced across right-hand side of Panel 1, 3 sc in corner, work 171 sc evenly spaced across top edge of Panel 1, 3 sc in corner, work 106 sc evenly spaced down left-hand side of Panel 1, join with a sl st in first sc. Fasten off F.

Rnd 2: With RS facing, join G with a sl st in top right-hand corner of blanket, *3 sc in corner st, sc in each st across to next corner; rep from * around, join with a sl st in first sc.

Rnd 3: Sl st in next sc, *(sc, ch 2, sc) in corner st (**corner made**), (ch 2, sk next 2 sts, sc in next st) across to within 3 sts of next corner, ch 2, sk next 2 sts; rep from * around, join with a sl st in first sc.

Rnds 4 and 5: Sl st in next ch-sp, (sc, ch 2) in each ch-sp around, join with a sl st in first sc.

Rnd 6: Sl st in first ch-sp, sc in same sp, *(ch 2, sc in next ch-sp, 4 hdc in next sc, sc in next ch-sp) across to ch-sp just before corner, ch 2, sc in next ch-sp, 9 dc in corner ch-sp, sc in next ch-sp; rep from * around, omitting last sc, join with a sl st in first sc.

Rnd 7: Sl st in first ch-sp, sc in same sp, ** *(dc in next hdc, ch 3, sc in top side bars of previous dc (**Picot** made) 3 times, dc in next hdc, sc in next ch-sp; rep from * across to next corner, (dc, Picot) in each of next 8 hdc, dc in last hdc, sc in next ch-sp; rep from ** around, omitting last sc, join with a sl st in first sc. Fasten off. Weave in ends.

CHAPTER 4

Paper Cutting

MAUD VANTOURS

THE ARTIST

Maud Vantours is a designer and paper-cutting artist who lives and works in Paris. Her background is in textiles and materials research, but paper has become her favorite medium. She sculpts it to make three-dimensional shapes, superimposing layers and colors to transform a simple piece of paper into a vibrant work of art. Color and pattern have an important role in her works, and she often creates imaginative and dreamlike landscapes. Maud's works can be found in galleries and international exhibitions, including the Luciano Benetton collection *Imago Mundi* in France.

THE INSPIRATION

Unlike the flowing textile art of fabrics, paper cutting is a precise and discrete art. Maud Vantours makes striking paper art from her studio in France by carefully cutting and layering brightly colored paper to create visually opulent art pieces. The clear-cut lines and smaller cut elements force the eye to pay attention to both the micro and macro aspects simultaneously. Translating this notion to crochet, I liken the micro elements to smart stitch choice and the macro elements to the big picture and what effect the overall design has on the viewer.

When I see Maud Vantours's works, I often find myself wondering how she does it. I can easily relate to traditional fiber arts such as weaving and fabric design, but drawing on a more hard-edged art medium such as paper challenges me to expand my creative boundaries and incorporate new elements into my textile craft. Like crochet, cut paper projects require precision and patience to complete. Inspired by Vantours's *Flora* piece, I designed the Color Garden blanket to create the look of layered paper flower petals and detailed "cutouts" made with cleverly placed eyelets. In Layered Waves, I work asymmetric flat and rippled stripes with a stitch technique that imitates overlapping colors, made with the *Landscape* art piece in mind. And finally, Perfect Scallops uses contrasting colors in a repeating pattern inspired by Maud's *Motif*, a meticulously carved paper project.

NOTES

▶ *Three types of motifs are made and joined as-you-go on the final round, as numbered in order on the Schematic. Sides of blanket are squared off, and a contrast picot border is added for the finishing touch. First, I will show instructions for the three motif types, then the instruction for beginning the blanket.*

▶ *Use the Motif Types section for reference as you join motifs for the piece.*

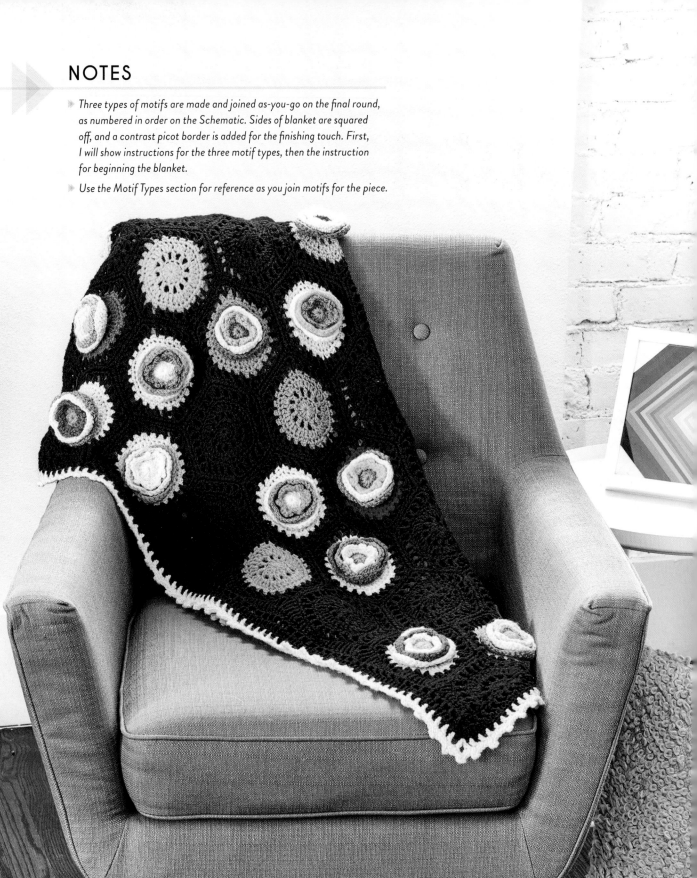

COLOR *Garden*

This blanket is an exercise in embracing the random. The flower petals are stacked in layers just as they are in the inspiration paper cut, *Flora* by Maud Vantours, and then they are randomly placed around the blanket for a visually interesting art piece. Whether you make this for a precious baby's crib or to lay across the back of your couch, it will be the conversation piece you're looking for.

FINISHED SIZE
33 × 39" (83 × 99 cm).

YARN
DK weight (#3 light).

Shown here: Stylecraft Special DK (100% acrylic; 322 yd [295 m]/3½ oz [100 g]): 1 ball each of the following colors, unless specified: #1011 Midnight (A), 4 balls; #1020 Lemon (B), 2 balls; #1081 Saffron (C); #1114 Sunshine (D); #1019 Cloud Blue (E); #1302 Denim (F); #1316 Spring Green (G); #1725 Sage (H); #1026 Apricot (I); #1132 Shrimp (J); #1084 Magenta (K); #1023 Raspberry (L); #1246 Lipstick (M).

HOOKS
US size H-8 (5 mm) hook.

US size G-6 (4.25 mm) hook—only used for last rnd of Border.

Adjust hook size if necessary to achieve gauge.

NOTIONS
Tapestry needle.

GAUGE
First 3 rnds of Motif A = 3" (7.5 cm) using size H-8 (5 mm) hook, blocked.

Motif Types

Type A (Make 18)

Rnd 1: With A, ch 3, join with a sl st in 3rd ch from hook to form a ring, (Beg dc [see Glossary], 11 dc) in ring, join with a sl st in top of Beg dc—12 dc.

Rnd 2: Beg dc in next st (referring to st to the left of joining st), *ch 1, dc in next st; rep from * 10 times, ch 1, join with a sl st in top of Beg dc—12 dc; 12 ch-sps.

Rnd 3: Sl st in first ch-sp, (Beg dc, dc) in first ch-sp, *dc in next st, 2 dc in next ch-sp; rep from * around, dc in next st, join with a sl st in top of Beg dc—36 dc.

Rnd 4: *Sc in each of next 2 sts, 2 sc in next st; rep from * around, join with a sl st in first sc—48 sc.

Rnd 5: (Beg dc, ch 1, dc) in next st, *[ch 1, sk next st, dc in next st] 3 times, ch 1, sk next st**, (dc, ch 1, dc) in next st; rep from * around, ending last rep at **, join with a sl st in top of Beg dc—30 dc; 30 ch-sp.

Joining Rnd

Note: *These are the basic instructions for this rnd. The blanket instructions will include additional information for working this round in the "join-as-you-go" manner. To join as you go, do not work all motifs complete; rather, all Base Circles of Motif Type B and all Flowers/Base Circles of Motif Type C can be worked complete, then when ready to join, finish motifs in the order that they are to be joined according to Schematic. Alternatively, all motifs can be worked complete and sewn together with preferred method afterward if that is easier.*

Rnd 6: *3 sc in first ch-sp, sc in each st across to next corner ch-sp; rep from * around, join with a sl st in first sc—72 sc.

Type B (Make 5)

Base Circle
Note: *Make 1 each in the following contrast colors: E, C, J, K, D.*

Rnds 1–4: Using contrast color, work Rnds 1–4 of Motif Type A. Fasten off.

Rnds 5 and 6: With RS facing, join A with a sl st in any sc of Rnd 4. Rep Rnds 5 and 6 of Motif A. Fasten off.

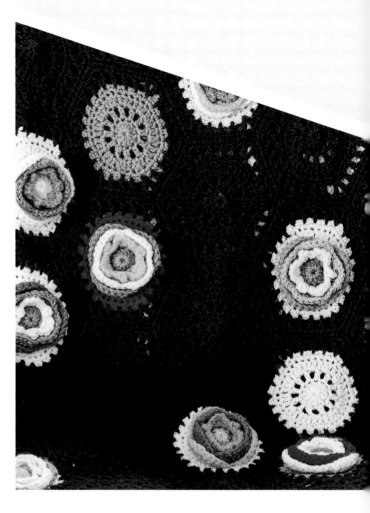

Type C (Make 22)

Note: *Use the Motif Type C Color Sequence Chart to know which colors to use on all 22 Motif Type C.*

Base Circle
Rnds 1–4: With 1st Color as indicated in Color Sequence Chart, work Rnds 1–4 of Motif Type A. Fasten off.

Bottom Petal
Rnds 1 and 2: With 2nd Color, work Rnds 1 and 2 of Motif Type A.

Rnd 3: Sl st in first ch-sp, *2 sc in next ch-sp, hdc in next st, 2 dc in next ch-sp, tr in next st, 3 tr in next ch-sp, tr in next st, 2 dc in next ch-sp, hdc in next st; rep from * twice, join with a sl st in first sc. Fasten off.

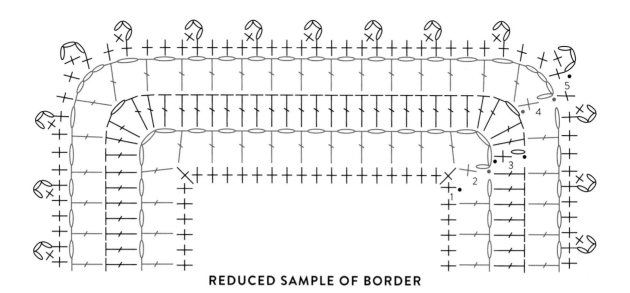

REDUCED SAMPLE OF BORDER

STITCH KEY

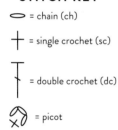

= chain (ch)

= single crochet (sc)

= double crochet (dc)

= picot

Middle Petal

Rnds 1 and 2: Using 3rd Color, work Rnds 1 and 2 of Motif Type A.

Rnd 3: Sl st in first ch-sp, *2 sc in next ch-sp, hdc in next st, 2 dc in next ch-sp, dc in next st, 2 dc in next ch-sp, hdc in next st; rep from * 3 times, join with a sl st in first sc. Fasten off.

Top Petal

Rnd 1: Using 4th Color, work Rnd 1 of Motif Type A. Fasten off, leaving a 12" (30.5 cm) sewing length for assembling flowers later.

Rnd 2: Using 5th Color, (sc, hdc) in first st, *3 dc in next st, (hdc, sc) in next st, (sc, tr, sc) in next st**, (sc, hdc) in next st; rep from * around, ending last rep at **, join with a sl st in first sc. Fasten off.

Assemble Flowers

Draw long tail from Top Petal through any dc from Rnd 1 on both Middle and Bottom Petals and the Base Circle.

Note: *Petal Layers do not line up any certain way, therefore any dc from Rnd 1 can be chosen.*

Working through all 4 pieces, insert hook through next dc on all layers through to the back. Yo with sewing length and draw up loop to front of work. Insert hook through next dc on all pieces, yo, draw loop up and make a sl st. Work sl st in all dc sts around, sealing all layers of flower together.

Repeat until all 22 flowers are complete, attaching 3 Petal layers to the Base Circles for each flower.

Rnds 5 and 6: With RS of Base facing, join A with a sl st in any sc of Rnd 4 of Base Circle. Rep Rnds 5 and 6 of Motif A (see Make Blanket for joining instructions). Fasten off.

Make Blanket

Note: *Use Schematic for motif placement.*

Motif 1

Choose any Type C motif and work Rnds 5 and 6 complete. Fasten off.

Subsequent Motifs

Work Motif Type indicated through Rnd 5.

Rnd 6: (Joining Rnd) Place motif as shown in Schematic, lining up start of Rnd 6 with green dot on Schematic. Work Side 1 (shown in red) and any other plain sides until joining side (marked in blue) as directed in pattern. Join blue side(s) to the adjacent side of the completed motif as follows: Using Join Hexagon Motifs as You Go chart (see Techniques) as a guide, 2 sc in corner before joining side, PLT in corresponding st on completed motif, sc in same corner, (PLT in corresponding st of completed motif, sc in next st) across side to next corner st, sc in corner st, PLT, continue around the hexagon, using the PLT Join for Hexagons chart as a guide for working joining sides, work any rem sides plain. Fasten off.

Half Hexagons

When all hexagons are joined, it is time to work Half Hexagons to fill in the gaps at top and bottom.

Row 1: With A, ch 3, join with a sl st in 3rd ch from hook to form a ring, (Beg dc, 6 dc) in ring, turn—7 dc.

Row 2: Beg dc in first st, *ch 1, dc in next st; rep from * across, turn—7 dc; 6 ch-sp.

Row 3: Beg dc in first st, *2 dc in next ch-sp, dc in next st; rep from * across, turn—19 dc.

Row 4: Sc in first 2 sts, *2 sc in next st**, sc in each of next 2 sts; rep from * across, ending last rep at **, sc in last st, turn—25 sc.

Row 5: (Beg dc, ch 1, dc) in first st, *[ch 1, sk next st, dc in next st] 3 times, ch 1, (dc, ch 1, dc) in next st; rep from * twice, turn—17 dc; 16 ch-sps.

MOTIF TYPE C COLOR SEQUENCE CHART

Motif C Number	Base Circle (Color 1)	Bottom Petal (Color 2)	Middle Petal (Color 3)	Top Petal, Rnd 1 (Color 3)	Top Petal, Rnd 1 (Color 3)
1	D	E	B	K	M
3	K	G	M	I	L
6	C	K	I	E	D
7	E	B	L	I	H
11	B	D	K	J	H
16	F	G	D	E	L
17	G	J	H	C	F
19	M	F	G	D	L
20	B	L	K	G	F
23	J	M	B	H	C
27	G	I	F	J	C
29	D	H	J	L	G
31	H	F	E	B	M
32	G	B	D	F	K
32	J	L	C	H	F
35	C	J	E	I	G
41	K	D	M	G	J
42	I	M	F	B	K
45	E	C	J	F	B
46	I	K	G	L	J
47	F	G	K	L	B
49	L	E	H	C	D

SCHEMATIC

CHART KEY

A = Type A

B = Type B

C = Type C

1, 2, 3… = Motif number

● = Start joining rnd

—— = First side of joining rnd

—— = Joined sides

Row 6: (Joining Row) Place half hexagon in any gap on either side, to join first side, (sc, PLT) in each of first 11 sts or sps, using PLT Join for Hexagons chart to make corner, 3 sc in corner ch-sp, (sc, PLT) in each of next 9 sts or sps to join next side, 3 sc in next corner ch-sp as before, to join last side, (sc, PLT) in each of next 11 sts or sps—37 sc. Fasten off.

Make and join 7 more Half Hexagons in gaps on both sides of piece.

Fill Zigzag Sides

Join A with a sl st in first st on either zigzag side, *sc in next st, hdc in each of next 2 sts, dc in each of next 2 sts, tr in each of next 3 sts, dtr in each of next 3 sts, skip junction between Hexagon Motifs, dtr in each of next 3 sts, tr in each of next 3 sts, dc in each of next 2 sts, hdc in each of next 2 sts, sc in next st, skip next st (center sc of "peak" corner); rep from * across. Fasten off.

Rep on the other side. Do not fasten off.

Border

Rnd 1: (foundation rnd) With RS facing, join A with a sl st in corner before one short side of afghan, *3 sc in corner st, work 119 sc evenly spaced across short side, 3 sc in next corner, work 147 sc evenly spaced across long side; rep from * once, join with a sl st in first sc.

Rnd 2: Sl st in next corner st, (Beg dc, ch 3, dc) in corner sc, *(ch 1, sk next st, dc in next st) across to next corner, ch 1**, (dc, ch 3, dc) in corner st; rep from * around, ending last rep at **, join with a sl st in Beg dc.

Rnd 3: Sl st in first ch-sp, (Beg dc, ch 1, 3 dc) in ch-sp, *dc in each st across to next corner ch-sp**, (3 dc, ch 1, 3 dc) in next ch-sp; rep from * around, ending last rep at **, 2 dc in first corner to complete it, join with a sl st in Beg dc. Fasten off.

Rnd 4: With RS facing, join B with a sl st in any corner, rep Rnd 2.

Rnd 5: Change to smaller hook, *(sc, Picot, sc) in ch-sp, sc in next st, sc in next ch-sp, Picot, (sc in each of next 4 sts or sps, Picot) across to first dc of next corner, sc in first dc of corner; rep from * around, join with a sl st in first sc. Fasten off. Weave in ends.

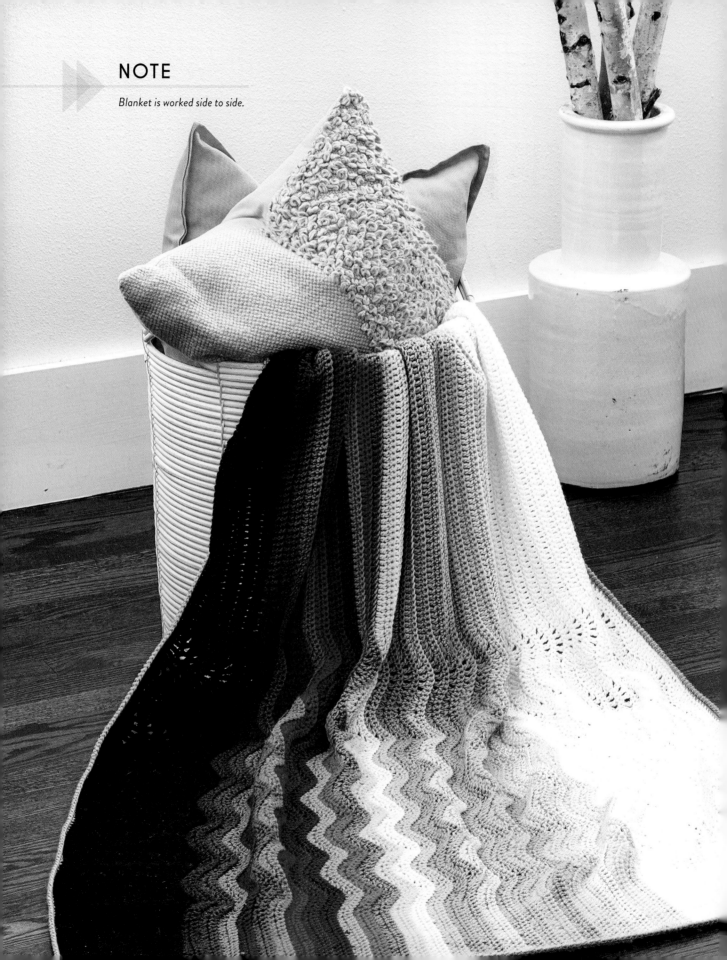

NOTE

Blanket is worked side to side.

LAYERED
Waves

In this project, you will find a slight variation on a traditional design. Flat plains become rolling hills in *Landscape* by Maud Vantours. I could not get the image of a dual straight/ripple blanket out of my mind. This unique pairing, together with the updated side-to-side orientation, injects a modern twist that encourages a gentle microevolution of our art.

FINISHED SIZE
36 × 46" (152 × 162 cm).

YARN
DK weight (#3 light).

Shown here: Scheepjes Merino Soft (50% wool, 25% microfiber, 25% acrylic; 115 yd [105 m]/1¾ [50 g]): 1 ball each of the following colors, unless specified: #601 Pollack (A), 3 balls; #622 Klee (B); #631 Millais (C); #627 Manet (D); #623 Rothko (E); #608 Dali (F); #619 Gauguin (G); #621 Picasso (H); #636 Carney (I); #638 Hockney (J); #635 Matisse (K); #620 Munch (L); #639 Monet (M); #646 Miro (N); #628 Botticelli (O); #633 Bennett (P); #641 Van Gogh (Q); #613 Giotto (R); #625 Kandinsky (S); #604 Lowry (T); #634 Copley (U); #642 Caravaggio (V); #624 Renoir (W); #632 Degas (X); #629 Constable (Y); #610 Turner (Z); #644 Durer (AA); #606 Da Vinci (BB); #600 Malevich (CC), 5 balls.

HOOKS
US size H-8 (5 mm) hook for blanket body.

US size G-6 (4 mm) hook for border.

Adjust hook size if necessary to achieve gauge.

NOTIONS
Tapestry needle.

GAUGE
16 sts and 10 rows in body pattern on either side of wave pattern = 4" (10 cm), with size H-8 (5 mm) hook, blocked.

Row 1: (RS) Using size H-8 (5 mm) hook and A, ch 201, sc in 2nd ch from hook, sc in each ch across, turn—200 sc.

Row 2: Sc in each of first 81 sts, *hdc in next st, dc in each of next 2 sts, tr in each of next 5 sts, dc in each of next 2 sts, hdc in next st, sc in each of next 6 sts; rep from * 5 times, sc in each of next 17 sts, turn—30 tr; 24 dc; 12 hdc; 134 sc.

Row 3: (Pattern Row) Beg dc (see Glossary) in first st, dc in each of next 19 sts, *[dc2tog (see Glossary) over next 2 sts] 3 times, [ch 1, dc in next st] 5 times, ch 1, [dc2tog over next 2 sts] 3 times; rep from * 5 times, dc in each st across, turn.

Row 4: Sc in each st and ch-sp across, turn.

Rows 5–14: Rep Rows 3 and 4. Fasten off.

Row 15: With RS facing, join B with a sl st in back loop of first st, beg dc in same st, working in back loops only (this creates a nice ridge on the RS between each color, mimicking stacked "layers" of cut paper), dc in each of next 19 sts, *dc2tog over next 2 sts (3 times), [ch 1, dc in next st] 5 times, ch 1, dc2tog over next 2 sts (3 times); rep from * 5 times, dc in each st across, turn.

Row 16: Sc in each st and ch-sp across, turn. Fasten off.

Rows 17–70: Using C–CC, working 2 rows of each color, rep Rows 15 and 16, making color stripes. Do not fasten off CC.

Rows 71–96: Working through both loops of sts throughout, with CC only, rep Rows 3 and 4.

Row 97: Beg dc in first st, dc in each of next 19 sts, *hdc in next st, sc in each of next 11 sts, hdc in each of next 2 sts, dc in each of next 2 sts, tr in each of next 2 sts, dc in each of next 2 sts, hdc in next st; rep from * 4 times, hdc in next st, sc in each of next 11 sts, hdc in next st, dc in each st across, turn.

Row 98: Sc in each of first 81 sts. Fasten off. With WS facing, sk next 96 sts, rejoin CC with a sl st in next st, sc in same st, sc in each of rem 22 sts, turn.

Row 99: Beg dc in first st, dc in each of next 22 sts, hdc in each of next 2 sts, sc in each of next 92 sts, hdc in each of next 2 sts, dc in each st across. Fasten off.

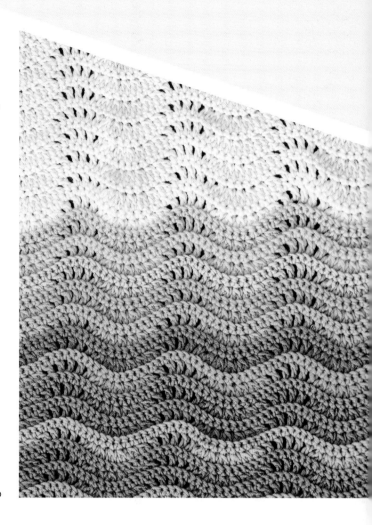

Border

Rnd 1: With size G-6 (4 mm) hook, join T with a sl st in any corner, *3 sc in same st, sc evenly across to next corner; rep from * around, join with a sl st in first sc.

> **TIP**
> *When working into sides of sts, be sure to make 2 sc on the side of a dc st, and 1 sc on the side of each sc st. Work "into" the st, not "around" it, to avoid creating holes down the sides of your piece. Be sure to verify opposing sides of piece have identical number of sc.*

Rnd 2: Working from left to right, reverse sc (see Glossary) in each st around (for nice, rounded corners, join with a sl st in first reverse sc). ***Note:*** *Do not work any extra sts in the corners to leave a neat, rounded corner.* Fasten off. Weave in ends.

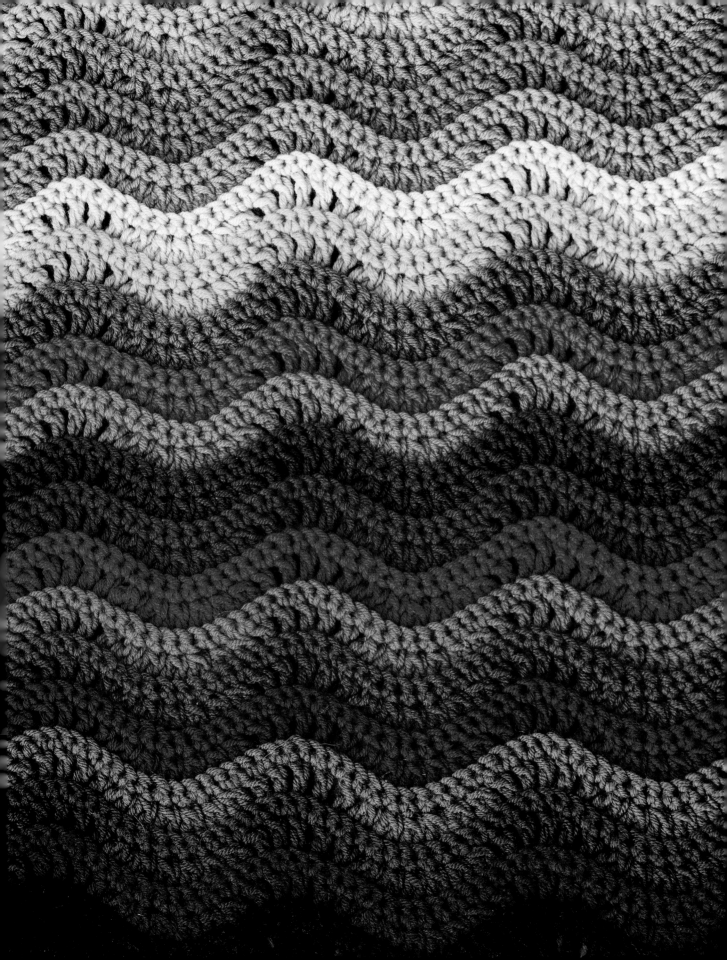

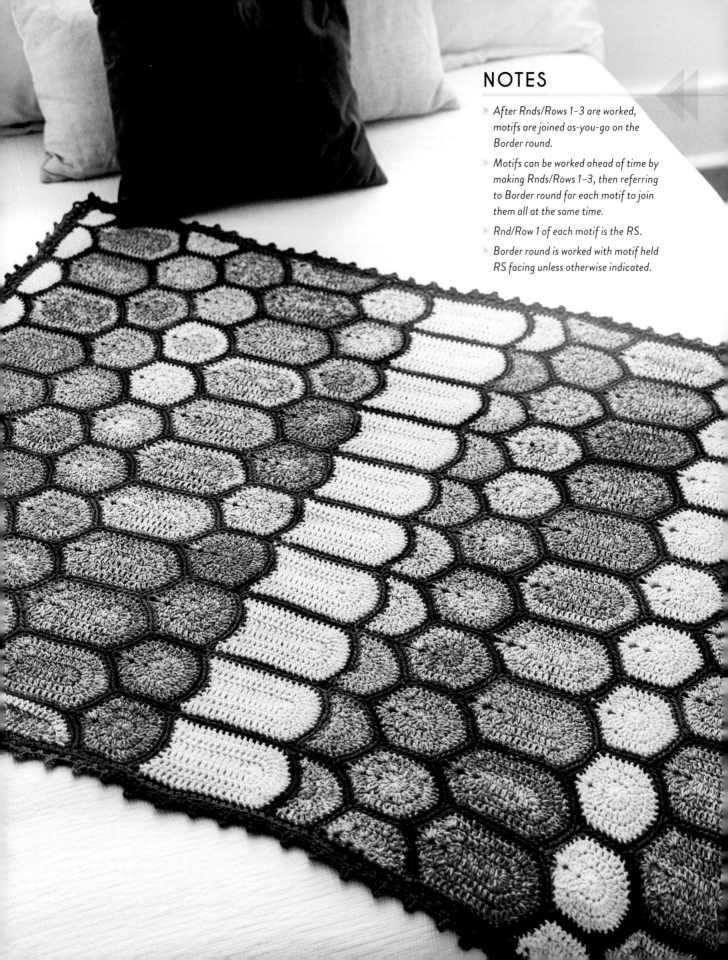

NOTES

▸ After Rnds/Rows 1–3 are worked, motifs are joined as-you-go on the Border round.

▸ Motifs can be worked ahead of time by making Rnds/Rows 1–3, then referring to Border round for each motif to join them all at the same time.

▸ Rnd/Row 1 of each motif is the RS.

▸ Border round is worked with motif held RS facing unless otherwise indicated.

PERFECT *Scallops*

Motifs by Maud Vantours

With six (or twelve) fun, unique motifs and a join-as-you-go method, this blanket certainly has an engaging construction that remains simple enough for a relaxing crochet session. But it's the design and final outcome of this beauty that will grab your attention. Perfect Scallops, inspired by the gorgeous paper-cut art piece *Motifs* by Maud Vantours, is an opulent blanket with neat and tidy finishing.

FINISHED SIZE
39 × 46" (99 × 117 cm).

YARN
DK weight (#3 light).

Shown here: Scheepjes Softfun Aquarel (60% cotton, 40% acrylic; 153 yd [140 m]/1¾ oz [50 g]): #805 (A), 2 balls; #809 (B), 4 balls; #803 (C), 2 balls; #802 (D), 2 balls.

Scheepjes Softfun Denim (60% cotton, 40% acrylic; 153 yd [140 m]/1¾ oz [50 g]): #501 (E), 4 balls.

HOOKS
US size H-8 (5 mm) hook for motifs and joining.

US size G-6 (4 mm) hook for border.

Adjust hook size if necessary to achieve gauge.

NOTIONS
Stitch markers; tapestry needle.

GAUGE
9 sts = 2" (5 cm); 3 rows dc = 1½" (38 mm) using size H-8 (5 mm) hook.

Motif 1

Row 1: With A and size H-8 (5 mm) hook, make a Magic Ring, (Beg dc [see Glossary], 3 dc) in ring, turn—4 dc.

Row 2: Beg dc in first st, 2 dc in each st across, turn—7 dc.

Row 3: Beg dc in first st, *2 dc in next st, dc in next st; rep from * across. Fasten off—10 dc.

Border rnd: With RS facing, join E with a sl st in center ring on bottom of motif, 3 sc in ring, work 5 sc evenly spaced across side to next corner, 3 sc in corner dc, [sc in each of next 2 sts, 2 sc in next st] twice, sc in each of next 2 sts, 3 sc in last st, pm in center sc of this corner, work 5 sc evenly spaced across side to center ring, join with a sl st in first sc—29 sc. Fasten off.

Motifs 2–10

Row 1: With A and size H-8 (5 mm) hook, make a Magic Ring, (Beg dc, 7 dc) in ring, turn—8 dc.

Row 2: Beg dc in first st, 2 dc in each of next 6 sts, dc in last st, turn—14 dc.

Row 3: Beg dc in first st, [2 dc in next st, dc in next st] 3 times, [dc in next st, 2 dc in next st] 3 times, dc in last st—20 dc. Fasten off.

Border rnd: With RS facing, join E with a sl st in first st of Row 3, 2 sc in same st, **PLT** as follows: Drop loop from hook, insert hook front to back in marked st on previous motif, removing marker. Pick up dropped loop and Pull Loop Through to front of work. This joining maneuver will be referred to simply as "PLT" throughout the pattern, sc in the same st again to complete the 3-sc corner, PLT in corresponding st (the next sc) on previous motif, (sc, PLT) in each of next 2 sts, 2 sc in next st, sc in each of next 2 sts, 2 sc in next st, sc in each of next 6 sts, 2 sc in next st, sc in each of next 2 sts, 2 sc in next st, sc in each of next 2 sts, 3 sc in last dc of row, pm in center sc of this corner, work 5 sc evenly spaced across to center ring, sc in center ring, work 5 sc evenly spaced across to beg, join with a sl st in first sc. Fasten off.

Note: Top side of blanket will look uneven after motifs are joined, but first round of border will straighten it.

Motif 11

Rows 1–3: Work same as Motif 1 through Row 3.

Border rnd: Holding motif with WS facing, join E with a sl st in first st of Row 3, sc in same st, PLT in marked st of previous motif, removing marker, (sc, PLT) in same st to complete corner, (sc, PLT) in each of next 2 sts, [2 sc in next st, sc in each of next 2 sts] twice, 3 sc in last dc, pm in center sc of this corner, work 5 sc evenly spaced across side to center ring, 3 sc in center ring, work 5 sc evenly spaced across side to beg, join with a sl st in first sc. Fasten off.

Motif 12

Rnd 1: With B and size H-8 (5 mm) hook, ch 12, 3 dc in 5th ch from hook (beg ch counts as dc, ch 1), dc in each of next 6 ch, 8 dc in last ch, working across opposite side of foundation ch, dc in each of next 6 ch, 2 dc in next ch, join with a sl st in 3rd ch of beg ch-4.

Rnd 2: Sl st in first ch-sp, (Beg dc, ch 1, 2 dc) in same ch-sp, dc2tog over next 2 sts, 3 dc in next st, dc in each of next 7 sts, 2 dc in each of next 6 sts, dc in each of next 7 sts, 3 dc in next st, dc2tog (see Glossary) over next 2 sts, dc in first ch-sp of rnd, join with a sl st in top of Beg dc.

Rnd 3: Sl st in first ch-sp, (Beg dc, ch 1, 3 hdc) in same ch-sp, dc3tog (see Glossary) over next 3 sts, 4 dc in next st, pm in 4th dc, dc in each of next 9 sts, [2 dc in next st, dc in next st] 3 times, [dc in next st, 2 dc in next st] 3 times, dc in each of next 9 sts, 4 dc in next st, dc3tog over next 3 sts, 2 hdc in first ch-sp of rnd, join with a sl st in top of Beg dc. Fasten off.

Border rnd: With RS facing, join E with a sl st in marked st, removing marker, sc in same st, sc in each of next 11 sts, 2 sc in next st, pm in first sc, sc in each of next 2 sts, 2 sc in next st, sc in each of next 6 sts, 2 sc in next st, sc in each of next 2 sts, 2 sc in next 2 sts, pm in 2nd sc to use when joining Motif 22, sc in each of next 12 sts, 2 sc in next st, PLT in marked st on Motif 11, removing marker, sc in same st on current motif, PLT in next st on Motif 11, (sc, PLT) in

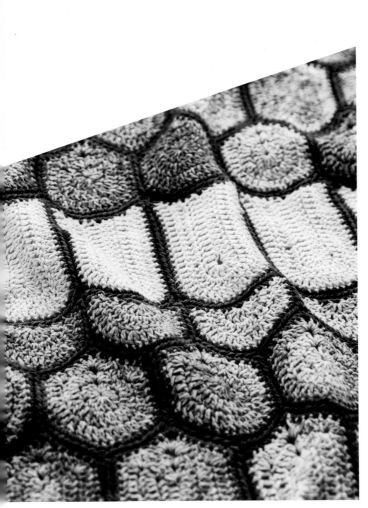

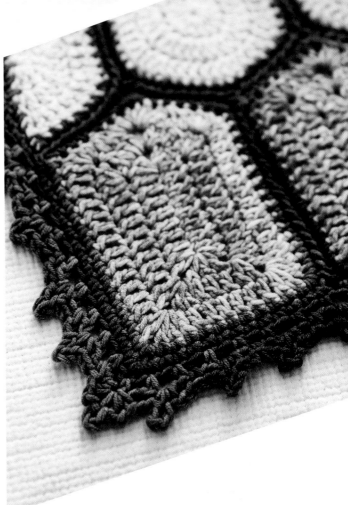

each of next 6 sts, sc in next ch-sp, PLT, sc in same ch-sp, **Join Corner** as follows: drop loop, insert hook front to back in cornermost sc on Motif 10, insert hook back to front in cornermost sc on Motif 11, pick up dropped loop, Pull Loop Through both sts, sc in ch-sp, PLT in next st on Motif 10, (sc, PLT) in each of next 6 sts, (sc, PLT, sc) in next st, join with a sl st in first sc. Fasten off.

Motifs 13–21

Rnds 1–3: Work same as Motif 12 through Rnd 3.

Border rnd: With RS facing, join E with a sl st in marked st, removing marker, sc in same st, sc in each of next 11 sts, 2 sc in next st, pm in first sc, sc in each of next 2 sts, 2 sc in next st, sc in each of next 6 sts, 2 sc in next st, sc in each of next 2 sts, 2 sc in next st, PLT in marked st of previous motif, remove marker, (sc, PLT) in each of next 12 sts, (sc, PLT on previous motif, sc, PLT on corresponding semicircle motif)

all in next st on current motif, (sc, PLT) in each of next 6 sts, sc in next ch-sp, PLT, sc in same ch-sp, Join Corner as before, sc in same ch-sp, PLT, (sc, PLT) in each of next 6 sts, sc in next st, PLT in semicircle motif, sc in same st, join with a sl st in first sc. Fasten off.

Motif 22

Row 1: With D and size H-8 (5 mm) hook, make a Magic Ring, (Beg dc, 6 dc, ch 1, dc) in ring, turn. (8 dc; 1 ch-sp)

Row 2: Beg dc in first st, ch 1, 2 dc in next ch-sp, dc2tog over next 2 sts, 3 dc in next st, dc in next st, 2 dc in each of next 3 sts, turn—14 dc; 1 ch-sp.

Row 3: Beg dc in first st, [2 dc in next st, dc in next st] 3 times, dc in each of next 2 sts, 4 dc in next st, dc3tog over next 3 sts, 3 hdc in first ch-sp, ch 1, dc in last st—18 dc; 3 hdc; 1 ch-sp. Fasten off.

Border rnd: With WS of motif facing, join E with sl st in first dc of Row 3, [sc, PLT] twice in same st, sc in next ch-sp, PLT in next st on Motif 12, (sc, PLT) in each of next 6 sts, (sc, PLT, sc) in next st, sc in each of next 5 sts, 2 sc in next st, pm in first sc, sc in each of next 2 sts, 2 sc in next st, sc in each of next 2 sts, 3 sc in next st, work 12 sc evenly spaced across to beg, join with a sl st in first sc. Fasten off.

Motifs 23–31

Rnd 1: With D and size H-8 (5 mm) hook, make a Magic Ring, (Beg dc, ch 1, 13 dc) in ring, join with a sl st in top of beg dc—14 dc; 1 ch-sp.

Row 2: Sl st in first ch-sp, (Beg dc, ch 1, 2 dc) in same ch-sp, dc2tog over next 2 sts, 3 dc in next st, dc in next st, 2 dc in each of next 6 sts, dc in next st, 3 dc in next st, dc2tog over next 2 sts, dc in next ch-sp of rnd, join with a sl st in top of Beg dc.

Rnd 3: Sl st in first ch-sp, (Beg dc, ch 1, 3 hdc) in same ch-sp, dc3tog over next 3 sts, 4 dc in next st, pm in 4th dc, dc in each of next 3 sts, [2 dc in next st, dc in next st] 3 times, [dc in next st, 2 dc in next st] 3 times, dc in each of next 3 sts, 4 dc in next st, dc3tog over next 3 sts, 2 hdc in next ch-sp of rnd, join with a sl st in top of Beg dc. Fasten off.

Border rnd: With RS facing, join E with a sl st in marked st, removing marker, sc in same st, sc in each of next 5 sts, 2 sc in next st, pm in first sc, sc in each of next 2 sts, 2 sc in next st, sc in each of next 6 sts, 2 sc in next st, sc in each of 2 sts, 2 sc in next st, PLT in marked st, removing marker, (sc, PLT) in each of next 5 sts, (sc, PLT on previous motif, sc, PLT on semicircle motif) in next st, (sc, PLT) in each of next 6 sts, sc in next ch-sp, PLT, sc in same ch-sp, Join Corner as before, sc in same ch-sp, PLT, (sc, PLT) in each of next 6 sts, sc, PLT in semicircle motif, sc in same st, join with a sl st in first sc. Fasten off.

Motif 32

Rows 1–3: Work as for Motif 22 through Rnd 3.

Border rnd: With RS of motif facing, work same as Motif 22 Border.

Motif 33

Rows 1–3: Work same as Motif 23 through Row 3.

Border rnd: With RS facing, join E with a sl st in marked st, removing marker, sc in same st, sc in each of next 5 sts, 2 sc in next st, pm in first sc, sc in each of next 2 sts, 2 sc in next st, sc in each of next 6 sts, 2 sc in next st, sc in each of next 2 sts, 2 sc in next st, pm in 2nd sc, sc in each of next 5 sts, 2 sc in next st, PLT in marked st on Motif 22, removing marker, sc in same st, PLT in next st on Motif 23, (sc, PLT) in each of next 6 sts, sc in next ch-sp, PLT, sc in same ch-sp, **Join Corner** as follows, drop loop, insert hook front to back in cornermost sc on Motif 22, insert hook back to front in cornermost sc on Motif 23, pick up dropped loop, Pull Loop Through both sts, sc in same ch-sp, PLT in next st on Motif 23, (sc, PLT) in each of next 6 sts, (sc, PLT, sc) in next st, join with a sl st in first sc. Fasten off.

Motifs 34–42

Work as for Motif 23.

Motif 43

Row 1: With B and size H-8 (5 mm) hook, ch 12, 3 dc in 5th ch from hook (beg ch-4 counts as dc, ch 1), dc in each of next 6 ch, 4 dc in last ch, turn.

Rnd 2: (Beg dc, dc) in first st, 2 dc in each of next 2 sts, dc in each of next 7 sts, 3 dc in next st, dc2tog over next 2 sts, 2 dc in next st, ch 1, dc in last st, turn.

Rnd 3: Sl st in first ch-sp, (Beg dc, ch 1, 3 hdc) in same ch-sp, dc3tog over next 3 sts, 4 dc in next st, dc in each of next 9 sts, [2 dc in next st, dc in next st] 3 times. Fasten off.

Border rnd: With WS of motif facing, join E with a sl st in first dc of Row 3, (sc, PLT) twice in same st, sc in ch-sp, PLT in next st on Motif 33, (sc, PLT) in each of next 6 sts, (sc, PLT, sc) in next st, sc in each of next 11 sts, 2 sc, pm in first sc, sc in each of next 2 sts, 2 sc in next st, sc in each of next 2 sts, 3 sc in next st, work 23 sc evenly spaced across to beg, join with a sl st in first sc. Fasten off.

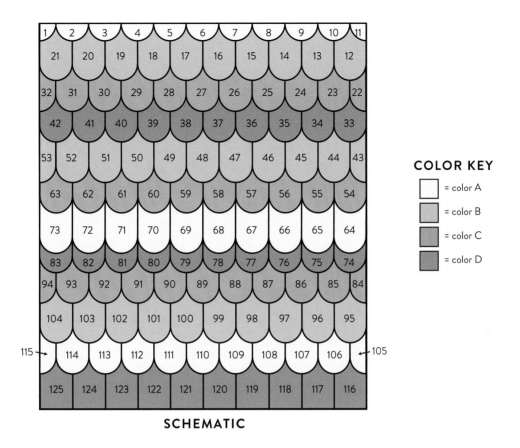

SCHEMATIC

COLOR KEY

☐ = color A
▢ = color B
▢ = color C
▢ = color D

Motifs 44–52

Work same as Motif 13.

Motif 53

Rows 1–3: Work same as Motif 43 through Rnd 3.

Border rnd: With RS facing, work same as Motif 43 Border.

Motif 54–63

With D, work same as Motifs 33–42.

Motif 64

Row 1: With A and size H-8 (5 mm) hook, ch 16, dc in 3rd ch from hook (beg ch-2 does not count as a st), dc in each of next 12 ch, 8 dc in last ch, working across opposite side of foundation ch, dc each of last 13 ch, turn—34 dc.

Row 2: (Beg dc, dc) in first st, dc in each of next 13 sts, 2 dc in each of next 6 sts, dc in each of next 13 sts, 2 dc in last st, turn.—42 dc.

Row 3: (Beg dc, dc) in first st, dc in each of next 14 sts, [2 dc in next st, dc in next st] 3 times, [dc in next st, 2 dc in next st] 3 times, dc in each of next 14 sts, 2 dc in last st. Fasten off—50 dc.

Border rnd: With RS of motif facing, join E with a sl st in top of first dc of Row 1, sc in each of next 16 sts, 2 sc in next st, pm in first sc, sc in each of next 2 sts, 2 sc in next st, sc in each of next 6 sts, 2 sc in next st, sc in each of next 2 sts, 2 sc in next st, sc in each of next 16 sts, (sc, PLT) evenly spaced across all sts of semicircle portion of motif 54, sc in last st, join with a sl st in first sc. Fasten off.

Motifs 65–73

Rows 1–3: Work same as Motif 64 through Row 3.

Border rnd: With RS of motif facing, join E with a sl st in top of first dc of Row 1, sc in each of next 16 sts, 2 sc in next st, sc in each of next 2 sts, 2 sc in next st, sc in each of next 6 sts, 2 sc in next st, sc in each of next 2 sts, 2 sc in next st, PLT in marked st, removing marker, (sc, PLT) in each of next 16 sts, (sc, PLT evenly spaced across all sts of semicircle portion of corresponding motif) sc in last st, join with a sl st in first sc. Fasten off.

Motif 74

Row 1: With C and size H-8 (5 mm) hook, make a Magic Ring, (Beg dc, 7 dc) in ring, turn. (8 dc)

Row 2: (Beg dc, dc) in first st, 2 dc in each st across, turn. (16 dc)

Row 3: (Beg dc, dc) in first st, dc in next st, [2 dc in next st, dc in next st] 3 times, [dc in next st, 2 dc in next st] 4 times. Fasten off.

Border rnd: With RS of motif facing, join E with a sl st in top of first dc of Row 3, sc in each of first 5 sts, 2 sc in next st, pm in first sc, 2 sc in next st, sc in each of next 6 sts, 2 sc in next st, sc in each of next 2 sts, 2 sc in next sts, sc in each of next 5 sts, (sc, PLT) evenly spaced across all sts of semicircle portion of motif 64), join with a sl st in first sc. Fasten off.

Motifs 75–83

Rows 1–3: Work same as Motif 74 through Row 3.

Border rnd: With RS of motif facing, join E with a sl st in top of first dc of Row 1, sc in each of first 5 sts, 2 sc in next st, pm in first sc, sc in each of next 2 sts, 2 sc in next st, sc in each of next 6 sts, 2 sc in next st, sc in each of next 2 sts, 2 sc in next sts, (sc, PLT) in each of next 5 sts, (sc, PLT) evenly spaced across all sts of semicircle portion of corresponding motif), join with a sl st in first sc. Fasten off.

Motifs 84–94

Work same as Motifs 22–32.

Motifs 95–104

Work same as Motifs 12–21.

Motifs 105–115

With A, work same as Motifs 22–32.

Motif 116

Rnd 1: With C and size H-8 (5 mm) hook, ch 12, 3 dc in 5th ch from hook (beg ch-4 counts as dc, ch 1), dc in each of next 6 ch, (2 dc, ch 1, 3 dc, ch 1, 2 dc) in last ch, working across opposite side of foundation ch, dc in each of next 6 ch, 2 dc in next ch, join with a sl st in same ch as first 3 dc—25 dc; 3 ch-sps.

Rnd 2: Sl st in first ch-sp, (Beg dc, ch 1, 2 dc) in same ch-sp, dc2tog over next 2 sts, 3 dc in next st, dc in each of next 8 sts, (2 dc, ch 1, 2 dc) in next ch-sp, dc in each of next 3 sts, (2 dc, ch 2, 2 dc) in next ch-sp, dc in each of next 8 sts, 3 dc in next st, dc2tog over next 2 sts, dc in first ch-sp of rnd, join with a sl st in top of Beg dc—39 dc; 3 ch-sps.

Rnd 3: Sl st in first ch-sp, (Beg dc, ch 1, 3 hdc) in same ch-sp, dc3tog over next 3 sts, 4 dc in next st, pm in 4th dc, dc in each of next 12 sts, (2 dc, ch 2, 2 dc) in next ch-sp, dc in each of next 7 sts, (2 dc, ch 2, 2 dc) in next ch-sp, dc in each of next 12 sts, 4 dc in next st, dc3tog over next 3 sts, 2 hdc in first ch-sp of rnd, sl st in top of Beg dc. Fasten off.

Border rnd: With RS facing, and point facing up, join E with a sl st in bottom left-hand corner ch-sp, 3 sc in the same corner ch-sp, sc in each of next 11 sts across to next corner ch-sp, 3 sc in corner ch-sp, sc in each of next 15 sts, 2 sc in next st, PLT on adjacent corner st on Motif 105, sc in same st as previous, PLT, (sc, PLT) in each of next 6 sts, sc in next ch-sp, PLT, sc in same ch-sp, Join Corner as before, sc in next ch-sp, PLT, (sc, PLT) in each of next 7 sts, sc in same st as first st, sc in each of next 15 sts, join with a sl st in first st. Fasten off.

Motifs 117–125

Rnds 1–3: Work same as Motif 116 through Row 3.

Border rnd: With RS facing, and point facing up, join E with a sl st in bottom left-hand corner ch-sp, 3 sc in the same corner ch-sp, sc in each of next 11 sts across to next corner ch-sp, (2 sc, PLT in adjacent motif corner st, sc in same corner, PLT on adjacent motif, (sc, PLT) in each of next 14 sts,

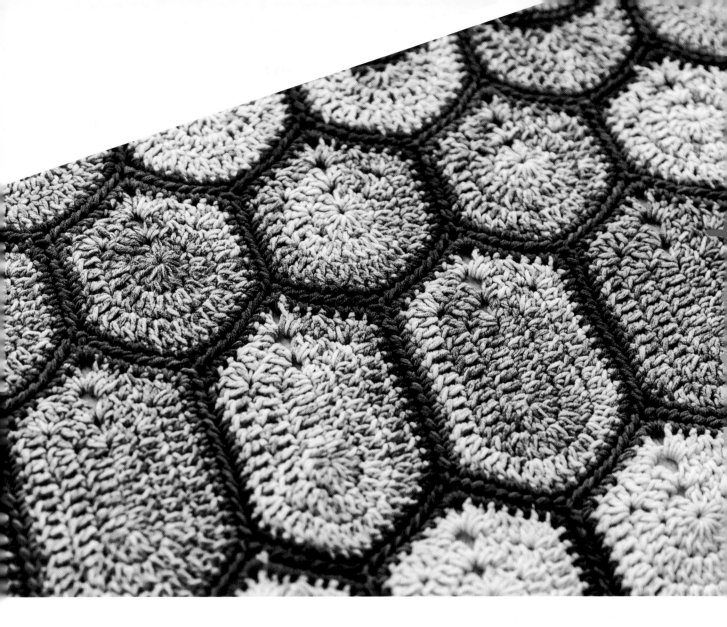

2 sc in next st, PLT on adjacent corner st on corresponding motif, sc in same st as previous sc, PLT, (sc, PLT) in each of next 6 sts, sc in next ch-sp, PLT, sc in same ch-sp, Join Corner as before, sc in same ch-sp, PLT, (sc, PLT) in each of next 6 sts, sc in same st as previous sc, sc in each of next 14 sts, join with a sl st in first sc. Fasten off.

Border

Rnd 1: With RS facing and size G-6 (4 mm) hook, join E with a sl st in any corner, *3 sc in corner st, sc evenly across to next corner, (working a multiple of 3 plus 1 sts); rep from * around, join with a sl st in first sc.

Rnd 2: Sl st in next st, *(sc, ch 2, sc) in corner st, (ch 1, sk next st, sc) across to next corner, ch 1; rep from * around, join with a sl st in first sc. ***Note:*** *There should be an odd number of ch-sps on each side.*

Rnd 3: Sl st in next corner ch-sp, *(sc, ch 2, sc, ch 4, sc, ch 2, sc) in corner ch-sp, ch 2, sc in next ch-sp, ch 2, (sc, ch 4, sc) in next ch-sp; rep from * across to within last ch-sp before corner, ch 2, sc in next ch-sp, ch 2; rep from * around, join with a sl st in first sc. Fasten off.

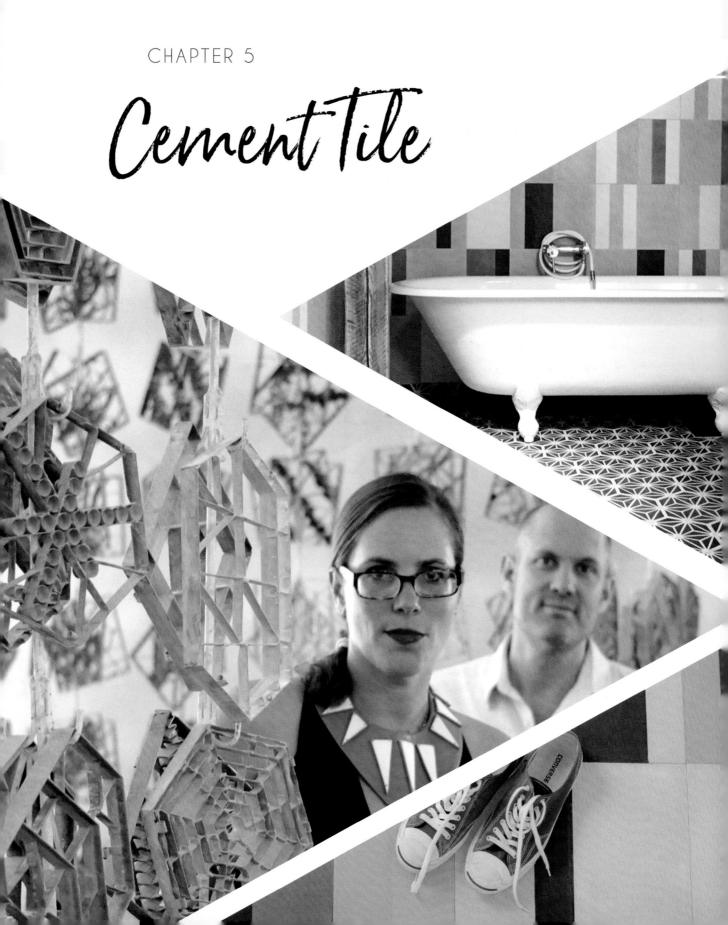

CHAPTER 5

Cement Tile

CAITLIN DOWE-SANDES

THE ARTIST

Caitlin Dowe-Sandes and her husband, Samuel, founded the cement-tile company Popham Design, based in the North African country of Morocco. In keeping with the local style of architecture and design, the company's tile decor picks up on bold earth tones and simple, clean lines. Caitlin takes pride in her team of artisans, who not only create beautiful handmade cement tiles, but embody the cultural and artistic identity of Morocco. With the focus frequently being the couple's bungalow, which is well decorated with many of her own creations, Caitlin's work has been featured in magazine publications more than one hundred times.

THE INSPIRATION

Unlike the colorful, bright, and intricate patterns that provided inspiration in the previous chapters, cement tile inhabits a more muted realm, defined by bold, earthy tones and large, expansive motifs. Interest in laying rich and interesting floor-tile designs is growing, and tile designers like Caitlin Dowe-Sandes influence the cement tile industry daily, Caitlin in particular with her allegiance to the Moroccan aesthetic and culture, and a longing to preserve the art deco movement.

As a crochet blanket pattern designer, I see potential blankets everywhere I look, and the bold, repetitive shapes with simple geometry and clean lines that Caitlin and her team create are the perfect blanket-design inspiration. Traditional Moroccan art culture often features smooth surfaces and streamlined geometric shapes. The Dowe-Sandes team has fused this look with a modern, updated style.

For the designs in this chapter, I chose three tile lines from Popham Design and drew inspiration from the large shapes. I used earth-toned, neutral yarn colors and lightly textured stitches to mimic the surface of flooring on a large scale, and I translate the idea of large tile shapes to generously sized motifs with long lines and smooth edges. Stone Path, inspired by *Tate,* features a tiling of repeated rectangles. Moroccan Tile draws from the gathering of a few of Caitlin's designs, such as *Zigzag* and *Envelope.* The Northerner, influenced by *Honeycomb Hex,* is built on a fresh and simple hexagon tile motif.

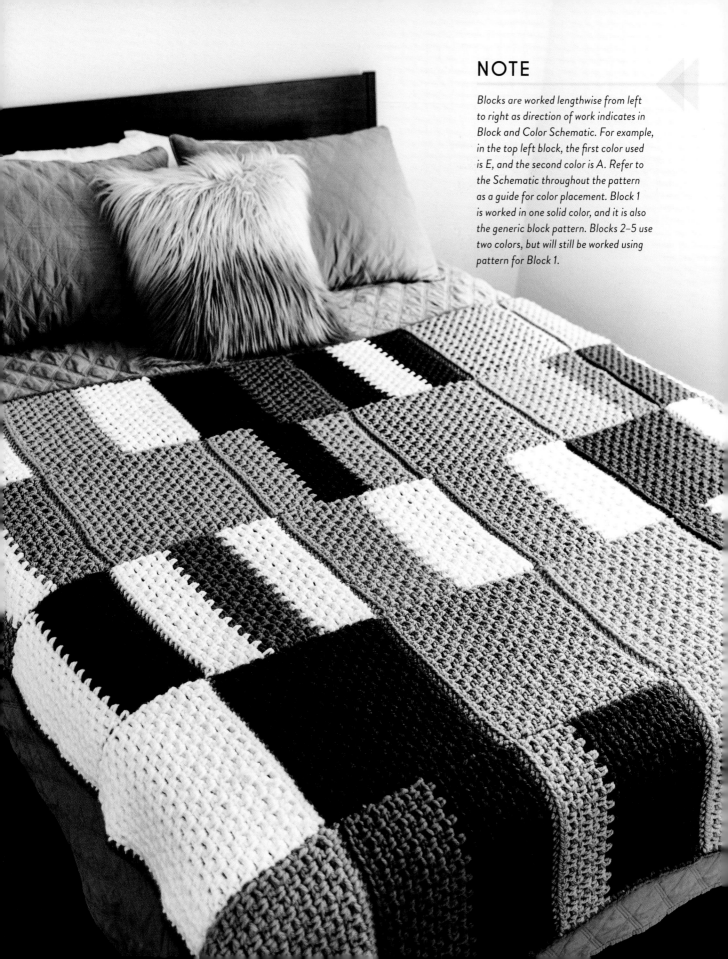

NOTE

Blocks are worked lengthwise from left to right as direction of work indicates in Block and Color Schematic. For example, in the top left block, the first color used is E, and the second color is A. Refer to the Schematic throughout the pattern as a guide for color placement. Block 1 is worked in one solid color, and it is also the generic block pattern. Blocks 2–5 use two colors, but will still be worked using pattern for Block 1.

STONE *Path*

Sometimes I like a slow-moving, complex pattern with a fine gauge, and other times I just want to pull out a huge hook and whip up something simple, chic, and superchunky. Stone Path is inspired by Caitlin Dowe-Sandes's cement-tile walkway design, which features clean lines and a stylish, sophisticated palette. For this project, I chose linen stitch because it yields a lightly textured look, echoing the stone, and when worked in a bulky yarn it makes a weighty piece perfect for sleeping late in snowy weather.

FINISHED SIZE
65 × 72" (165 × 183 cm).

YARN
Superbulky weight (#6 superbulky).

Shown here: Scheepjes Roma Big (100% acrylic; 144 yd [132 m]/7¾ oz [220 g]): #56 (A), #4 (B), #2 (C), #1 (D), #23 (E), 4 balls each.

HOOKS
US size N/P-15 (10 mm) hook for blanket blocks and joining.

US size M-13 (9 mm) hook for border.

Adjust hook size if necessary to achieve gauge.

NOTIONS
Tapestry needle.

GAUGE
8 sts and 7 rows = 4" (10 cm), in linen stitch with size N/P-15 (10 mm) hook, blocked.

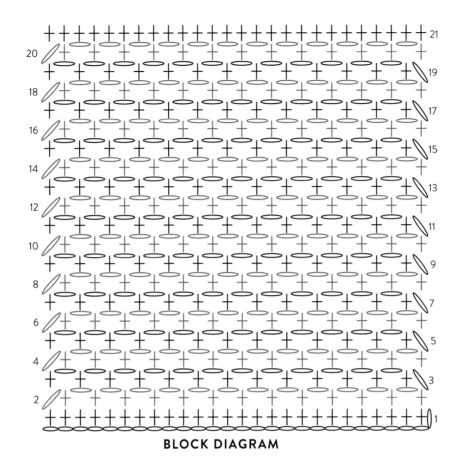

BLOCK DIAGRAM

STITCH KEY

⬯ = chain (ch)

╋ = single crochet (sc)

Block 1 (Make 10)

Row 1: With color indicated and size N/P-15 (10 mm) hook, ch 27, sc in 2nd ch from hook, sc in each ch across, turn—26 sc.

Row 2: *Ch 1, sk next st, sc in next st; rep from * across, turn—13 sc; 13 ch.

Row 3: (Pattern Row) *Ch 1, sk next st, sc in next ch-sp; rep from * across, turn—13 sc; 13 ch.

Rows 4–20: Rep Row 3.

Row 21: Sc in each st and ch-sp across. Fasten off. Weave in ends—26 sc.

Block 2 (Make 6)

Rows 1–7: With first color indicated and size N/P-15 (10 mm) hook, work same as Block 1. Fasten off.

Rows 8–14: Join second color with a sl st in first sc, work same as Block 1. Fasten off.

Rows 15–21: Rejoin first color with a sl st in first sc, work same as Block 1. Fasten off. Weave in ends.

Block 3 (Make 4)

Rows 1–7: With first color indicated and size N/P-15 (10 mm) hook, work same as Block 1. Fasten off.

Rows 8–21: Join 2nd color with a sl st in first sc, work same as Block 1. Fasten off. Weave in ends.

Block 4 (Make 9)

Rows 1–10: With first color indicated and size N/P-15 (10 mm) hook, work same as Block 1. Fasten off.

Rows 11–21: Join 2nd color with a sl st in first sc, work same as Block 1. Fasten off. Weave in ends.

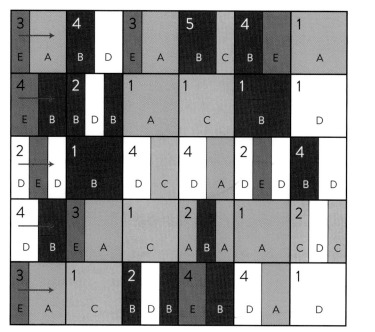

SCHEMATIC

CHART KEY

□ = Block

| = Color change

→ = Direction of work

1, 2, 3 ... = Block type

■ = #56 salmon (A)

■ = #3 anthracite gray (B)

■ = #2 mouse gray (C)

□ = #1 white (D)

■ = #23 deer brown (E)

Block 5 (Make 1)

Rows 1–14: With first color indicated and size N/P-15 (10 mm) hook, work same as Block 1. Fasten off.

Rows 15–21: Join 2nd color with a sl st in first sc, work same as Block 1. Fasten off. Weave in ends.

Joining the Blocks

Lay out blocks as shown on the Schematic.

Work the joins with E, using size N/P-15 (10 mm) hook. Working in vertical columns then horizontal rows, join blocks by working sl st on the WS through back loops only as follows:

Pick up 2 adjacent blocks and, holding RS together, sl st through outside loops across. Without fastening off, pick up next pair of blocks and continue in this manner down the piece until the end of the final block is reached. Cut yarn and weave in ends. Join each subsequent column of blocks until all vertical columns are joined.

Rotate the piece to join horizontal rows in the same manner. When all squares are joined, it is time to work the simple border.

> **TIP**
> *When working horizontal joins and crossing over the vertical joins, work one chain to "cross over" the vertical join. If this chain is omitted, the blanket may pull or pucker at the corners where four blocks meet.*

Border

Using size M-13 (9 mm) hook, with RS facing, join E with a sl st in any corner, 3 sc in same st, sc evenly in all sts and sps around, working 3 sc in each corner, join with a sl st in first sc. Fasten off. Weave in ends.

> **TIP**
> *On sides where sc is worked into sides of rows, be sure to put 1 sc in side of every row. Be sure to verify opposing sides of piece have identical number of sc.*

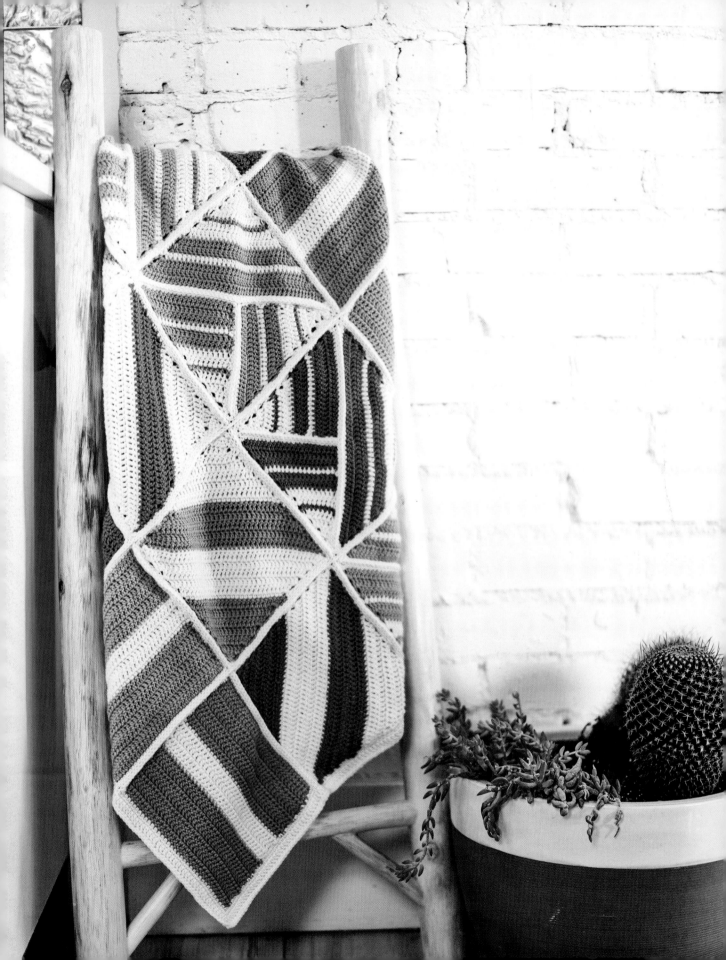

MOROCCAN *Tile*

Nothing updates a room like fresh, new flooring—especially if it's a beachy beauty like these cement tiles by designer Caitlin Dowe-Sandes. The tile medley that caught my eye includes her *Envelope* and *Zigzag* styles that I incorporated into this unique piece. As it turns out, a fresh, new blanket with a radiant palette will update a room, too! Create this piece using two colors for a striking effect.

FINISHED SIZE
39 × 46" (99 × 117 cm).

YARN
DK weight (#3 light).

Shown here: Cascade 220 Superwash (100% superwash wool; 220 yd [200 m]/3½ oz [100 g]): #817 Aran (MC), 10 balls; #846 Blue (A), #884 Skyline Blue (B), #883 Puget Sound (C), 4 balls each.

HOOKS
US size G-6 (4.25 mm) hook for motifs.

US size F-5 (3.75 mm) hook for border.

Adjust hook size if necessary to achieve gauge.

NOTIONS
Tapestry needle.

GAUGE
16 sts and 12 rows = 4" (10 cm) in dc, using size G-6 (4.25 mm) hook, blocked.

STITCH GUIDE

Beg dec
Beg dc (does not count as a st), sk 1, dc in next st.

End dec
Yo, insert hook in next st, yo, pull up loop, YO, draw yarn through 2 loops on hook, yo twice, sk 1, insert hook into next st, yo, pull up loop, (yo, draw yarn through 2 loops on hook) twice, yo, draw yarn through all 3 loops on hook.

Motif 1

Note: Make 12 with MC and Contrast Color [CC] A, B, or C as shown on Schematic.

Row 1: (WS) With size G-6 (4.25mm) hook and CC, ch 38 somewhat loosely, dc in 4th ch from hook (turning ch counts as 1 dc), dc in each ch across, turn—36 dc.

Rows 2–7: Beg dc (see Glossary) in first st, dc in each st across, turn. Fasten off after Row 7.

Row 8: With RS facing, join MC with a sl st in first st, sc in same st, sc in each st across, turn—36 sc.

Rows 9–11: Rep Row 2.

Row 12: Sc in each st across. Fasten off.

Rows 13–19: With WS facing, join same CC with a sl st in first st, rep Row 2. Fasten off.

Motif border rnd: With RS facing, join MC with a sl st in first st of Row 19, *3 sc in same st, sc in each st across, 3 sc in last st of row, work 34 sc evenly spaced across next side; rep from * once, join with a sl st in first sc. Fasten off.

Motif 2

Note: Make 12 with MC and CC A, B, or C as shown on Schematic.

Row 1: (WS) With CC, ch 3, sl st in 3rd ch from hook to form a ring, (Beg dc, ch 1, 3 dc, ch 1, tr) in ring, turn—4 dc; 1 tr; 2 ch-sps.

Rows 2–7: Beg dc in first st, ch 1, 2 dc in next ch-sp, dc in each st across to next ch-sp, 2 dc in next ch-sp, ch 1, tr in last st, turn—28 dc; 1 tr; 2 ch-sps. Fasten off.

Row 8: With RS facing, join MC with a sl st in first st, sc in same st, ch 1, sk next ch, sc in each st across to ch-sp, ch 1, sc in last st, turn—30 sc; 2 ch-sps.

Rows 9–13: Rep Row 2—48 dc; 1 tr; 2 ch-sps at end of Row 13.

Row 14: Sk first st, sc in next ch-sp, sc in each st across to next ch-sp, sc in next ch-sp, turn, leaving last st unworked—49 sc. Fasten off.

Row 15: With WS facing, join same CC with a sl st in first st, Beg dec (see Stitch Guide) over first 3 sts, dc in each st across to last 3 sts, work end dec over last 3 sts, turn—45 sts.

Rows 16–19: Beg dec over first 3 sts, dc in each st across to last 3 sts, work end dec over last 3 sts, turn—29 sts at end of Row 19. Fasten off.

Row 20: With RS facing, join MC with a sl st in first st, sc in each st across, turn—29 sc.

Rows 21–26: Rep Row 16—5 sts at end of Row 26.

Row 27: Beg dc, dc4tog (see Glossary) over next 4 sts, ch 1 and pull ch closed to secure final st, turn. Do not fasten off.

Motif border rnd: *3 sc in corner st, work 34 sc evenly spaced across next side; rep from * around, join with a sl st in first sc. Fasten off.

Motif 3

Note: Make 6 with MC and CC A, B, or C as shown on Schematic.

Large Triangle (Make 1)

Row 1: (RS) With MC, ch 3, sl st in 3rd ch from hook to form a ring, (Beg dc, ch 1, 3 dc, ch 1, tr) in ring, turn—4 dc; 1 tr; 2 ch-sps.

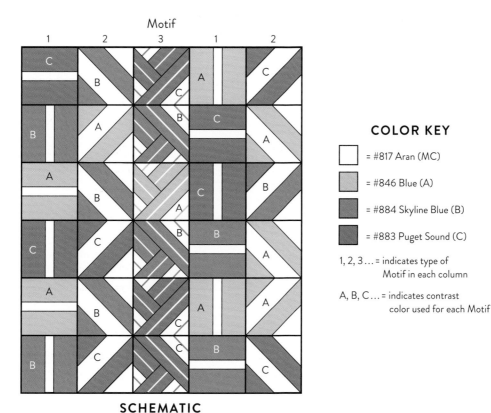

Motif

SCHEMATIC

COLOR KEY

☐ = #817 Aran (MC)

▨ = #846 Blue (A)

▨ = #884 Skyline Blue (B)

■ = #883 Puget Sound (C)

1, 2, 3… = indicates type of
Motif in each column

A, B, C… = indicates contrast
color used for each Motif

Rows 2–4: Beg dc in first st, ch 1, 2 dc in next ch-sp, dc in each st across to next ch-sp, 2 dc in next ch-sp, ch 1, tr in last st, turn—16 dc; 1 tr; 2 ch-sps at end of Row 4. Fasten off.

Row 5: With RS still facing, join CC with sl st in first st, Beg dc in first st, ch 1, hdc in next ch-sp, hdc in each st across to next ch-sp, hdc in next ch-sp, ch 1, hdc in last st, turn—1 dc; 18 hdc; 2 ch-sps. Fasten off.

Row 6: With WS facing, join MC with a sl st in first st, rep Row 2, turn—22 dc; 1 tr; 2 ch-sps.

Row 7: Rep Row 2—26 dc; 1 tr; 2 ch-sps. Fasten off.

Rows 8 and 9: With CC, rep Row 2—34 dc; 1 tr; 2 ch-sps. Fasten off.

Row 10: With RS facing, join MC with a sl st in first st, rep Row 5—1 dc; 36 hdc; 2 ch-sps. Fasten off.

Rows 11–13: With CC, rep Row 2—47 dc; 1 tr; 2 ch-sps. Fasten off.

Row 14: With RS facing, join MC with a sl st in first st, sc in same st, sc in next ch-sp, sc in each st across to next ch-sp, sc in next ch-sp, sc in last st. Fasten off, leaving a sewing length about 3 times the length of diagonal.

Small Triangle

Note: *Make 2 with MC and CC A, B, or C as shown on Schematic.*

Row 1: (RS) With MC, ch 3, sl st in 3rd ch from hook to form a ring, (Beg dc, ch 1, tr) in ring, turn—1 dc; 1 tr; 1 ch-sp.

Row 2: Beg dc in first st, ch 1, 2 dc in next ch-sp, dc in each st across, turn—4 dc; 1 ch-sp.

Row 3: Beg dc in first st, dc in each st across to ch-sp, 2 dc in next ch-sp, ch 1, tr in last st, turn—6 dc; 1 ch-sp.

Row 4: Rep Row 2—8 dc; 1 ch-sp. Fasten off.

Row 5: With RS facing, join CC with a sl st in first st, Beg dc in first st, hdc in each st across to next ch-sp, hdc in next ch-sp, ch 1, dc in last st, turn—7 hdc; 2 dc; 1 ch-sp. Fasten off.

Row 6: With WS facing, join MC with a sl st in first st, rep Row 2—11 dc; 1 ch-sp.

Row 7: Rep Row 3—13 dc; 1 ch-sp. Fasten off.

Rows 8 and 9: With CC, rep Rows 6 and 7—17 dc; 1 ch-sp at end of Row 9. Fasten off.

Row 10: With RS still facing, join MC with a sl st in first st, rep Row 5—16 hdc; 2 dc; 1 ch-sp. Fasten off.

Rows 11–13: With CC, Rep Rows 2–3, then rep Row 2—24 dc; 1 ch-sp at end of Row 13.

Border row: With RS facing, join MC with a sl st in ring, work 24 sc evenly spaced across side edge to top of beg dc in Row 13, 3 sc in top of Beg dc, sc in each st across to next ch-sp, sc in next ch-sp, sc in last st. Fasten off, leaving a long sewing length for joining. Arrange Triangles as shown in Schematic.

Join Small Triangles

Hold small triangles with wrong sides together and locate the long tail for joining. Being careful to match up stitches of Border row as you go, sl st across, working through back loops only (inside loops). Fasten off.

Join Large Triangle to Make the Square Motif

Holding pieces with wrong sides together, locate long tail for joining, sl st across, working through back loops only (inside loops) as before. Fasten off.

Motif 3 border rnd: With RS facing, join MC with a sl st in any corner, *3 sc in corner, work 34 sc evenly spaced across to next corner; rep from * around, join with a sl st in first sc. Fasten off.

Assemble Blanket

Using Schematic as a guide, lay out squares. Using MC, join motifs with a sl st join, just as pieces of Motif 3 were joined together. Work first in vertical rows joining motifs and then in horizontal rows as folls: Pick up 2 adjacent motifs and, holding wrong sides together, sl st through inside loops across, being careful to match up sts as you go. ***Note:*** *You will be working through the BLO of both squares. Without breaking yarn, pick up next pair of motifs and continue in this manner down the piece until the edge of the blanket is reached.* Fasten off and weave in ends. Join each subsequent column of squares, until all vertical columns are joined.

Rotate the piece to join horizontal rows in the same manner. When all squares are joined, it is time to work the simple border.

> **TIP**
> *When working horizontal joins and crossing over the vertical joins, work one chain to "cross over" the vertical join. If this chain is omitted, the blanket may pull or pucker at the corners where four blocks meet.*

Border

Rnd 1: With size F-5 (3.75 mm) hook, join MC with a sl st in any corner, *3 sc in corner st, sc evenly across side, being sure to place 23 sc across each block; rep from * around, join with a sl st in first sc.

Rnd 2: Sl st in next sc, (Beg dc, ch 2, 2 dc) in corner st, *dc in each st across to next corner st**, (2 dc, ch 2, 2 dc) in next corner st; rep from * around, ending last rep at **, dc in first corner sc to complete corner, join with a sl st in top of Beg dc.

Rnd 3: Sl st in first corner ch-sp, *3 sc in corner ch-sp, sc in each st across to next ch-sp; rep from * around, join with a sl st in first sc. Fasten off. Weave in ends.

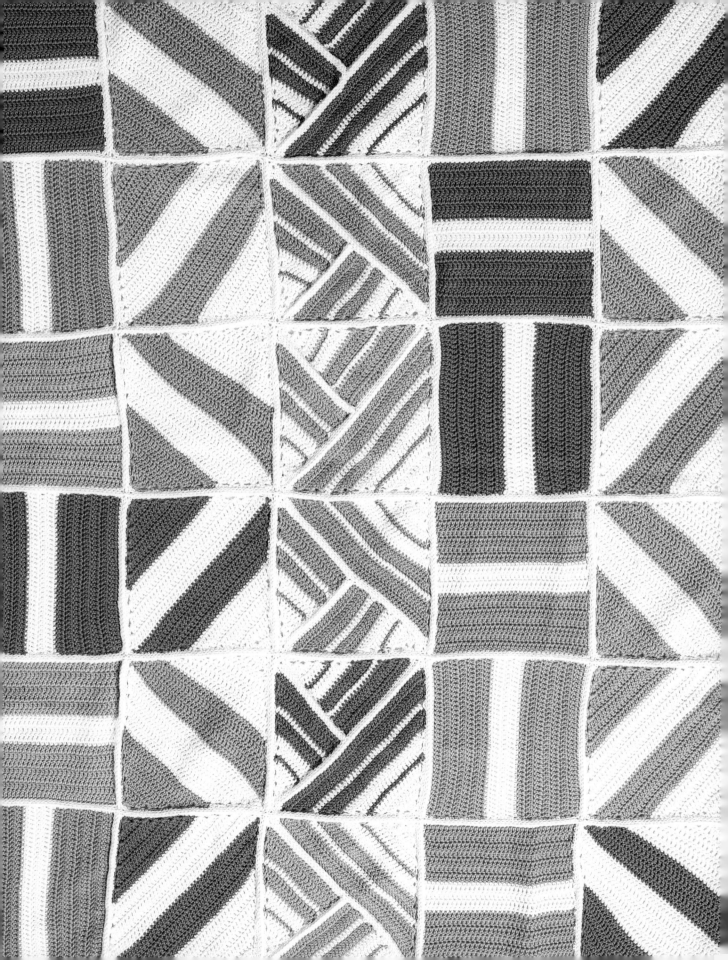

NOTES

▸ Each full hexagon is worked complete, then border rounds are added. With Schematic as a placement guide, use join-as-you-go technique (see Techniques) on final border round to adjacent completed hexagons to make the main blanket body.

▸ Half hexagons are made to fill gaps, and zigzag sides are squared off with triangle motifs before final border is worked to finish the piece.

Honeycomb Hex by Caitlin Dowe-Sandes

THE
Northerner

As complex and detailed floor tiles increase in popularity, it feels refreshing to draw inspiration from a simple cement tile with a clever and eye-catching color placement. *Honeycomb Hex* has a perfect layout and lends itself to playing with rotating motifs for a gorgeous textured eyelet detail. I named this one The Northerner because it reminds me of the chic and sophisticated style of New York architecture and decor.

FINISHED SIZE
58 × 63" (147.5 × 160 cm).

YARN
Worsted weight (#4 medium).

Shown here: Wool and the Gang Billie Jean Yarn (148 yd [135 m]/3½ oz [100 g]): Dirty Denim (A) (60% upcycled denim, 40% upcycled raw cotton), 11 balls; Raw Denim (B) (100% upcycled denim), 8 balls; Washed Out Denim (C) (20% upcycled denim, 80% upcycled raw cotton), 8 balls.

HOOKS
US size J-10 (6 mm) hook.

US size I-9 (5.5 mm) hook.

US size H-8 (5 mm) hook for last rnd of border.

Adjust hook size if necessary to achieve gauge.

NOTIONS
6 stitch markers; tapestry needle.

GAUGE
Rows 1–3 of Full Hexagon measure 8½" (21.5 cm) across, as worked in pattern, using size I-9 (5.5 mm)/J-10 (6 mm) hooks.

Hexagon 1

Note: *Use A for first color, B for 2nd color, and C for 3rd color.*

Row 1: (RS) With size I-9 (5.5 mm) hook and first color, ch 24, sc in 3rd ch from hook (turning ch counts as 1 sc), sc in each ch across, turn—23 sc.

Row 2: Change to size J-10 (6 mm) hook, Beg hdc (see Glossary) in first st, *ch 1, sk next st, hdc in next st; rep from * across, turn—12 hdc; 11 ch-sps.

Row 3: 2 sc in first st, sc in next ch-sp, (2 sc in each ch-sp) across, 2 sc in last hdc, turn—25 sc.

Rows 4 and 5: 2 sc in first st, sc in each st across, 2 sc in last st, turn—29 sc at end of Row 5.

Rows 6–13: Rep Rows 2–5 twice—41 sc at end of Row 13.

Rows 14–16: Rep Rows 2–4—45 sc at the end of Row 16.

Rows 17 and 18: Sk first st, sc in each st across to last st, turn, leaving last st unworked—41 sc at the end of Row 18.

Row 19: Rep Row 2—21 hdc; 20 ch-sps.

Row 20: Sc in first ch-sp, 2 sc in all rem ch-sps across, turn—39 sc.

Rows 21 and 22: Rep Row 17—35 sc at end of Row 22.

Rows 23–30: Rep Rows 19–22 twice—23 sts at end of Row 30.

Row 31: Rep Row 2—12 hdc; 11 ch-sps.

Row 32: Sc in first ch-sp, 2 sc in each ch-sp across, ch 1 and pull working yarn to close ch, securing final st, turn to RS—23 sc. Do not fasten off.

Hexagon Border

Rnd 1: With RS facing, with same color, using size J-10 (6 mm) hook, sc in side of final sc from Row 32, mark this sc with stitch marker as Corner 1, *work 21 sc evenly spaced across to next corner**, sc in next corner and mark this st as Corner 2; rep from * around, marking Corners 3, 4, 5, and 6, then rep from * to ** once, join with a sl st in first sc—132 sc. Fasten off.

Rnd 2: With size I-9 (5.5 mm) hook and RS facing, join 2nd color with a sl st in Corner 1, sc in each st around, join with a sl st in first sc. Move each marker to corresponding corner sc—132 sc.

Rnd 3: Sl st in next sc, (Beg dc [see Glossary], 2 dc) in corner sc, moving marker to center dc, *dc in each st to next marked corner st**, 3 dc in corner st, moving marker to center dc; rep from * around, ending last rep at **, join with a sl st in Beg dc—144 dc.

Rnd 4: Sl st in next dc, 3 sc in corner dc, moving marker to center sc, *sc in each st across to next marked corner dc**, 3 sc in next corner dc; rep from * around, ending last rep at **, join with a sl st in first sc—156 sc. Fasten off.

Rnds 5–7: With RS facing, join 3rd color with a sl st in marked corner 1, rep Rnds 2–4, removing markers as Rnd 7 is worked—180 sc. Fasten off.

Hexagon 2

Note: *Use A for first color, B for 2nd color, and C for 3rd color.*

Note: *Pay attention to orientation of Corner 1 and Side 1 of Full Hexagon. This is important because (hdc, Ch 1) "eyelet" rows form stripes that become a design element when facing a certain way, as seen in photo of finished piece.*

Work same as Hexagon 1 through Rnd 6 of Border.

Rnd 7: (Joining Rnd) Removing markers as rnd is worked, sl st in next st, 3 sc in Corner 1, sc in each st across to Corner 2, 3 sc in Corner 2, sc in each st across to Corner 3, 2 sc in Corner 3, remove loop from hook, insert hook from front to back in Corner 1 of Full Hexagon 1, catch loop, Pull Loop Through to front of work (PLT), work 3rd sc in Corner 3, PLT in corresponding st on Full Hexagon 1, (sc, PLT) in each st across side 3 to Corner 4, sc in Corner 4, PLT, 2 sc in Corner 4, finish rnd plain without any more PLT joining, join with a sl st in first sc—180 sc. Fasten off.

BORDER

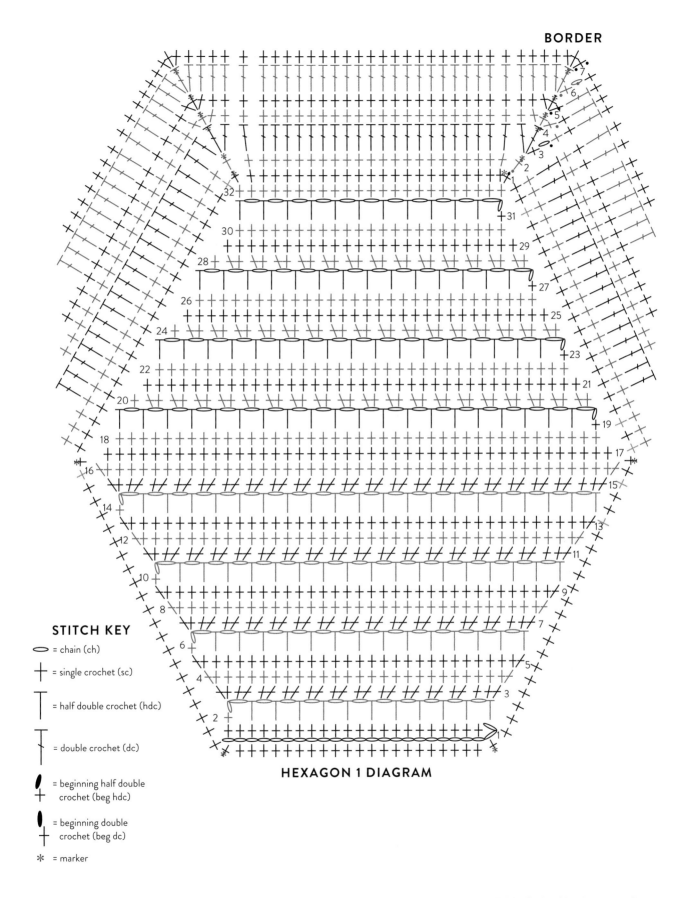

STITCH KEY

- ⬭ = chain (ch)
- ✛ = single crochet (sc)
- ⊤ = half double crochet (hdc)
- ⊤ = double crochet (dc)
- 🖊✛ = beginning half double crochet (beg hdc)
- 🖊✛ = beginning double crochet (beg dc)
- ✳ = marker

HEXAGON 1 DIAGRAM

Hexagons 3–14

Note: *Make 12 more as follows using Hexagon Diagram as a guide: Make 6 more using A for first color, B for 2nd color, and C for 3rd color. Make 4 using B for first color, C for 2nd color, and A for 3rd color. Make 2 using C for first color, B for 2nd color, and A for 3rd color.*

Work same as Hexagon 2, joining to sides indicated by blue lines on Schematic.

> **TIP**
> *When a Corner is reached where 2 Hexagons meet, work corner sc, drop loop, insert hook from front to back in left hexagon corner st, then in right hexagon corner st, PLT through both layers and sc to complete Corner as before.*

Half Hexagon 16 and 18

Note: *Make 1 using B for first color, C for 2nd color, and A for 3rd color. Make 1 using C for first color, B for 2nd color, and A for 3rd color.*

Rows 1 (WS) and 2: Work same as Rows 1 and 2 of Hexagon 1.

Row 3: 2 sc in first st, sc in next ch-sp, 2 sc in each ch-sp across, turn—23 sc.

Row 4: Sk first st, sc in each st across to last st, 2 sc in last st, turn—23 sc.

Row 5: 2 sc in first st, sc in each st across, turn, leaving last st unworked—23 sc.

Rows 6–13: Rep Rows 2–5 twice—23 sc at end of Row 13.

Rows 14–16: Rep Rows 2–4—23 sc at end of Row 16.

Rows 17 and 18: Sk first st, sc in each st across to last st, turn, leaving last st unworked—19 sc at end of Row 18.

Row 19: Rep Row 2—10 hdc; 9 ch-sps.

Row 20: Sc in first ch-sp, 2 sc in each ch-sp across, turn—17 sc.

Rows 21 and 22: Rep Row 17—13 sc at end of Row 22.

Rows 23–26: Rep Rows 19–22—7 sc at end of Row 26.

Rows 27 and 28: Rep Rows 19 and 20—5 sc at end of Row 28.

Row 29: Sk first st, sc in each of next 4 sts, turn—4 sc.

Row 30: Sk first st, sc in each of next 2 sts, turn, leaving last st unworked—2 sc.

Row 31: Sc in first st, ch 1, sc in last st, turn.

Row 32: Sc in next ch-sp, ch 1 and pull working yarn to close ch, securing final st, turn so that RS is facing. Do not fasten off. Proceed to Half Hexagon Border.

Half Hexagons 15 and 17

Note: *Make 1 using C for first color, B for 2nd color, and A for 3rd color. Make 1 using B for first color, C for 2nd color, and A for 3rd color.*

With first color, work same as Hexagon 1, through Row 16. Do not fasten off. Proceed to Half Hexagon Border.

Half Hexagon Border

Rnd 1: With RS facing, with same color, using J-10 (6 mm) hook, for Half Hexagon 16 and 18: sc in side of sc in Row 32, (for Half Hexagon 15 and 17: sc in first st of row 16) *work 21 sc evenly spaced across side, sc and mark this st as a corner; rep from * twice. Fasten off. **Note:** *It is not necessary to mark 4th corner—67 sc.*

Row 2: With RS facing and size I-9 (5.5 mm) hook, join 2nd color with a sl st in first st, sc in each st across, advancing 2 markers, turn—67 sc.

Row 3: (Beg dc, dc) in first st, *dc in each st across to next marked corner st, 3 dc in next corner st, moving marker to center dc; rep from * once, dc in each st across to last st, 2 dc in last st, turn—73 dc.

Row 4: 2 sc in first st, *sc in each st across to next marked corner st, 3 sc in next corner st, moving marker to center sc; rep from * once, sc in each st across to last st, 2 sc in last st—79 sc. Fasten off.

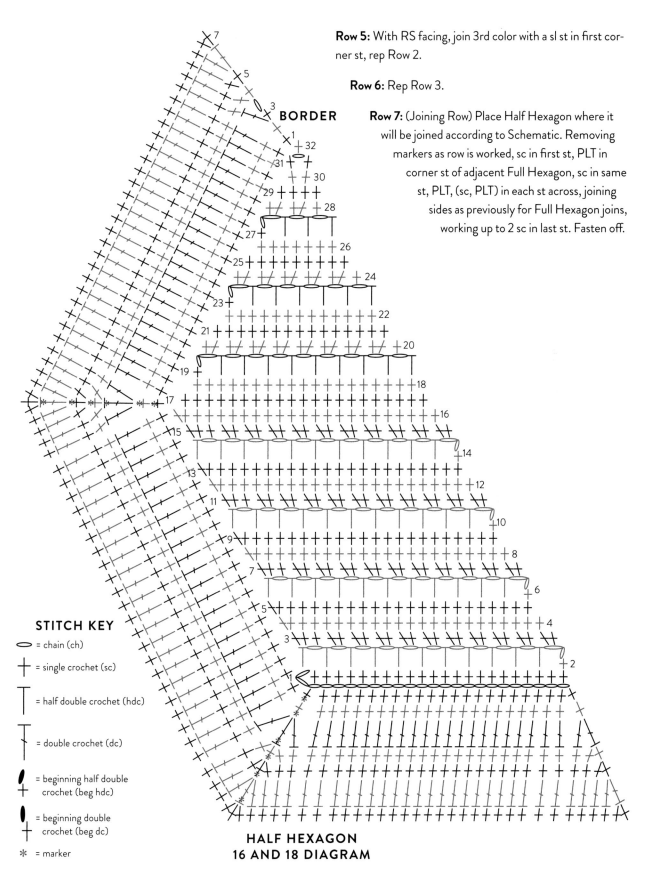

Row 5: With RS facing, join 3rd color with a sl st in first corner st, rep Row 2.

Row 6: Rep Row 3.

Row 7: (Joining Row) Place Half Hexagon where it will be joined according to Schematic. Removing markers as row is worked, sc in first st, PLT in corner st of adjacent Full Hexagon, sc in same st, PLT, (sc, PLT) in each st across, joining sides as previously for Full Hexagon joins, working up to 2 sc in last st. Fasten off.

BORDER

STITCH KEY

◯ = chain (ch)

✛ = single crochet (sc)

┼ = half double crochet (hdc)

╫ = double crochet (dc)

● = beginning half double crochet (beg hdc)

● = beginning double crochet (beg dc)

✳ = marker

**HALF HEXAGON
16 AND 18 DIAGRAM**

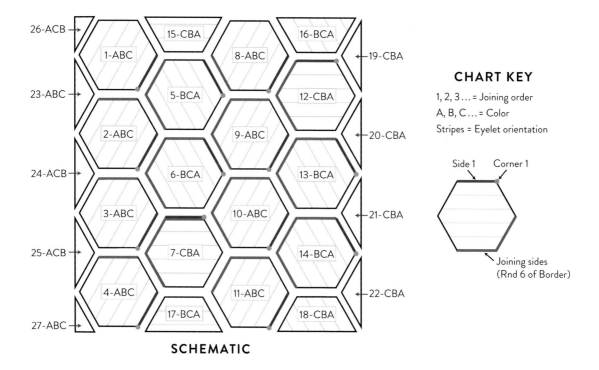

SCHEMATIC

CHART KEY

1, 2, 3 … = Joining order
A, B, C … = Color
Stripes = Eyelet orientation

Side 1 Corner 1

Joining sides
(Rnd 6 of Border)

Square Off Sides

Square off zigzag sides with Large and Small Triangles as follows:

Large Triangles (For Motifs 19–25)

Note: Make 4 using C for first color, B for 2nd color, and A for 3rd color. Make 2 using A for first color, C for 2nd color, and B for 3rd color. Make 1 with A for first color, B for 2nd color, and C for 3rd color.

Row 1: With size I-9 (5.5 mm) hook and RS facing, join first color in center sc of 3-sc corner at right-hand side of triangle gap, sc2tog (see Glossary) over first 2 sts, sc in each of next 29 sts, sc2tog over next sc on same Hexagon and first sc on next Hexagon, sc in each of next 29 sts, sc2tog over next 2 sts, turn.

Row 2: Beg dc3tog (see Glossary) over first 3 sts, dc in each of next 25 sts, dc3tog over next 3 sts, dc in each of next 25 sts, dc5tog (see Glossary) over next 5 sts, turn.

Row 3: Sc2tog over first 2 sts, sc in next 23 sts, sc3tog (see Glossary) over next 3 sts, sc in next 23 sts, sc2tog over next 2 sts, do not turn. Fasten off.

Row 4: With RS facing, join 2nd color with a sl st in first st, sc2tog over first 2 sts, sc in next 21 sts, sc3tog over next 3 sts, sc in next 21 sts, sc2tog over next 2 sts, turn.

Row 5: Beg dc3tog over first 3 sts, dc in next 18 sts, dc3tog over next 3 sts, dc in next 18 sts, dc3tog over next 3 sts, turn.

Row 6: Sc2tog over first 2 sts, sc in next 16 sts, sc3tog over next 3 sts, sc in next 16 sts, sc2tog over next 2 sts, do not turn. Fasten off.

Row 7: Switching to size J-10 (6 mm) hook and still holding RS facing, join 3rd color with a sl st in first st, sc2tog over first 2 sts, sc in next 14 sts, sc3tog over next 3 sts, sc in next 14 sts, sc2tog over last 2 sts, turn.

Row 8: Beg dc4tog (see Glossary) over first 4 sts, dc in next 10 sts, dc3tog over next 3 sts, dc in next 10 sts, dc4tog over last 4 sts, turn.

Row 9: Beg dc4tog over first 4 sts, dc in next 6 sts, dc3tog over next 3 sts, dc in next 6 sts, dc4tog over last 4 sts, turn.

Row 10: Beg dc4tog over first 4 sts, dc in next st, dc5tog over next 5 sts, dc in next st, dc4tog over last 4 sts, turn.

Row 11: Sc5tog (see Glossary) over first 5 sts. Fasten off.

Small Triangle 26

Row 1: With size I-9 (5.5 mm) hook and RS facing, join A in center sc of 3-sc corner at right-hand side of triangle gap, sc2tog over first 2 sts, sc in each of next 29 sts, sc2tog over last 2 sts, turn—31 sts.

Row 2: Beg dc3tog over first 3 sts, dc in each of next 25 sts, dc3tog over last 3 sts, turn—27 sts.

Row 3: Sc2tog over first 2 sts, sc in each of next 23 sts, sc2tog over last 2 sts. Fasten off—25 sts.

Row 4: With RS still facing, join C with a sl st in first st, sc2tog over first 2 sts, sc in each of next 21 sts, sc2tog over last 2 sts, turn—23 sts.

Row 5: Beg dc3tog over first 3 sts, dc in each of next 18 sts, dc2tog (see Glossary) over last 2 sts, turn—20 sts.

Row 6: Sc2tog over first 2 sts, sc in each of next 16 sts, sc2tog over last 2 sts—18 sts. Fasten off.

Row 7: Switching to size J-10 (6 mm) hook and still holding RS facing, join B with a sl st in first st, sc2tog over first 2 sts, sc in next 14 sts, sc2tog over next 2 sts, turn—16 sts.

Row 8: Beg dc4tog over first 4 sts, dc in each of next 10 sts, dc2tog over next 2 sts, turn—12 sts.

Row 9: Beg dc2tog over next 2 sts, dc in each of next 6 sts, dc4tog over next 4 sts, turn—8 sts.

Row 10: Beg dc4tog over next 4 sts, dc in next st, dc3tog over next 3 sts, turn—3 sts.

Row 11: Sc3tog over first 3 sts—1 st. Fasten off.

Small Triangle 27

Row 1: With size I-9 (5.5 mm) hook and RS facing, join A in center sc of 3-sc corner at right-hand side of triangle gap, sc2tog over first 2 sts, sc in each of next 29 sts, sc2tog over last 2 sts, turn—31 sts.

Row 2: Beg dc3tog over first 3 sts, dc in each of next 25 sts, dc3tog over last 3 sts, turn—27 sts.

Row 3: Sc2tog over first 2 sts, sc in each of next 23 sts, sc2tog over last 2 sts—25 sts. Fasten off.

Row 4: With RS still facing, join B with a sl st in first st, sc2tog over first 2 sts, sc in each of next 21 sts, sc2tog over last 2 sts, turn—23 sts.

Row 5: Beg dc2tog over first 2 sts, dc in each of next 18 sts, dc3tog over last 3 sts, turn—20 sts.

Row 6: Sc2tog over first 2 sts, sc in each of next 16 sts, sc2tog over last 2 sts—18 sts. Fasten off.

Row 7: Switching to size J-10 (6 mm) hook and still holding RS facing, join B with a sl st in first st, sc2tog over first 2 sts, sc in next 14 sts, sc2tog over last 2 sts, turn—16 sts.

Row 8: Beg dc2tog over first 2 sts, dc in each of next 10 sts, dc4tog over last 4 sts, turn—12 sts.

Row 9: Beg dc4tog over first 4 sts, dc in next 6 sts, dc2tog over last 2 sts, turn—8 sts.

Row 10: Beg dc3tog over first 3 sts, dc in next st, dc4tog over last 4 sts, turn—2 sts.

Row 11: Sc3tog over first 3 sts—1 st. Fasten off.

Now the blanket is squared off and ready for a border.

Border

Rnd 1: With RS facing and size I-9 (5.5 mm) hook, join A in any corner, 3 sc in same st, sc evenly around, being sure to work the same amount of sts at opposing sides of piece, placing 3 sc in each corner, join with a sl st in first sc.

Rnd 2: Working from left to right, reverse sc (see Glossary) in each st around, join with a sl st in first reverse sc. **Note:** *Do not work any extra sts in the corners to leave a neat, rounded corner.* Fasten off. Weave in ends.

CHAPTER 6

Quilting

TULA PINK

THE ARTIST

Tula Pink is an influential quilt designer who lives in a small town outside of Kansas City, Missouri. When she is not using her talents to create designer fabric collections, stand as an Ambassador for Bernina sewing machines, and develop collections for Aurifil threads and Renaissance Ribbons, she can be found writing popular quilt patterns and taking her designs on the road. Tula tours the world appearing at quilt conventions to showcase her works. She is also a major influencer in the industry, standing as a Senior Designer with both Moda Fabrics and FreeSpirit Fabrics.

THE INSPIRATION

The comforting and warm tradition of quilting has been a huge source of visual inspiration for me throughout my crochet lifetime. To me, each quilt block is like a mini-study in geometry and movement, and I often fuse those design elements with my crochet art in an attempt to influence the industry and help it stay fresh and evolve. I find continual inspiration from Tula Pink in particular, whose bold, bright color choices and high-volume, high-powered designs have made her a consistent, strong presence in the quilting and fabric-design arenas.

Although quilting is something I've had a strong interest to try (and I have a dusty box of cut fabric and quilting supplies to show for it), I could never put my hook down long enough to give it a fair shake. Luckily, crochet lends itself well to exploring aspects of quilting. In Ombré Stripe, inspired by Tula Pink's *Shoreline* quilt, I play with "fussy cutting" techniques. In quilting, this technique shows off a specific area of a piece of fabric. I've translated this to cutting gradient yarns in specific places to create an opulent blanket design. City Sunrise incorporates traditional quilt blocks such as flying geese and the nine-patch, as they are seen in the inspiration piece, *Flower Market* quilt. And Sweet Spring, my nod to one of my personal favorites of Tula's patterns, *The Butterfly* quilt, offers the chance to relish in the slow-moving art of hand piecing.

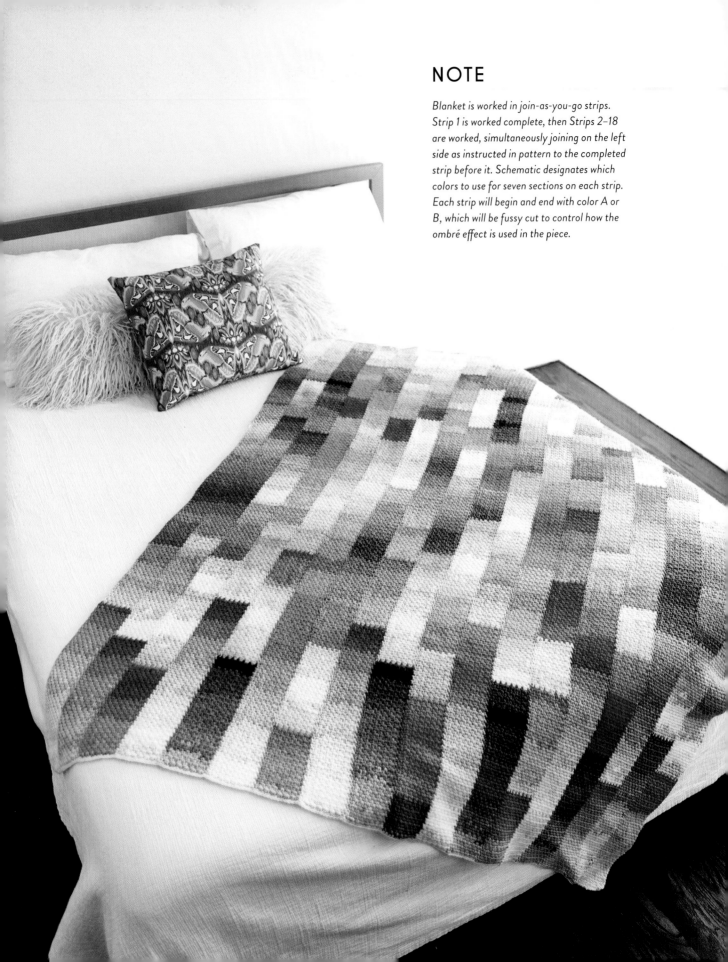

NOTE

Blanket is worked in join-as-you-go strips. Strip 1 is worked complete, then Strips 2–18 are worked, simultaneously joining on the left side as instructed in pattern to the completed strip before it. Schematic designates which colors to use for seven sections on each strip. Each strip will begin and end with color A or B, which will be fussy cut to control how the ombré effect is used in the piece.

OMBRÉ *Stripe*

When I see a quilt that so easily translates to crochet in my mind, I almost always have to get it on my hook that very moment. Tula Pink's *Shoreline* quilt called me to the design board and had me figuring out how to incorporate that beautiful tonal color range. Paging through dozens of yarns online, one of my favorite pastimes, I discovered Kamgarn Papatya Batik yarn, which features monochrome palettes with long color changes. There are other yarns like this on the market; just pick a favorite and you, too, can daydream you're working with a full range of ombré fabrics for this mock quilt.

FINISHED SIZE
52 × 66" (132 × 168 cm).

YARN
DK weight (#3 light).

Shown here: Kamgarn Papatya Batik (100% acrylic; 393 yd [360 m]/3½ oz [100 g]): #554-10 (A), #554-19 (B), #554-04 (C), #554-05 (D), #554-07 (E), #554-03 (F), #554-06 (G), #554-08 (H), 2 balls each.

HOOKS
US size H-8 (5 mm) hook.

US size I-9 (5.5 mm) hook.

Adjust hook size if necessary to achieve gauge.

NOTIONS
Tapestry needle.

GAUGE
Each strip (14 sts) = 3" (7.5 cm) wide; 17 rows = 4" (10 cm) in pattern, using size I-9 (5.5 mm) hook, blocked.

Prepare Yarn Colors A and B

These balls of yarn have long color changes, from darker shades of the color all the way to white. To achieve the faded effect shown at the top and bottom edges of the blanket, and really make the center colors "pop," prepare the yarn before you start your blanket. Remove the ball band and grab free end of yarn. Begin winding the yarn into a small ball, noting that your color is getting either progressively darker or progressively lighter. When you arrive somewhere around the center of the most extreme color, whether it is the darkest shade or brightest white, cut yarn and finish winding up the ball. Now start winding a new ball, watching the color change as you go, and cut yarn at the middle of the next extreme shade. Continue in this manner until the entire ball of yarn is used up, then do the same for the rest of colors A and B. Your fussy-cut yarn balls will be about the size of golf balls. Some have white on the outside, some have the darkest shade of color showing. Divide the pile into white balls and dark balls. Start each strip at bottom edge (Section 1) with the balls from the white pile and end each strip (Section 7) with balls from the dark pile to create the faded effect at top and bottom edges.

Strip 1
Section 1

Row 1: (RS) With A and size H-8 (5 mm) hook, ch 15, sc in 3rd ch from hook (turning ch counts as a ch-sp), *ch 1, sk 1 ch, sc in next ch; rep from * across, turn—7 sc; 7 ch-sps.

Rows 2 and 3: *Ch 1 (counts as a ch-sp), sc in next ch-sp; rep from * across, turn—7 sc; 7 ch-sps.

Rows 4–50: Change to size I-9 (5.5 mm) hook, rep Row 2. Fasten off.

Section 2

With RS facing, join C with a sl st in first sc. Rep Row 2 for 36 rows. Fasten off.

Section 3

With RS facing, join H with a sl st in first sc. Rep Row 2 for 20 rows. Fasten off.

Section 4

With RS facing, join C with a sl st in first sc. Rep Row 2 for 72 rows. Fasten off.

Section 5

With RS facing, join H with a sl st in first sc. Rep Row 2 for 20 rows. Fasten off.

Section 6

With RS facing, join C with a sl st in first sc. Rep Row 2 for 36 rows. Fasten off.

Section 7

With RS facing, join A with a sl st in first sc. Rep Row 2 for 50 rows for a total of 284 rows. Fasten off.

STITCH KEY

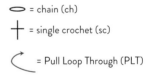

⬭ = chain (ch)

✝ = single crochet (sc)

↶ = Pull Loop Through (PLT)

JOINING OF STRIPS DIAGRAM

Strip Number

1 2 3 4 5 6 7 8 9 10 11 12 13 14 15 16 17 18

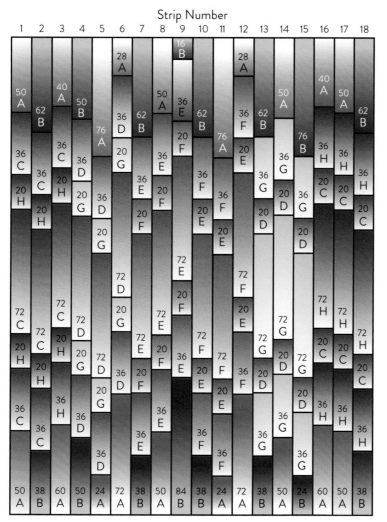

SCHEMATIC

COLOR KEY

- = #554-10 (A)
- = #554-19 (B)
- = #554-04 (C)
- = #554-05 (D)
- = #554-07 (E)
- = #554-03 (F)
- = #554-06 (G)
- = #554-08 (H)

Strips 2–18

Note: Use Schematic as a guide to see which colors should be used for each strip. Strip 1 is on left-hand side of Schematic. Change hook size as indicated in Strip 1 Section 1.

Row 1: With size H-8 (5 mm) hook, join first color (A or B as seen in Schematic) with a sl st in bottom right corner of previous strip, ch 15, rep Row 1 of Strip 1.

Row 2: WS of piece should be facing. Before beginning row, remove loop from hook, insert hook from front to back through final sc of Row 2 on completed strip, replace loop back on hook, and Pull Loop Through (PLT, see Techniques) to front of work. *Ch 1, sc in next ch-sp; rep from * across, turn.

Row 3: *Ch 1, sc in next ch-sp; rep from * across, turn.

Rows 4–284: Work in pattern, working PLT join at the beginning of every even-numbered row, joining strip as you go. Work following Schematic for color changes, working color indicated by letter and number of rows indicated by number.

> **TIP**
> *Weave in yarn ends as you go for an easy finish as there is no border for this piece. Enjoy the raw edges!*

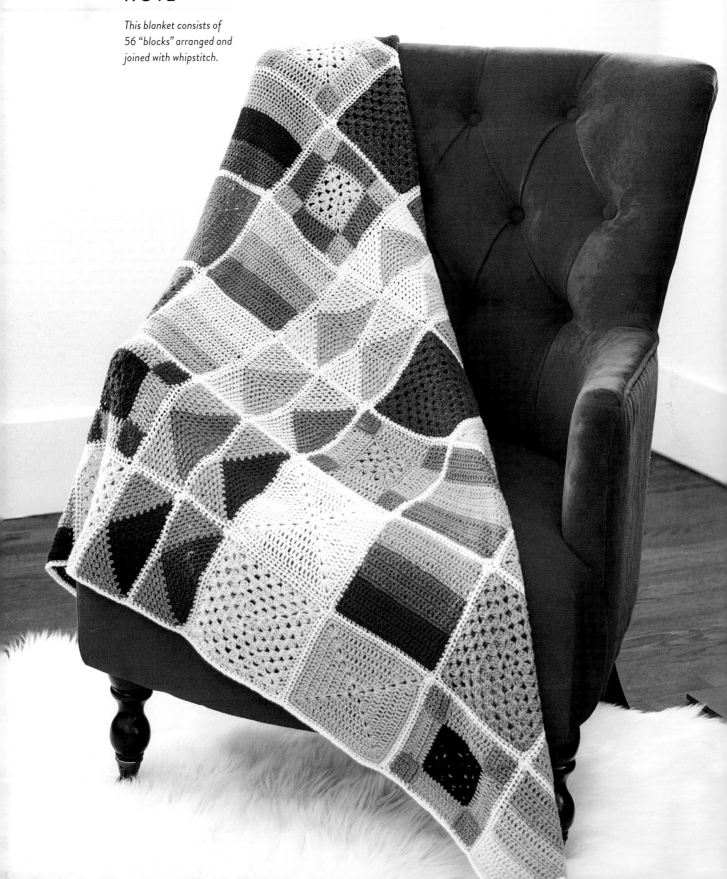

NOTE

This blanket consists of 56 "blocks" arranged and joined with whipstitch.

CITY *Sunrise*

Flower Market by Tula Pink

For this bright and cheery piece, I drew inspiration from the *Flower Market* quilt by Tula Pink, a quilt pattern in which she uses the lush, sunny tones of her *Eden* fabric line. You'll feel like a true quilter as you stitch up nine-patch and flying geese blocks. This is handstitching at its best!

FINISHED SIZE
39 × 44" (99 × 112 cm).

YARN
Fingering weight (#2 fine).

Shown here: Knit Picks Palette (100% Peruvian Highland wool; 231 yd [200 m]/1¾ [50 g]): #25548 Clarity (A), 4 balls; #26044 Wonderland Heather (B), #25549 Sagebrush (C), #25094 Tranquil (D), #25547 Marina (E), #24558 Custard (F), #25086 Safflower (G), #24252 Cornmeal (H), #24251 Turmeric (I), #24569 Cotton Candy (J), #23721 Hyacinth (K), #24568 Cosmopolitan (L), #24553 Serrano (M), #25089 Regal (N), #24570 Blossom Heather (O), #24555 Mai Tai Heather (P), #24557 Conch (Q), #26057 Cayenne (R), #24248 Masala (S), 1 ball each.

HOOK
US size F-5 (3.75 mm) hook.

Adjust hook size if necessary to achieve gauge.

NOTIONS
Tapestry needle.

GAUGE
First 5 rnds of Block 1 = 4 × 4" (10 × 10 cm), unblocked.

STITCH GUIDE

Inc (increase)
(Sc, ch 1, sc) in same st or sp indicated.

Block 1: Granny Square (Make 10)

Note: Refer to Schematic for colors.

Rnd 1: (RS) Ch 3, sl st in 3rd chain from hook to form a ring, Beg dc (see Glossary) in ring, (ch 3, 3 dc) 3 times in ring, ch 3, 2 dc in ring, join with a sl st in top of Beg dc, turn.

Rnd 2: (WS) Sl st in first ch-sp, (Beg dc, ch 3, 3 dc) in first ch-sp, (3 dc, ch 3, 3 dc) in each of next 3 ch-sps, 2 dc in first corner ch-sp to complete corner, join with a sl st in top of Beg dc, turn.

Rnd 3: (Pattern Rnd) (RS) Sl st in first ch-sp, (Beg dc, ch 3, 3 dc) in first ch-sp, *3 dc between all 3-dc groups across to next corner ch-sp**, (3 dc, ch 3, 3 dc) in corner ch-sp; rep from * around, ending last rep at **, 2 dc in first corner ch-sp to complete corner, join with a sl st in top of Beg dc, turn.

Rnds 4–7: Rep Rnd 3, turning at end of each rnd. Fasten off.

Block 2: Solid Granny Square (Make 10)

Note: Refer to Schematic for colors.

Rnd 1: (RS) Ch 3, sl st in 3rd chain from hook to form a ring, Beg dc in ring, (ch 3, 3 dc) 3 times in ring, ch 3, 2 dc in ring, join with a sl st in top of Beg dc.

Rnd 2: (pattern rnd) (Beg dc, ch 2, 2 dc) in first ch-sp, *dc in each st across to next ch-sp**, (2 dc, ch 2, 2 dc) in next ch-sp; rep from * around, ending last rep at **, dc in first corner to complete corner, join with a sl st in top of Beg dc.

Rnds 3–6: Rep Rnd 2.

Rnd 7: Sl st in first ch-sp, *3 sc in corner ch-sp, sc in each st across to next corner ch-sp; rep from * around, join with a sl st in first sc. Fasten off.

Block 3: Stripe Square (Make 17)

Note: This block is worked using three colors. Refer to Schematic for each block's colors and note that they are numbered in order from left to right: first color, 2nd color, and 3rd color.

Row 1: (RS) With first color, ch 27, sc in 3rd ch from hook (turning ch counts as 1 sc), sc in each ch across, turn—26 sc.

Row 2: Beg dc in first st, dc in each st across, turn. (26 dc)

Rows 3–5: Sc in each st across, turn.

Row 6: Rep Row 2.

Row 7: Rep Row 3. Fasten off.

Row 8: With WS facing, join 2nd color in first st, rep Row 3.

Rows 9–14: Rep Rows 2–7.

Row 15: With RS facing, join 3rd color in first st, rep Row 3.

Rows 16–21: Rep Rows 2–7. Fasten off.

Block 4: Nine-Patch (Make 14)

Note: This block is worked using three colors. Refer to Schematic for each block's colors and note that they are numbered in the order that they are used in the pattern. Use Nine-Patch Diagram as a reference if needed.

Center Square

Rnds 1–3: With first color, work as for Block 1 through Rnd 3, do not turn work after Rnd 3.

Rnd 4: With RS facing, sl st in first ch-sp, *3 sc in ch-sp, sc in in each st across to next corner ch-sp; rep from * around, join with a sl st in first sc. Fasten off.

Side Rectangle

Row 1: With RS facing, join 2nd color with a sl st in any corner sc of Center Square, Beg dc in same st, dc in each st across to next corner sc, turn—13 dc.

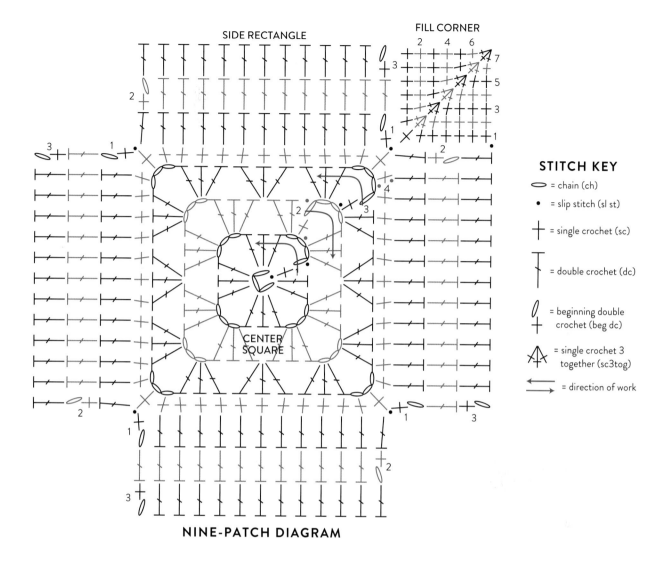

SIDE RECTANGLE

FILL CORNER

CENTER SQUARE

NINE-PATCH DIAGRAM

STITCH KEY

⬭ = chain (ch)

• = slip stitch (sl st)

+ = single crochet (sc)

╪ = double crochet (dc)

₵ = beginning double crochet (beg dc)

⋔ = single crochet 3 together (sc3tog)

← = direction of work

Rows 2 and 3: Beg dc, dc in each st across, turn. Fasten off.

Rep Side Rectangle on rem 3 sides of Center Square.

Fill Corner

Row 1: With RS facing, join 3rd color with a sl st in top of last dc of any Side Rectangle, sc in same place, work 5 more sc evenly spaced across side of same Side Rectangle, sc in center sc from Rnd 4 of Center Square, work 6 sc evenly spaced across next Side Rectangle, turn—13 sc.

Row 2: Sc in first 5 sts, sc3tog (see Glossary) over next 3 sts, sc in each of last 5 sts, turn.

Rows 3–5: Sc in each st across to within 1 st of center decrease, sc3tog over next 3 sts, sc in each rem st across, turn.

Row 6: Sc in first st, sc3tog over next 3 sts, sc in last st, turn.

Row 7: Sc3tog over first 3 sts. Fasten off.

Rep Fill Corner in each of 3 rem corners of Nine-Patch. Weave in ends.

Block 5: Flying Geese (Make 10)

Note: This is a rectangle. Two blocks stacked up equal one square block. Refer to Schematic for Colors 1 and 2. Use Flying Geese Diagram as a reference if needed.

Main Triangle

Row 1: (RS) With first color, ch 3, join with a sl st in 3rd ch from hook to form a ring, (Beg dc, 8 dc) in ring, turn—9 dc.

Row 2: Inc in first st, (ch 1, sk next st, sc in next st, ch 1, sk 1 st, Inc in next st) twice, turn.

Rows 3–9: Inc in first st, *(ch 1, sc) in each ch-sp across to next Inc, ch 1, Inc in ch-sp of next Inc; rep from * once, turn. Do not turn at end of last rnd. Fasten off—3 Inc; 16 sc; 18 ch-sps after Row 9.

Fill Corners

Row 1: (RS) With RS facing, join 2nd color with a sl st in ch-sp of first Inc in Row 9, sc in same sp, (ch 1, sc) in each of next 10 ch-sps, ending in ch-sp of next Inc, turn—11 sc; 10 ch-sp.

Rows 2–10: Sc in first ch-sp, (ch 1, sc) in each ch-sp across, turn—2 sc; 1 ch-sp at end of Row 10.

Row 11: Sc in next ch-sp. Fasten off.

With WS facing, rep for 2nd side of Main Triangle.

Join Blocks

Prepare all blocks with a round of sc using A as follows:

Blocks 1–4

With RS facing, join A with a sl st in any corner, *3 sc in corner sp, work 24 sc evenly spaced across to next corner; rep from * around, join with a sl st in first sc. Fasten off.

Block 5

With RS facing, join A with a sl st in a corner just before a long side, *3 sc in corner sp, work 24 sc evenly spaced across to next corner, 3 sc in corner st, work 11 sc evenly spaced across short side to next corner; rep from * once, join with a sl st in first sc. Fasten off.

STITCH KEY

⬯ = chain (ch)

• = slip stitch (sl st)

✝ = single crochet (sc)

𝕋 = double crochet (dc)

𝕆 = beginning double crochet (beg dc)

⋀ = single crochet 3 together (sc3tog)

⟵ = direction of work

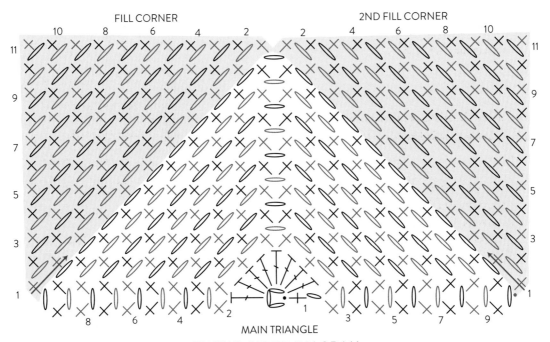

MAIN TRIANGLE

FLYING GEESE DIAGRAM

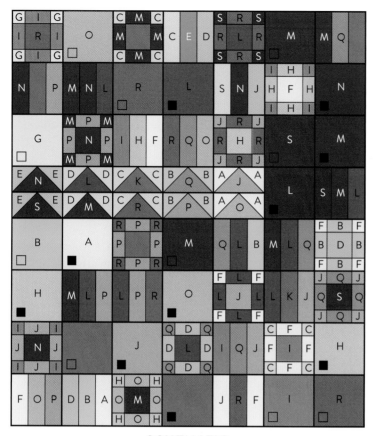

SCHEMATIC

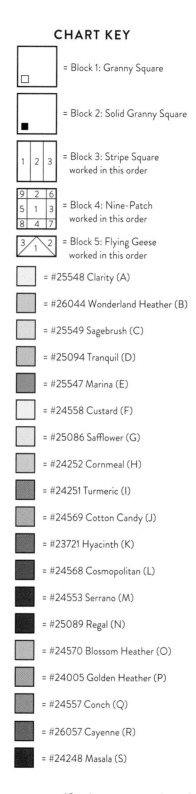

With tapestry needle and A, whipstitch 2 matching Block 5 motifs together holding blocks with wrong sides together, using Schematic as a guide, making 5 square Flying Geese blocks.

> **TIP**
>
> *When working into side of dc st, work into st, not "around" it, so as not to make holes down the sides of the block.*

Arrange all 56 blocks with RS facing according to Schematic. With tapestry needle and A, whipstitch all blocks together, working in rows, first horizontally, then vertically, until all blocks are joined.

Border

Rnd 1: With RS facing, join A with a sl st in any corner, *3 sc corner st, sc in each sc across to next corner; rep from * around join with a sl st in first sc.

Rnd 2: Sl st in next corner sc, *3 sc in corner st, sc in each sc across to next corner; rep from * around, join with a sl st in first sc. Fasten off. Weave in ends.

NOTE

*All blocks are made individually
and sewn together with whipstitch
according to the Schematic, then
Fill Spaces are worked to square off
the piece. A Granny Stripe section
is worked across the top and bottom
before adding a simple border.*

The Butterfly by Tula Pink

SWEET *Spring*

Is there anything more fun than stitching up a whimsical stack of squares? So much joy comes from this blanket, inspired by *The Butterfly* quilt by Tula Pink, worked up in bright colors and handstitched together, just like piecing quilt blocks. These quilting skills are paired with the quintessential crochet technique: granny-stitch stripes. Pure happiness! Sweet Spring is a creative and engaging pattern that is sure to bring delight.

FINISHED SIZE
65 × 70" (165 × 178 cm).

YARN
Bulky weight (#5 chunky).

Shown here: Scheepjes Bloom (100% cotton; 87 yd [80 m]/1¾ oz [50 g]): #423 Daisy (A), 18 balls; #403 Viola (B), 4 balls; #412 Light Fern (C), 5 balls; #406 Tulip (D), 6 balls; #411 Dark Fern (E), 4 balls; #408 Geranium (F), 4 balls; #407 Fuchsia G), 6 balls; #402 French Lavender (H), 4 balls; #404 Lilac (I), 6 balls.

HOOK
US size J-10 (6 mm) hook for blanket blocks.

US size I-9 (5.5 mm) hook for border.

Adjust hook size if necessary to achieve gauge.

NOTIONS
Tapestry needle.

GAUGE
Block L measures 4½ × 4½" (11.5 × 11.5 cm), using size J-10 (6 mm) hook, blocked.

STITCH GUIDE

Beg dc4tog (Beginning double crochet 4 together [over 5 sts])

Beg dc (does not count as a st), yo, insert hook in next st, yo, pull loop through st, yo, draw yarn through 2 loops on hook, sk next st of ch, (yo, insert hook in next st, yo, pull loop through st, yo, draw yarn through 2 loops on hook) twice, yo, draw through 4 loops on hook.

Dc2tog (double crochet 2 together [over 3 sts])

Yo, insert hook in next st, yo, pull loop through st, yo, draw through 2 loops on hook, sk next st of ch, yo, insert hook in next st, yo, pull loop through st, yo, draw through 2 loops on hook, yo, draw through 3 loops on hook.

Dc4tog (double crochet 4 together [over 5 sts])

(Yo, insert hook in next st, yo, pull loop through st, yo, draw yarn through 2 loops on hook) twice, sk next st of ch, (yo, insert hook in next st, yo, pull loop through st, yo, draw yarn through 2 loops on hook) twice, yo, draw through 5 loops on hook.

Sc2tog (single crochet 2 together [over 3 sts])

Insert hook in next st, yo, pull loop through st, sk next st of ch, insert hook in next st, yo, pull loop through st, yo, draw through 3 loops on hook.

Block A (Make 2)

Row 1: (RS) With size J-10 (6 mm) hook and B, ch 45, dc in 4th ch from hook (turning ch counts as dc here and throughout), dc in each of next 17 ch, dc4tog over next 5 ch (see Stitch Guide), dc in each of next 19 ch, turn—38 dc; 1 dc4tog.

Row 2: Sc in each of first 18 sts, sc2tog over next 3 sts (see Stitch Guide), sc in each of next 18 sts, turn—36 sc; 1 sc2tog. Fasten off.

Row 3: With RS facing, join C with a sl st in first st, Beg dc (see Glossary) in same st, dc in each of next 15 sts, dc4tog over next 5 sts, dc in each of next 16 sts, turn—32 dc; 1 dc4tog.

Row 4: Sc in each of first 15 sts, sc2tog over next 3 sts, sc in each of next 15 sts, turn—30 sc; 1 sc2tog. Fasten off.

Row 5: With RS facing, join D with a sl st in first st, Beg dc in same st, dc in each of next 13 sts, dc2tog over next 3 sts (see Stitch Guide), dc in each of next 14 sts, turn—28 dc; 1 dc2tog.

Row 6: Sc in each of first 13 sts, sc2tog over next 3 sts, sc in each of next 13 sts, turn—26 sc; 1 sc2tog. Fasten off.

Row 7: With RS facing, join E with a sl st in first st, Beg dc in same st, dc in each of next 10 sts, dc4tog over next 5 sts, dc in each of next 11 sts, turn—22 dc; 1 dc4tog.

Row 8: Sc in each of first 10 sts, sc2tog over next 3 sts, sc in each of next 10 sts, turn—20 sc; 1 sc2tog. Fasten off.

Row 9: With RS facing, join B with a sl st in first st, Beg dc in same st, dc in each of next 8 sts, dc2tog over next 3 sts, dc in each of next 9 sts, turn—18 dc; 1 dc2tog.

Row 10: Sc in each of first 8 sts, sc2tog over next 3 sts, sc in each of next 8 sts, turn—16 sc; 1 sc2tog. Fasten off.

Row 11: With RS facing, join F with a sl st in first st, Beg dc in same st, dc in each of next 5 sts, dc4tog over next 5 sts, dc in each of next 6 sts, turn—12 dc; 1 dc4tog.

Row 12: Sc in each of first 5 sts, sc2tog over next 3 sts, sc in each of next 5 sts, turn—10 sc; 1 sc2tog. Fasten off.

Row 13: With RS facing, join C with a sl st in first st, Beg dc in same st, dc in each of next 2 sts, dc4tog over next 5 sts, dc in each of next 3 sts, turn—6 dc; 1 dc4tog.

Row 14: Sc in each of first 2 sts, sc2tog over next 3 sts, sc in each of next 2 sts, turn—4 sc; 1 sc2tog.

Row 15: Beg dc4tog over first 5 sts (see Stitch Guide). Fasten off.

Block B (Make 6)

Row 1: (RS) With size J-10 (6 mm) hook and D, ch 35, dc in 4th ch from hook (turning ch counts as a dc), dc in each of next 12 sts, dc2tog over next 3 ch, dc in each of next 14 sts, turn.

Rows 2–11: Work same as Rows 6–15 of Block A.

Block C (Make 10)

Row 1: (RS) With size J-10 (6 mm) hook and B, ch 25, dc in 4th ch from hook, dc in each of next 7 sts, dc4tog over next 5 sts, dc in each of next 9 sts, turn.

Rows 2–7: Work same as Rows 10–15 of Block A, using B, F, and G, respectively.

Block D (Make 6)

Rows 1–7: Work same as Block C, except use D, G, and C, respectively.

Block E (Make 2)

Note: This block begins with one mitered square worked in four colors, then adds chains to work the rem three mitered squares directly onto completed squares in same four colors, so that the block is worked in one piece, without sewing. Refer to Schematic—on Block E, you will find an example of the Miters numbered 1–4.

Miter 1

Row 1: (RS) With size J-10 (6 mm) hook and C, ch 29, dc in 4th ch from hook (turning ch counts as a dc), dc in each of next 9 ch, dc4tog over next 5 ch, dc in each of next 11 sts, turn—22 dc; 1 dc4tog.

Rows 2–9: Work same as Rows 8–15 of Block A, except use C for Row 2, then F, B, and E, respectively.

Miter 2

Row 1: With RS facing, join C with a sl st in center ch at base of dc4tog from Row 1 of Miter 1, ch 15, dc in 4th ch from hook (turning ch counts as a dc), dc in each of next 9 ch, dc4tog over next 5 sts, dc in each of next 11 sts, turn.

Rows 2–9: Work same as Miter 1.

Miter 3

Rows 1–9: With RS facing, join C with a sl st in center ch at base of dc4tog from Row 1 of Miter 2, complete same as Miter 2.

Miter 4

Row 1: With RS facing, join C with a sl st in bottom loop of first dc on Miter 1, Beg dc in same st, dc in each of next 10 ch, dc4tog over next 5 sts, dc in each of next 11 sts, turn.

Rows 2–9: Work same as Rows 2–9 of Miter 1.

Block F (Make 2)

Work same as Block E, using E, C, H, and I, respectively.

Block G (Make 2)

Work same as Block E, using A, I, H, and C, respectively.

Block H (Make 2)

Work same as Block E, using G, E, G, and E, respectively.

Block I (Make 2)

Work same as Block E, using B, F, G, and A, respectively.

Block J (Make 2)

Rnd 1: With size J-10 (6 mm) hook and G, ch 3, sl st in 3rd ch from hook to form a ring, (Beg dc, 15 dc) in ring, join with a sl st in top of Beg dc—16 dc.

Rnd 2: (Beg dc, dc) in first st, 2 dc in each st around, join with a sl st in top of Beg dc—32 dc. Fasten off.

Rnd 3: Join C with a sl st in any dc, (Beg dc, dc) in same st, dc in next st, 2 dc in next st, dc in next st, changing to E in last yo of last dc, *with E, working over C when not in use, [2 dc in next st, dc in next st] twice, changing to C in last yo of last dc**, with C, working over E, [2 dc in next st, dc in next st] twice, changing to C in last yo of last dc, with C; rep from * around, ending last rep at **, join with a sl st in top of Beg dc—48 dc.

Rnd 4: With C, (Beg dc, dc) in first st, dc in each of next 2 sts, 2 dc in next st, dc in each of next 2 sts, changing to E in last yo of last dc, *with E, [2 dc in next st, dc in each of next 2 sts] twice, change to C**, with C, [2 dc in next st, dc in each of next 2 sts] twice, change to E; rep from * around, ending last rep at **, join with a sl st in top of Beg dc—64 dc.

Rnd 5: With C, (Beg dc, dc) in first st, dc in each of next 3 sts, 2 dc in next st, dc in each of next 3 sts, changing to E in last yo of last dc, *with E, [2 dc in next st, dc in each of next 3 sts] twice, change to C**, with C, [2 dc in next st, dc in each of next 3 sts] twice, change to E; rep from * around, ending last rep at **, join with a sl st in top of Beg dc—80 dc. Fasten off.

Rnd 6: Join I with a sl st in last dc of any C section in Rnd 5, Beg dtr (see Glossary) in same st, ch 3, dtr in next st, *tr in next st, dc in each of next 2 sts, hdc in each of next 2 sts, sc in each of next 8 sts, hdc in each of next 2 sts, dc in each of next 2 sts, tr in next st**, dtr in next st; rep from * around, ending last rep at **, join with a sl st in top of Beg dtr—8 dtr; 8 tr; 16 dc; 16 hdc; 32 sc; 4 ch-sp.

Rnd 7: Sl st in next ch-sp, (Beg dc, dc, tr, 2 dc) in same ch-sp, *dc in each of next 20 sts**, (2 dc, tr, 2 dc) in next ch-sp; rep from * around, ending last rep at **, join with a sl st in top of Beg dc—4 tr; 96 dc. Fasten off.

Block K (Make 2)

Rnds 1 and 2: With size J-10 (6 mm) hook and D, work exactly as for Block J. Fasten off.

Rnd 3: Work same as Block J, starting with G and changing to B, alternating between these 2 colors.

Rnd 4: Work same as Block J, starting with D and changing to B, alternating between these 2 colors.

Rnd 5: Work same as Block J, starting with G and changing to B, alternating between these 2 colors.

Rnd 6: With RS facing, join C with a sl st in first st, (Beg dc, dc) in same st, dc in each of next 4 sts, 2 dc in next st, dc in each of next 4 sts changing to B in last dc, *with B, [2 dc in next st, dc in each of next 4 sts] twice, changing to C in last dc**, with C, [2 dc in next st, dc in each of next 4 sts] twice, changing to B in last dc; rep from * around, ending last rep at **, join with a sl st in top of Beg dc—96 dc. Fasten off.

Rnd 7: With RS facing, join F in last dc of any B section, Beg dtr in same st, *ch 3, 2 dtr in next st, dtr in next st, tr in each of next 2 sts, dc in each of next 2 sts, hdc in each of next 2 sts, sc in each of next 8 sts, hdc in each of next 2 sts, dc in each of next 2 sts, tr in each of next 2 sts, dtr in next st**, 2 dtr in next st; rep from * around, ending last rep at **, dtr in first st, join with a sl st in top of Beg dtr—24 dtr; 16 tr; 16 dc; 16 hdc; 32 sc; 4 ch-sps.

Rnd 8: (Beg dc, dc, tr, 2 dc) in first ch-sp, *dc in each of next 26 sts**, (2 dc, tr, 2 dc) in next ch-sp (**Corner** made); rep from * around, ending last rep at **, join with a sl st in top of Beg dc—4 tr; 120 dc. Fasten off.

Block L (Make 4)

Rnd 1: With size J-10 (6 mm) hook and E, ch 3, sl st in 3rd ch from hook to form a ring, Beg tr (see Glossary) in ring, [3 dc, tr] 3 times in ring, 3 dc in ring, join with a sl st in top of Beg tr—4 tr; 12 dc.

Rnd 2: (Beg dc, ch 3, dc) in same st, *dc in each of next 3 sts**, (dc, ch 3, dc) in next corner tr; rep from * around, ending last rep at **, join with a sl st in top of Beg dc—20 dc; 4 ch-sps.

Rnd 3: *Ch 4, sk next ch-sp, sc in each of next 5 dc; rep from * around, join with a sl st in first ch—20 sc; 4 ch-sps. Fasten off.

Rnd 4: With RS facing, join C with a sl st around both ch-sps from corners of Rnds 2 and 3, being sure to place sl st in center of ch-sps, (Beg tr, 2 dc) in corner ch-sp, *sc in each of next 5 sts of Rnd 3**, (2 dc, tr, 2 dc) over both ch-sps of next corner (**Corner** made); rep from * around, ending last rep at **, 2 dc over both ch-sps of first corner to complete it, join with a sl st in top of Beg tr—4 tr; 16 dc; 20 sc.

Rnd 5: (Beg dc, dc, tr, 2 dc) in same st, *dc in each of next 9 sts**, (2 dc, tr, 2 dc) in next corner tr; rep from * around, ending last rep at **, join with a sl st in top of Beg dc—4 tr; 52 dc. Fasten off.

Block M (Make 2)

Rnds 1–5: Work same as Block L, but using D and I, respectively.

Block N (Make 2)

Rnds 1–5: Work same as Block L, but using B and G, respectively.

Block O (Make 4)

Rnd 1: With size J-10 (6 mm) hook and H, ch 3, sl st in 3rd ch from hook to form a ring, Beg dc in ring, [ch 3, 3 dc] 3 times in ring, ch 3, 2 dc in ring, join with a sl st in top of Beg dc—12 dc; 4 ch-sps.

Rnd 2: *Ch 4, sk next ch-sp, sc in next 3 dc; rep from * around, join with a sl st in first ch of Rnd—12 sc; 4 ch-sps. Fasten off.

Rnd 3: With RS facing, join I with a sl st around both ch-sps from corners of Rnds 1 and 2, being sure to place sl st in center of ch-sps, (Beg tr, 2 dc) in corner ch-sp, *sc in each of next 3 sts**, (2 dc, tr, 2 dc) over ch-sps of next corner (corner made); rep from * around, ending last rep at **, 2 dc in first corner to complete it, join with a sl st to top of Beg tr—4 tr; 16 dc; 12 sc.

Rnd 4: *3 sc in corner st, sc in each of next 7 sts; rep from * around, join with a sl st in first sc—40 sc. Fasten off.

Block P (Make 2)

Rnds 1–4: Work same as Block O, but using C and G, respectively.

Block Q (Make 2)

Rnds 1–4: Work same as Block O, but using E and C, respectively.

Block R (Make 2)

Rnds 1–4: Work same as Block O, but using B and F, respectively.

Block S (Make 2)

Rnd 1: With size J-10 (6 mm) hook and F, ch 3, join with a sl st in 3rd ch from hook to form a ring, with F, (Beg dc, 3 dc) in ring changing to H in last yo of last dc, working over yarn when not in use, with H, 4 dc in ring, changing to F in last yo of last dc, with F, 4 dc in ring changing to H in last yo of last dc, 4 dc in ring changing to F in last yo of last dc, join with a sl st in top of Beg dc—16 dc.

Rnd 2: With F, (Beg dc, dc) in first st, 2 dc in each of next 3 sts, *changing to H in last yo of last dc, with H, 2 dc in each of next 4 sts, change to F**, with F, 2 dc in each of next 4 sts; rep from * to ** once, join with a sl st in top of Beg dc—32 dc.

Rnd 3: With F, (Beg dc, dc) in first st, dc in next st, [2 dc in next st, dc in next st] 3 times, *change to H, with H, [2 dc in next st, dc in next st] 4 times, change to F**, with F, [2 dc in next st, dc in next st] 4 times; rep from * to ** once, join with a sl st in top of Beg dc—48 dc. Fasten off.

Rnd 4: With RS facing, join I with a sl st in 6th st of Rnd 3, Beg tr in same st, *ch 3, tr in next st, dc in each of next 2 sts, hdc in next st, sc in each of next 4 sts, hdc in next st, dc in each of next 2 sts**, tr in next st; rep from * around, ending last rep at **, join with a sl st in top of Beg tr—8 tr; 16 dc; 8 hdc; 16 sc; 4 ch-sps. Fasten off.

Block T (Make 2)

Rows 1–4: Work same as Block S, but using C and G for Rnds 1–3, and F for Rnd 4.

Block U (Make 2)

Rows 1–4: Work same as Block S, but using C and E for Rnds 1–3, and F for Rnd 4.

Block V (Make 2)

Rows 1–4: Work same as Block S, but using B and E for Rnds 1–3, and C for Rnd 4.

Block W (Make 2)

Row 1: (RS) With size J-10 (6 mm) hook and D, ch 8, dc in 4th ch from hook (turning ch counts as a st), dc in each of next 4 ch, changing to G in last dc, turn—6 dc.

Row 2: With G, Beg dc in first st, dc in each st across, changing to D in last yo of last st, turn.

Rows 3–5: Alternating one row of each color, work even on 6 dc. Fasten off.

Block X (Make 2)

Rows 1–19: Work as for Block W, alternating colors for 19 rows, ending with D. Fasten off.

Block Y (Make 2)

Row 1: With size J-10 (6 mm) hook and I, ch 17, dc in 4th ch from hook (turning ch counts as a st), dc in next 13 ch, turn—15 dc.

Row 2: Sc in each st across, turn.

Row 3: Beg dc in first st, dc in each st across. Fasten off.

Block Z (Make 2)

Work same as Block Y through Row 3. Do not fasten off.

Rows 4–7: Rep Rows 2 and 3 (twice). Fasten off.

Block AA (Make 2)

Row 1: With size J-10 (6 mm) hook and D, ch 14, dc in 4th ch from hook (turning ch counts as a st), dc in each of next 10 ch, changing to G in last yo of last st, turn—12 dc.

Row 2: With G, Beg dc in first st, dc in each of next 11 sts, changing to D in last dc, turn.

Rows 3–7: Alternating 1 row of each color, work even on 11 dc. Fasten off.

Block BB (Make 2)

Row 1: (RS) With size J-10 (6 mm) hook and F, ch 3, join with a sl st in 3rd ch from hook to form a ring, Beg tr in ring, [3 dc, tr] twice in ring, turn—3 tr; 6 dc.

Row 2: (Beg tr, 2 dc) in first st, dc in each of next 3 sts, (2 dc, tr, 2 dc) in center tr (shell made), dc in each of next 3 sts, (2 dc, tr) in last st—3 tr; 14 dc. Fasten off.

Row 3: With RS facing, join A in first st, Beg dc3tog (see Glossary) over first 3 sts, dc in each of next 5 sts, (2 dc, tr, 2 dc) in next st, dc in each of next 5 sts, dc3tog over next 3 sts, turn—2 dc3tog; 1 shell; 10 dc.

Row 4: Rep Row 3. Fasten off.

Rows 5 and 6: With F, rep Rows 3 and 4.

Rows 7–10: Rep Rows 3–6.

Filler Triangle 1

Row 1: With RS facing and size J-10 (6 mm) hook, join A with a sl st in first st of Row 10, Beg dc3tog over first 3 sts, dc in each of next 3 sts, dc3tog over last 3 sts, turn—2 dc3tog; 3 dc.

Row 2: Beg dc3tog over first 3 sts, dc2tog over last 2 sts, turn.

Row 3: Sc2tog over first 2 sts. Fasten off.

Filler Triangle 2

Rows 1–3: With WS facing and size J-10 (6 mm) hook, join A in first st of Row 10, and rep Filler Triangle 1.

Block CC (Make 1)

Rows 1 and 2: With size J-10 (6 mm) hook and A, work Rows 1 and 2 same as Block BB.

Rows 3–6: Work same as Rows 3–6 of Block BB, but using E and G, alternating 2 rows each as for Block BB.

Rows 7–38: Rep Rows 3–6 (8 times). Fasten off.

Filler Triangles 1 and 2

With A, work same as Filler Triangles 1 and 2 on Block BB.

Joining the Blocks

Lay out blocks as shown in the Schematic, being sure to orient mitered square blocks as indicated by dashed line.

Join blocks using A and tapestry needle to whipstitch blocks together with WS facing, handstitching thoughtfully and meditating on the fusion of quilting with your own crochet art.

> **TIP**
>
> *On the Schematic, some joins are marked by paths of colors: red, blue, or green. The colors are arbitrary and only to maintain clarity. These paths of joining can be used to reduce the amount of cuts and woven ends in the joining process. All short joins are left black. Be sure to take advantage of every opportunity to join in a straight line whenever possible without cutting yarn, so as to minimize amount of yarn ends.*

When all blocks are handsewn and the butterfly is formed, it is time to work the Foundation Rnds and Fill Spaces to turn the butterfly into a rectangle. This next section will seem daunting, but stick to it! Once you get going, it is very intuitive, and will look impressive at the end, no matter what.

Foundation Rnds

Note: These are two rnds that go around the entire butterfly to set up the squaring process, so the st count is important.

Rnd 1: (Sc rnd) Locate the Block C with the shaded green square on the Schematic, and with RS facing, with size J-10 (6 mm) hook, join A with a sl st in the top left-hand corner of that Block, 3 sc in same st (**Sc Corner** made), sc in first 9 bottom loops of Block C, sc2tog (see Glossary) over next 2 sts, sc in each of last 8 dc of Block K, sc2tog over next 2 corner sts where two Blocks meet (counts as 1 sc), work 9 sc evenly spaced across Block D, 3 sc in next ch-sp, work 4 sc evenly spaced down side of Block D, sc2tog, work 9 sc evenly spaced across Block W, 3 sc in bottom loop of Block W, sc in each of next 4 sts down Block W, sc2tog over next 2 sts, sc in each of first 4 dc of Block L, [sc2tog, sc in 9 sts of Block D] twice, sc2tog, work 5 sc evenly spaced across last 3 rows of Block E, sc2tog, [work 9 sc evenly spaced across Block C, 3 sc in next corner, work 9 sc evenly spaced across

Block C, sc2tog] twice, work 3 sc evenly spaced across Block G, sc2tog, work 26 sc evenly spaced up Block CC, 3 sc in corner, work 10 sc evenly spaced across top of Block CC, 3 sc in corner st, reversing shaping, mirror opposite side, working across top edge of butterfly to upper Block C on side opposite first block, 3 sc in corner st of Block C, [work 9 sc evenly spaced across Block, sc2tog] twice, [work 15 sc evenly spaced across Block B, 3 sc in corner st] twice, work 4 sc evenly spaced across Block B, sc2tog, work 9 sc evenly spaced down Block C, 3 sc in corner st, work 9 sc evenly spaced across Block C, sc2tog, sc in each of last 15 dc of Block K, sc2tog, work 4 sc evenly spaced across top of Block A, 3 sc in corner st, work 20 sc evenly spaced across Block A, 3 sc in corner st, work 15 sc evenly spaced down Block A, sc2tog, work 27 sc evenly spaced down Block F, 3 sc in corner st, work 27 sc evenly spaced across Block F, sc2tog, work 10 sc evenly spaced down Block Z, sc2tog, work 4 sc evenly spaced down Block V, sc2tog, work 9 sc evenly spaced across Block D, 3 sc in corner st, work 9 sc evenly spaced down Block D, sc2tog, [work 13 sc evenly spaced across Block M, 3 sc in corner st] twice, work 3 sc evenly spaced across Block M, sc2tog, work 9 sc evenly spaced across Block P, 3 sc in corner st, work 9 sc evenly spaced across Block P, *[sc2tog, work 14 sc evenly spaced across next Block] twice, 3 sc in corner st **; rep from * to ** once, work 4 sc evenly spaced across Block T, sc2tog, work 9 sc evenly spaced across Block C, 3 sc in corner st, work 9 sc evenly spaced across Block C, sc2tog, work 4 sc evenly spaced across Block B, 3 sc in corner st, work 15 sc evenly spaced across Block B, sc2tog, work 4 sc evenly spaced across Block J, 3 sc in corner st, work 24 sc evenly spaced across Block J, sc2tog, work 4 sc evenly spaced across Block H, sc2tog, work 9 sc evenly spaced across Block O, sc2tog, work 30 sc evenly spaced across Block CC, 3 sc in corner st, work 10 sc evenly spaced across Block CC, reversing shaping, mirror opposite side, working around the piece up to first sc, join with a sl st in first sc.

Rnd 2: (Dc rnd) (Beg tr, 2 dc) in center sc of first Sc Corner, dc across to within 2 sts of next right-angle sc2tog, dc5tog (see Glossary) over next 5 sts, dc in each st across to center sc of next Sc Corner, (2 dc, tr, 2 dc) in corner sc (**Corner** made). *Note: Ignore any sc2tog that is used where 2 Blocks meet.* Work in established pattern around, making a Corner

in center sc of each Sc Corner, work dc in each st across to within 2 sts before each right angle sc2tog, work dc5tog over next 5 sts. **Note:** *The gaps on either side of the upper half of Block CC are very narrow. This is a good example showing how gaps will be closed when the blanket's Fill Spaces are worked. When the gap narrows, it is hard to fit both dc5tog in, so you must decrease all of the sts together at once. In this example, when you stop 2 sts before the first sc2tog—shown with a purple circle in Schematic—you will need to work dc9tog (see Glossary) over next 9 sts instead of working 2 dc5tog. Then continue with dc as established. Later on, this gap will be sewn up with whipstitch. When Beg of rnd is reached, work 2 dc in first corner to complete it, join with a sl st in top of Beg tr.* Do not fasten off. You are now ready for Fill Space 1.

Fill Spaces to Square Off Sides
Fill Space 1

To prepare for this section, locate two gaps on either side of upper part of Block CC, as indicated by purple lines. Whipstitch two gaps together to sew them shut. Always use a spare ball of A to whipstitch gaps closed. Weave in ends from sewing.

Row 1: With RS facing, pick up working yarn from end of Foundation Rnd 2, (Beg dc, dc) in same st of join from Rnd 2, dc in each st across to within 2 sts before next dc5tog, work dc5tog over next 5 st, dc in each st across to tr of next Corner, work Corner in tr, work down first side of piece, making Corners in corners and dc5tog in each valley as needed. When first sewn gap is reached, stop 2 sts before tr of Corner, work dc5tog over next 5 sts to form a right angle, continue with dc up Block CC to tr of Corner, work Corner in corner tr, work opposite side, mirroring all shaping, until opposite side of upper Block C is reached, work 2 dc in tr of Corner on upper Block C, turn, leaving rem sts unworked—12 dc5tog; 10 Corners.

Row 2: Beg dc in first st, dc in each st across to 2 sts before dc5tog, work dc5tog over each valley, dc in each st across to tr of next Corner, work Corner in corner tr, continue across in this manner until end of row is reached, placing dc in last st, turn.

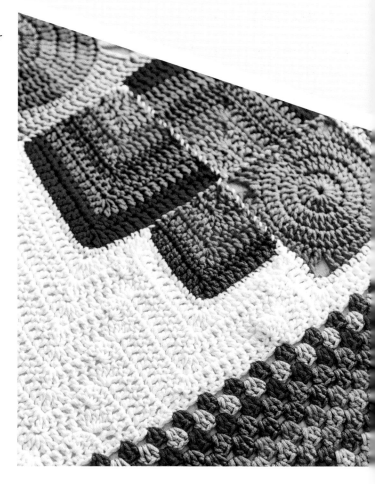

Row 3: Work same as Row 2, paying attention that on this row, you will have another 2 gaps to whipstitch closed. These gaps are approximated by orange lines on the Schematic. Weave in ends from sewing.

Row 4: Work same as Row 2, paying careful attention where gaps were sewn on Row 3.

Row 5: Work same as Row 2.

Row 6: Beg dc5tog (see Stitch Guide) over first 5 sts, work as established across, working dc5tog over last 5 sts. Fasten off.

Row 7: With RS facing, rejoin A in final Corner tr of previous row, (Beg dc, dc) in same st, work in established pattern across, working 2 dc in last Corner tr on opposite side, turn, leaving rem sts unworked.

Row 8: Work same as Row 2.

Row 9: Work same as Row 6. **Note:** *Straight top edge of Fill Space 1 is beginning to take shape.*

Row 10: With WS facing, work same as Row 7.

Rows 11–14: Work same as Row 2.

Row 15: Work same as Row 6.

Row 16: With WS facing, work same as Row 7. Whipstitch center gap, marked with a blue line on Schematic, closed. Fasten off. Weave in ends.

Fill Space 2

Rotate butterfly so that bottom edge is on top, locate Block T with blue shaded square. This is the starting point for Fill Space 2.

Row 1: (RS) With RS facing, using size J-10 (6 mm) hook, join A with a sl st in tr of Corner above shaded square, and work same as Row 1 of Fill Space 1, ending in corresponding corner on opposite side of butterfly.

Row 2: Work same as Row 2 of Fill Space 1. After Row 2, you will need to whipstitch the gaps on either side of the bottom part of Block CC, as shown with purple lines on Schematic. Weave in ends from sewing.

Row 3: Work same as Row 6 of Fill Space 1. After Row 3, another 2 (very short) gaps will need sewing, approximated by short orange lines on Schematic. Weave in ends from sewing.

Row 4: With WS facing, work same as Row 7 of Fill Space 1, paying careful attention where gaps were sewn on previous row.

Rows 5–8: Work same as Row 2 of Fill Space 1.

Row 9: Work same as Row 6 of Fill Space 1.

Row 10: With WS facing, work same as Row 7 of Fill Space 1. Whipstitch center gap, marked with a blue line on Schematic, closed. Fasten off. Weave in ends.

Fill Space 3

Locate Block B with purple shaded square. This is the starting point for Fill Space 3.

Row 1: (RS) With RS facing, using size J-10 (6 mm) hook, join A with a sl st in tr of Corner above shaded square, (Beg dc, dc) in same st, work in established pattern across side, placing 2 dc in last tr of last Corner in bottom left-hand corner of Block S, turn.

Row 2: Beg dc in first st, work as established across, placing dc in last st, turn.

Row 3: Beg dc5tog over first 5 sts, then finish row as for Row 2. After Row 3, you will need to whipstitch the gap as shown with a purple line on Schematic. Weave in ends from sewing.

Row 4: Beg dc in first st, work as established across, placing 2 dc in center tr of first Corner from previous row, turn, leaving rem sts unworked.

Row 5: Work same as Row 3. After Row 5, you will need to whipstitch the gap as shown with an orange line on Schematic. Weave in ends from sewing.

Row 6: Work same as Row 4.

Rows 7 and 8: Work in established pattern. After Row 8, you will need to whipstitch the gap as shown with a blue line on Schematic. Weave in ends from sewing.

Rows 9–13: Work in established pattern.

Row 14: Beg dc in first st, work in established pattern across, ending with dc5tog over last 5 sts, turn. Fasten off.

Row 15: Being sure to keep side of blanket straight, rejoin yarn in tr of first Corner, (Beg dc, dc) in same st, work in established pattern across, placing dc in last st.

Row 16: Beg dc5tog over first 5 sts, work in established pattern across, working dc5tog over last 5 sts, turn. Fasten off.

Row 17: Fill tiny rectangle corner in by working as for Row 1.

Fill Space 4

With WS facing, and starting in spot opposite starting point of Fill Space 3, where Square B has a orange shaded square, work same as Fill Space 3.

Work the Border

Note: Remainder of blanket is worked using size I-9 (5.5 mm) hook.

Foundation Rnd

With RS facing and size I-9 (5.5 mm) hook, join A with a sl st in the upper right-hand corner of blanket, *3 sc in corner st, work 231 sc evenly spaced across top of blanket, 3 sc in corner st, work 183 sc down side of blanket; rep from * once, join with a sl st in first st. Fasten off.

> ✳ **TIP**
>
> *Some parts of Foundation Rnd will be worked across the sides of dc sts. Be sure to put 2 sc in the side of every dc. To avoid making holes down the side of the piece, do not crochet "around" the st, rather directly into the side bars of the st.*

First Granny-Stripe Section

Row 1: With RS facing, and size I-9 (5.5 mm) hook, join H in corner st at top right-hand corner of the blanket, (Beg dc, dc) in same st, (sk next 2 sts, 3 dc in next st) across to within 2 sts before next corner st, 2 dc in corner st, do not turn—4 dc; seventy-seven 3-dc groups; 235 dc total. Fasten off.

Row 2: With RS facing, join I with a sl st in first st, Beg dc in first st, 3 dc between next dc and next 3-dc group, 3 dc between all 3-dc groups across to within last 2 sts, sk next st, dc in last st—2 dc; seventy-eight 3-dc groups. Fasten off.

Row 3: With RS facing, join D with a sl st in first st, Beg dc in first st, dc between first 2 sts, 3 dc between 3-dc groups across to within last 4 sts, dc between last 3-dc group and last st. Fasten off.

Rows 4–13: Rep Rows 2 and 3 for pattern, working 1 row each in the following color sequence: E, B, F, C, G, H, I, C, D, H.

Turn blanket to the opposite side and rep Rows 1–13 of First Granny Stripe Section.

Final Border

Rnd 1: With RS facing, join I with a sl st in first st at top right-hand corner, *3 sc in corner st, sc in each st across to next corner, 3 sc in corner st, work 21 sc evenly spaced down side of Granny Stripe Section, work 185 sc evenly spaced down side to next Granny Stripe Section, work 20 sc evenly spaced down next Granny Stripe Section; rep from * once, join with a sl st in first sc.

Rnd 2: Sl st in corner sc, *(sc, ch 2, sc) in corner st, (ch 2, sk next st, sc in next st) across to within last st before next corner, ch 2, sk next st; rep from * around, join with a sl st in first sc.

Rnd 3: (Beg tr, Picot [see Stitch Guide], [tr, Picot] 5 times, tr) in corner ch-sp, sk next ch-sp, ** *sc in next ch-sp, Picot, sc in next ch-sp, sk next ch-sp, ([tr, Picot] 4 times, tr) in next ch-sp (shell made), sk next ch-sp; rep from * across to last 3 ch-sps before corner st, sc in next ch-sp, Picot, sc in next ch-sp***, ([tr, Picot] 8 times, tr) in corner ch-sp; rep from ** 3 times, ending last rep at ***, join with a sl st in top of Beg tr. Fasten off.

Rnd 4 (optional sl st rnd): Using size J-10 (6 mm) hook, join A with a sl st in base of any corner st of Rnd 1 of Border. With the ball end of the yarn held behind the piece, work a sl st in base of every sc around the blanket. *Note: Be careful not to make the sts too tight.* Fasten off. Weave in ends.

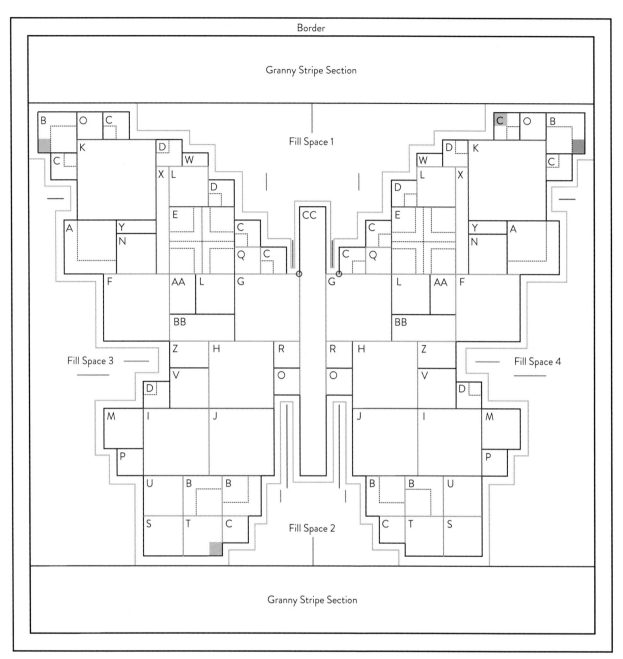

SCHEMATIC

CHART KEY

A, B, C ... = Letters indicate Block style
········· = Orientation of mitered blocks
——— = Continuous seams between blocks
——— = Continuous seams between blocks
——— = Short seams between blocks
——— = Outline of Foundation Rnds
O = Location of dc9tog on Foundation Rnd 2

⎫
⎬ = Fill space gaps to be sewn closed
⎭

■ = Joining location for Fill Space 1
■ = Joining location for Fill Space 2
■ = Joining location for Fill Space 3
■ = Joining location for Fill Space 4

Techniques

This section provides an overview of the special techniques used in this book, with a particular focus on tricky tips for certain stitches, motif joining maneuvers, and finishing methods to make your work as neat as possible. A straightforward pattern typically uses standard techniques, but I want to share my preferred, sometimes nonstandard methods with you!

For other techniques you don't know, be sure to visit the Glossary at www.interweave.com for more information.

SPECIAL TECHNIQUES

Changing Color

Note: This techniques is used for both starting a new row/rnd, or in the middle of a row/rnd. Pull the new color through the last two loops on the hook **(FIGURE 1)** to change colors in the middle of a stitch. Color change completed **(FIGURE 2)**. Finish off the old color before joining new yarn with a sl st in indicated st/sp.

FIGURE 1

FIGURE 2

Border Stitches

If the side is straight and not diagonal, then I work one st into a sc, two in a dc **(FIGURE 1)**, three in a tr, and so on. If the side is diagonal, I add an extra stitch for each row to account for the additional length. Be sure to work into the sides of the sts, not around the sts to avoid large holes forming.

FIGURE 1

Beginning the Row Without a Turning Chain

For this technique, you simply use "beginning" stitches such as "Beg dc" (sc, ch 1) **(FIGURE 1)** in the indicated st/sp to create the first dc st of the row/rnd.

FIGURE 1

Making Matching Decreases at Both Ends of a Row

Use beginning sts at the right side of the piece, which in this case do not count as a stitch for the starting decrease, then the usual decrease at the left side, for the end of the row.

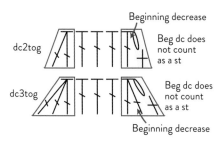

dc2tog

Beginning decrease

Beg dc does not count as a st

dc3tog

Beg dc does not count as a st

Beginning decrease

Making Tall Stitches Neater

Make your yarnovers snugly, and keep the wraps as close to the tip of the hook as possible **(FIGURE 1)**. Then don't loosen up as you work through two loops at a time **(FIGURE 2)** until the stitch is made.

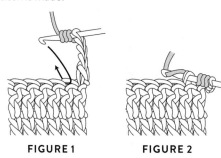

FIGURE 1 **FIGURE 2**

JOINING TECHNIQUES

Join as you go on the final round of each piece.

Joining Square Motifs as You Go

Work the first motif complete, then join adjacent sides of subsequent motifs on the final round, using the specified techniques provided in each pattern.

Joining Hexagon Motifs as You Go

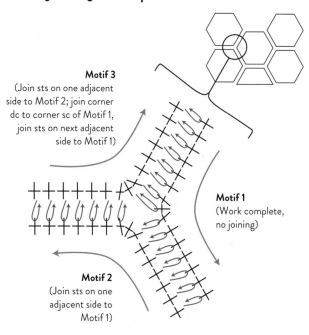

Motif 3
(Join sts on one adjacent side to Motif 2; join corner dc to corner sc of Motif 1, join sts on next adjacent side to Motif 1)

Motif 1
(Work complete, no joining)

Motif 2
(Join sts on one adjacent side to Motif 1)

JOINING TECHNIQUES

Pull Loop Through (PLT) Join

Release the loop from the hook **(FIGURE 1)**, insert the hook from front to back in st/sp indicated, grab the loop, pull the loop through to the front of the work without making any chains (unless directed as for joining adjacent chain-3 corners) **(FIGURE 2)**, and complete the stitch as normal **(FIGURE 3)**.

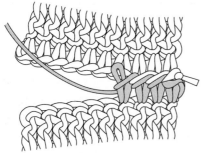

FIGURE 1

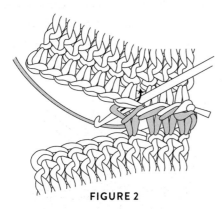

FIGURE 2

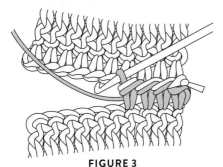

FIGURE 3

Slip-Stitch Motifs Together

Depending on the instructions in the pattern, you can slip-stitch motifs together on either the RS or WS of the work and either through both loops or through back loops only **(FIGURE 1)**. These variations will produce different visual effects.

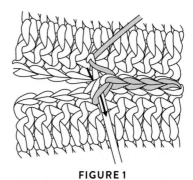

FIGURE 1

Whipstitch Motifs Together

Thread your joining yarn onto a tapestry needle. Hold the motifs with wrong sides together and secure the end of the joining yarn with a stitch through both motifs at the beginning of the joining edge. Insert the needle from front to back all the way through both loops of both motifs and pull the yarn through. Repeat across, always inserting the needle from front to back, and allowing the stitches to lie flush along the top of the joining edge. Resist the urge to tighten the stitches by pulling the joining yarn, as this will create puckering.

FINISHING

Blocking

While it may feel more natural to skip this step, it can be crucial to block your piece so that the often unconventional shapes and stitching methods of the projects in this book can lie as flat as possible. A simple blocking mat of interlocking foam flooring can be purchased relatively inexpensively, and this makes for a fantastic surface to pin your project. A couple of packs of pins should be sufficient for larger projects. Lay your project down on the mat, spritz all over with a little water, carefully pin your project out to the desired dimensions, easing it into position and letting it air-dry. I put a small but powerful fan in front of the mat to speed up the drying process.

Making a Flatter Border

Be sure to make the "just right" amount of stitches on each side of the blanket so that the border will lie flat. Too many stitches will create a border that ripples, and too few stitches can cause it to pucker. When placing stitches for the foundation round at the spot where two motifs meet, the stitch count should be decreased by a stitch or two to prevent rippling. Also, in nearly every case, you can achieve a flatter border by stitching it with a smaller size hook than the one used for the blanket body.

Weaving in Ends

Lacy, Open Stitches

Using a tapestry needle or a hook at least two sizes smaller than the one used in your project, weave in the yarn ends along the lacy stitches, being sure to change direction at least twice to secure. Do not simply "work over" the yarn end, as it will show through to the front of the piece. If possible, only weave in yarn ends through the same-color yarn section.

Solid Stitches

The beginning yarn end may be "worked over," that is, held against the fabric while working the following row, to encase the yarn end in the bottom of the stitches. The final yarn end may be woven in as follows: Insert a tapestry needle or smaller hook from back to front of work and grab the yarn tail, pulling it to the back of the piece. Working left to right, insert the hook from back to front through BLO of every stitch **(FIGURE 1)**, grabbing the yarn tail and pulling it to the back of the work repeatedly until yarn tail is exhausted. This is an easy way to create an invisible weave.

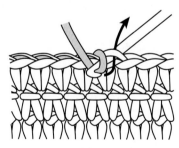

FIGURE 1

Abbreviations

beg begin; begins; beginning

bet between

blo back loop only

CC contrasting color

ch(s) chain(s)

cm centimeter(s)

dc double crochet

dec decrease(s); decreasing; decreased

dtr double treble crochet

foll follows; following

g gram(s)

hdc half double crochet

inc increase(s); increasing; increased

lp(s) loop(s)

MC main color

m marker; meter(s)

mm millimeter(s)

pm place marker

rem remain(s); remaining

rep repeat; repeating

rnd(s) round(s)

RS right side

sc single crochet

sk skip

sl slip

sl st slip(ped) stitch

sp(s) space(s)

st(s) stitch(es)

tog together

tr treble crochet

WS wrong side

yd yard(s)

yo yarn over

***** repeat starting point

() alternative measurements and/or instructions; work instructions within parentheses in place directed

[] work bracketed instructions a specified number of times

Metric Conversion Chart

TO CONVERT	TO	MULTIPLY BY
Inches	Centimeters	2.54
Centimeters	Inches	0.4
Feet	Centimeters	30.5
Centimeters	Feet	0.03
Yards	Meters	0.9
Meters	Yards	1.1

Glossary

Beg dc (beginning double crochet)
Sc, ch 1.

Beg dc3tog (beginning double crochet 3 together)
Beg dc, dc2tog.

Beg dc4tog (beginning double crochet 4 together)
Beg dc, dc3tog.

Beg dc5tog (beginning double crochet 5 together)
Beg dc, dc4tog.

Beg dc9tog (beginning double crochet 9 together)
Beg dc, dc8tog.

Beg dtr (beginning double treble crochet)
Sc, ch 3.

Beg hdc (beginning half double crochet)
Sc, ch 1.

Beg tr (beginning treble crochet)
Sc, ch 2.

dc2tog (double crochet 2 together)
(Yo, insert hook in next st, yo, pull loop up, yo, draw yarn through 2 loops on hook) twice as indicated, yo, draw yarn through all 3 loops on hook.

dc3tog (double crochet 3 together)
(Yo, insert hook in next st, yo, pull loop up, yo, draw yarn through 2 loops on hook) 3 times, yo, draw yarn through all 4 loops on hook.

dc4tog (double crochet 4 together)
(Yo, insert hook in next st, yo, pull loop up, yo, draw yarn through 2 loops on hook) 4 times, yo, draw yarn through all 5 loops on hook.

dc5tog (double crochet 5 together)
(Yo, insert hook in next st, yo, pull loop up, yo, draw yarn through 2 loops on hook) 5 times, yo, draw yarn through all 6 loops on hook.

dc8tog (double crochet 8 together)
(Yo, insert hook in next st, yo, pull loop up, yo, draw yarn through 2 loops on hook) 8 times, yo, draw yarn through all 9 loops on hook.

dc9tog (double crochet 9 together)
(Yo, insert hook in next st, yo, pull loop up, yo, draw yarn through 2 loops on hook) 9 times, yo, draw yarn through all 10 loops on hook.

Magic Ring
Make a large loop with the yarn. Holding the loop with your fingers, insert hook in loop and pull working yarn through loop. Yarn over hook, pull through loop on hook. Continue to work indicated number of stitches in loop. Pull on yarn tail to close loop.

reverse sc (reverse single crochet)
Working from left to right, insert hook in next st to the right, yo, draw yarn through st, yo, draw yarn through 2 loops on hook.

sc2tog (single crochet 2 together)
(Insert hook in next st, yo, draw yarn through st) twice, yo, draw yarn through 3 loops on hook.

sc3tog (single crochet 3 together)
(Insert hook in next st, yo, draw yarn through st) 3 times, yo, draw yarn through 4 loops on hook.

sc4tog (single crochet 4 together)
(Insert hook in next st, yo, draw yarn through st) 4 times, yo, draw yarn through 5 loops on hook.

sc5tog (singe crochet 5 together)
(Insert hook in next st, yo, draw yarn through st) 5 times, yo, draw yarn through 6 loops on hook.

sc6tog (single crochet 6 together)
(Insert hook in next st, yo, draw yarn through st) 6 times, yo, draw yarn through 7 loops on hook.

See the complete glossary for techniques and terms you don't know at www.interweave.com

Acknowledgments

Creating these designs and crafting them into a book has been equal parts challenging and rewarding, just as a great life experience should be. I would like to thank Stephanie White who approached me to write this book and everyone on the F+W Media team. Special thanks to Maya Elson, Kerry Bogert, and the other editors who gave their blessings and encouragement.

The bulk of my gratitude on this journey goes to my family. So many thanks to my extraordinary husband, Nicolas, and our four children, who provide never-ending love, confidence, positivity, and good vibes. When I stretch myself dangerously thin, they remind me to take a step back and slow down. Thanks also to my wonderfully supportive mother and sister, who listen to me drone on incessantly about my crafty endeavors without so much as one complaint.

I must also include the talented members of the Scheepjes blogger group, of which I am proud to be a member. Our fearless leader, Simy Somer, has pushed me to elevate my craft to new heights. She knows how to build you up, so you stand tall. There are no words sufficient to convey my appreciation for my partnership with Scheepjes Yarns.

To my Tester Tribe, who so graciously work up samples, arrange photo shoots, and provide me with precious feedback on my designs, thank you from the bottom of my heart. I could not do it without you talented lot! Special thanks to Kaelyn Guerin, Gwen Kok, Iris Dongo, and Carol Janik—who have all become great friends of mine through our mutual hook and yarn obsession.

Finally, thank you to the six artists who so kindly allowed me to include their works in this volume. To Caitlin Dowe-Sandes, Maryanne Moodie, Tula Pink, April Rhodes, Francisco Valle, Maud Van Tours, and to all of the other members of my creative community, I am honored to work alongside such a loving and spirited group of people, who encourage me to create every day.

About THE Author

RACHELE CARMONA is the crochet/knit pattern designer behind Cypress Textiles. She holds a Bachelor of Arts degree in English Rhetoric from Texas A&M University. Her needlecraft career began as a college hobby that grew to new heights after encouragement from her close friends and the creative community. Eventually, she left her job as a restaurant manager to stay home with her budding family and focus on her craft. Rachele resides in the Houston area with her husband and their four children and four fur-babies.

Yarn Resources

CASCADE YARNS
(800) 548-1048

www.cascadeyarns.com

220 Superwash, 220 Superwash Sport, Ultra Pima

KNIT PICKS
(800) 574-1323

www.knitpicks.com

Palette

KAMGARN
1 90 276 253 33 05

www.kamgarn.com

Papatya Batik

SCHEEPJES
www.scheepjes.com/en

Bloom, Catona, Catona Denim, Colour Crafter, Colour Crafter Velvet, Merino Soft, Roma Big, Softfun Aquarel, Sunkissed

STYLECRAFT
01535 609798

www.stylecraft-yarns.co.uk

Classique Cotton DK, Special DK

WOOL AND THE GANG
(844) 742-437

www.woolandthegang.com

Billie Jean, Shiny Happy Cotton

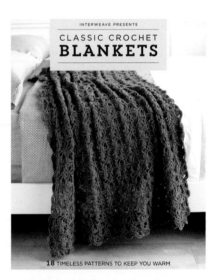